the **WRITING** on the **WALL**

ART IN PROFILE

Michele Hardy, Curator, Nickle Galleries, University of Calgary
ISSN 1700-9995 (Print) ISSN 1927-4351 (Online)

The Art in Profile series showcases the meaningful contributions of Canadian artists and architects, both emerging and established. Each book provides insight into the life and work of an artist or architect who asserts creativity, individuality, and cultural identity.

No. 1 · **Ancestral Portraits: The Colour of My People** Frederick R. McDonald
No. 2 · **Magic off Main: The Art of Esther Warkov** Beverly J. Rasporich
No. 3 · **The Garden of Art: Vic Cicansky, Sculptor** Don Kerr
No. 5 · **Reta Summers Cowley** Terry Fenton
No. 6 · **Spirit Matters: Ron (Gyo-Zo) Spickett, Artist, Poet, Lay-Priest** Geoffrey Simmins
No. 7 · **Full Spectrum: The Architecture of Jeremy Sturgess** Edited by Geoffrey Simmins
No. 8 · **Cultural Memories and Imagined Futures: The Art of Jane Ash Poitras** Pamela McCallum
No. 9 · **The Art of John Snow** Elizabeth Herbert
No. 10 · **Cover and Uncover: Eric Cameron** Edited by Ann Davis
No. 11 · **Marion Nicoll: Silence and Alchemy** Ann Davis and Elizabeth Herbert
No. 12 · **John C. Parkin, Archives, and Photography: Reflections on the Practice and Presentation of Modern Architecture** Linda Fraser, Michael McMordie, and Geoffrey Simmins
No. 13 · **From Realism to Abstraction: The Art of J. B. Taylor** Adriana A. Davies
No. 14 · **The Writing on the Wall: The Work of Joane Cardinal-Schubert** Edited by Lindsey V. Sharman

UNIVERSITY OF CALGARY Press

the WRITING on the WALL
THE WORK OF JOANE CARDINAL-SCHUBERT

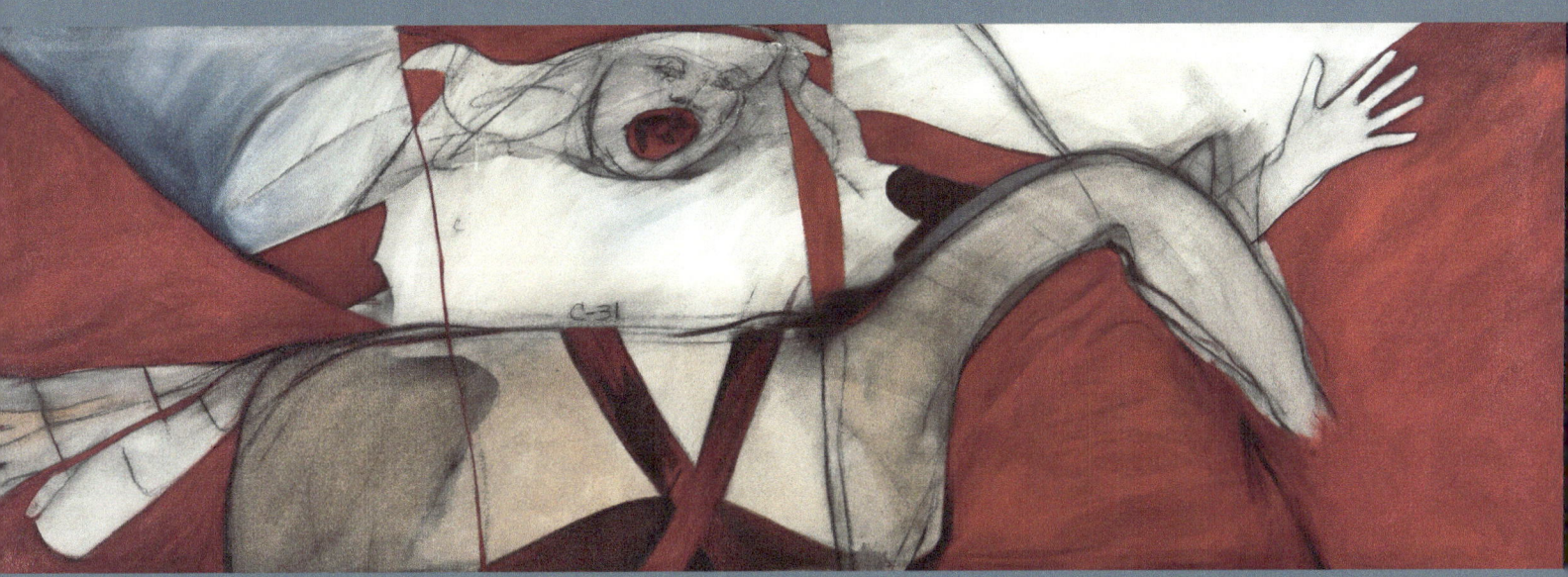

Edited by Lindsey V. Sharman

Art in Profile Series
ISSN 1700-9995 (Print) ISSN 1927-4351 (Online)

© 2017 Lindsey V. Sharman

University of Calgary Press
2500 University Drive NW
Calgary, Alberta
Canada T2N 1N4

press.ucalgary.ca

This book is available as an ebook which is licensed under a Creative Commons license. The publisher should be contacted for any commercial use which falls outside the terms of that license.

Library and Archives Canada Cataloguing in Publication

Writing on the wall (Calgary, Alta.)
　　The writing on the wall : the work of Joane Cardinal-Schubert / edited by Lindsey V. Sharman.

(Art in profile, ISSN 1700-9995 ; no. 14)
Issued in print and electronic formats.
ISBN 978-1-55238-949-2 (softcover).—ISBN 978-1-55238-950-8 (Open Access PDF).—
ISBN 978-1-55238-952-2 (EPUB).—ISBN 978-1-55238-953-9 (Kindle).—
ISBN 978-1-55238-951-5 (PDF)

　　1. Cardinal-Schubert, Joane, 1942–2009. 2. Painters—Canada—Biography. I. Sharman, Lindsey V., editor II. Cardinal-Schubert, Joane, 1942–2009. Paintings. Selections. III. Title. IV. Series: Art in profile ; no. 14

ND249.C277W75 2017　　　759.11　　C2017-904971-2
　　　　　　　　　　　　　　　　　　　　C2017-904972-0

The University of Calgary Press acknowledges the support of the Government of Alberta through the Alberta Media Fund for our publications. We acknowledge the financial support of the Government of Canada. We acknowledge the financial support of the Canada Council for the Arts for our publishing program.

This publication has been supported by Rod Green, Masters Gallery Ltd.

Front cover art: Joane Cardinal-Schubert, *Rider*, 1986.
Courtesy of the Estate of Joane Cardinal-Schubert
Copyediting by Kathryn Simpson
Cover design, page design, and typesetting by Melina Cusano

TABLE OF CONTENTS

Introduction *1*
 BY LINDSEY V. SHARMAN

"I Am out of the Woods Now" – Joane Cardinal-Schubert *9*
 BY MIKE SCHUBERT

Remembering Joane Cardinal-Schubert *37*
 BY MONIQUE WESTRA

"Terribly Beautiful": Joane Cardinal-Schubert's "Intervention of Passion" *63*
 BY DAVID GARNEAU

Still Seeing Red *87*
 BY ALISDAIR MACRAE

Recollections *117*
 BY TANYA HARNETT

[Still] Responding to Everyday Life *143*
 BY JOANE CARDINAL-SCHUBERT AND GERALD MCMASTER

Image List *153*

Curriculum Vitae *165*

Contributors *181*

1. *Rider*, 1986
152 x 213 cm
60" x 84"
Oil and graphite on canvas
From the Estate of Joane Cardinal-Schubert

This work is a reaction to Bill C-31, a bill to amend sections of the Indian Act that legally affiliated a married woman not with her own heritage but with either the Indigenous membership or settler heritage of her husband.

"Since I was a small child I had tried to equal the skills of my brothers and my father – perhaps I noticed a type of inequality – perhaps I didn't realize that to be a girl meant that I couldn't do as well, or wasn't as strong. People had a description for girls like me then, I was called a Tom-boy. I figured out this was not a good moniker to have and when my father presented me a gift on my 5th birthday of a statue of a little girl one sock up and one sock down with a definite pout on her face, I yelled that I was going to smash it with a hammer. Besides, the statue was one of a girl with blond hair and blue eyes – I knew I didn't look that way. After all these years I still have that statue and guard it. It is precious to me because it is symbolic of the time in my life when I had absolute freedom. Looking at it (I keep it in my wardrobe on the hat shelf – just at eye level) it recalls the lake with the water lilies, the Canadian Geese, the ducks, and other water birds, the muskrats and beaver, the wind, the flood waters, the trees and all the smells, and textures of the earth, my parents the way they were then, and my brothers and sister, my grandmother and grandfather.

I am my mother and my father and my sister and my brothers, I am my grandmothers and my grandfathers and I am an Indian..."

Joane Cardinal-Schubert, RCA
"Song Transforming to Revenge Walker" from the artist's personal documents

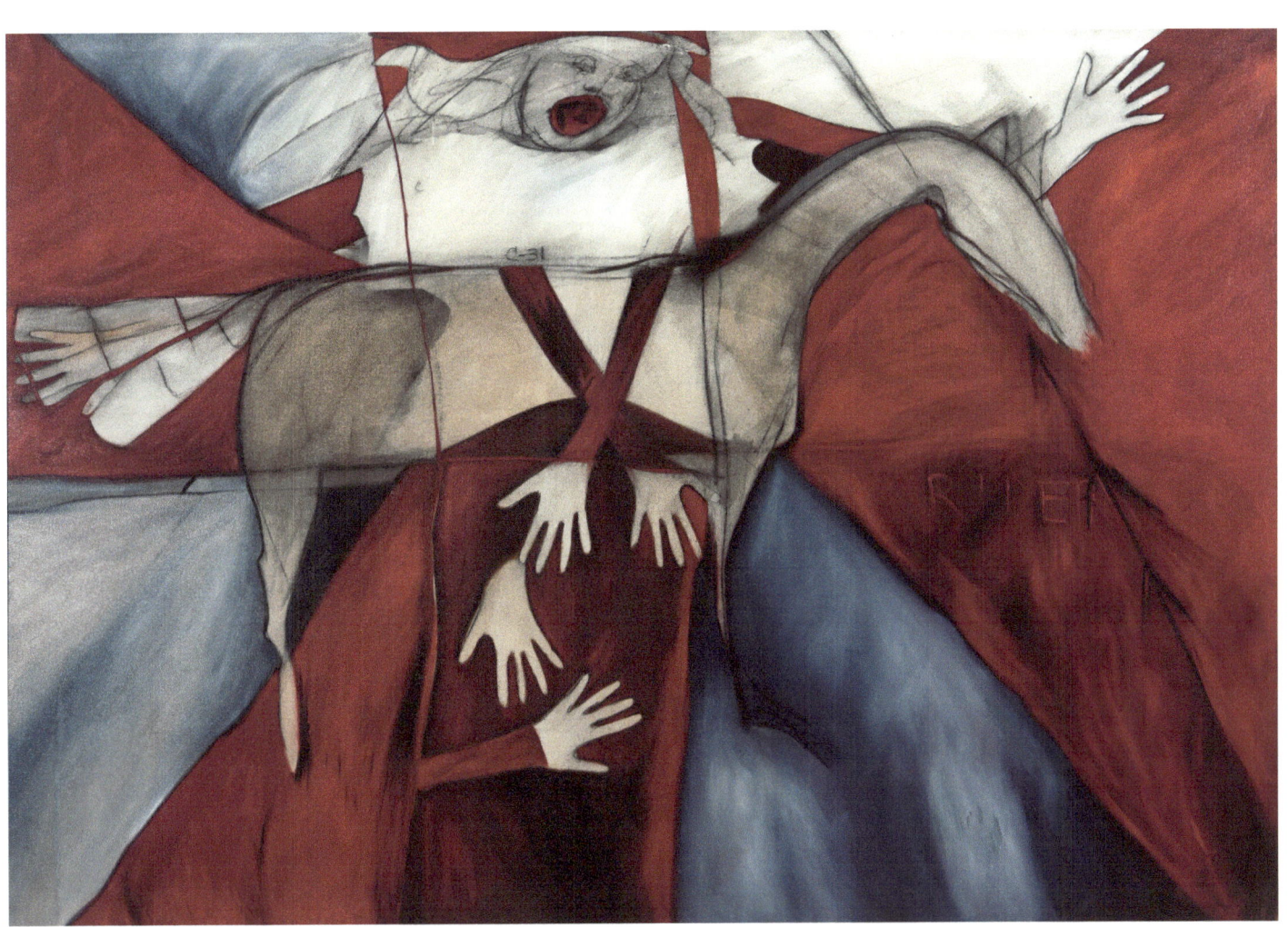

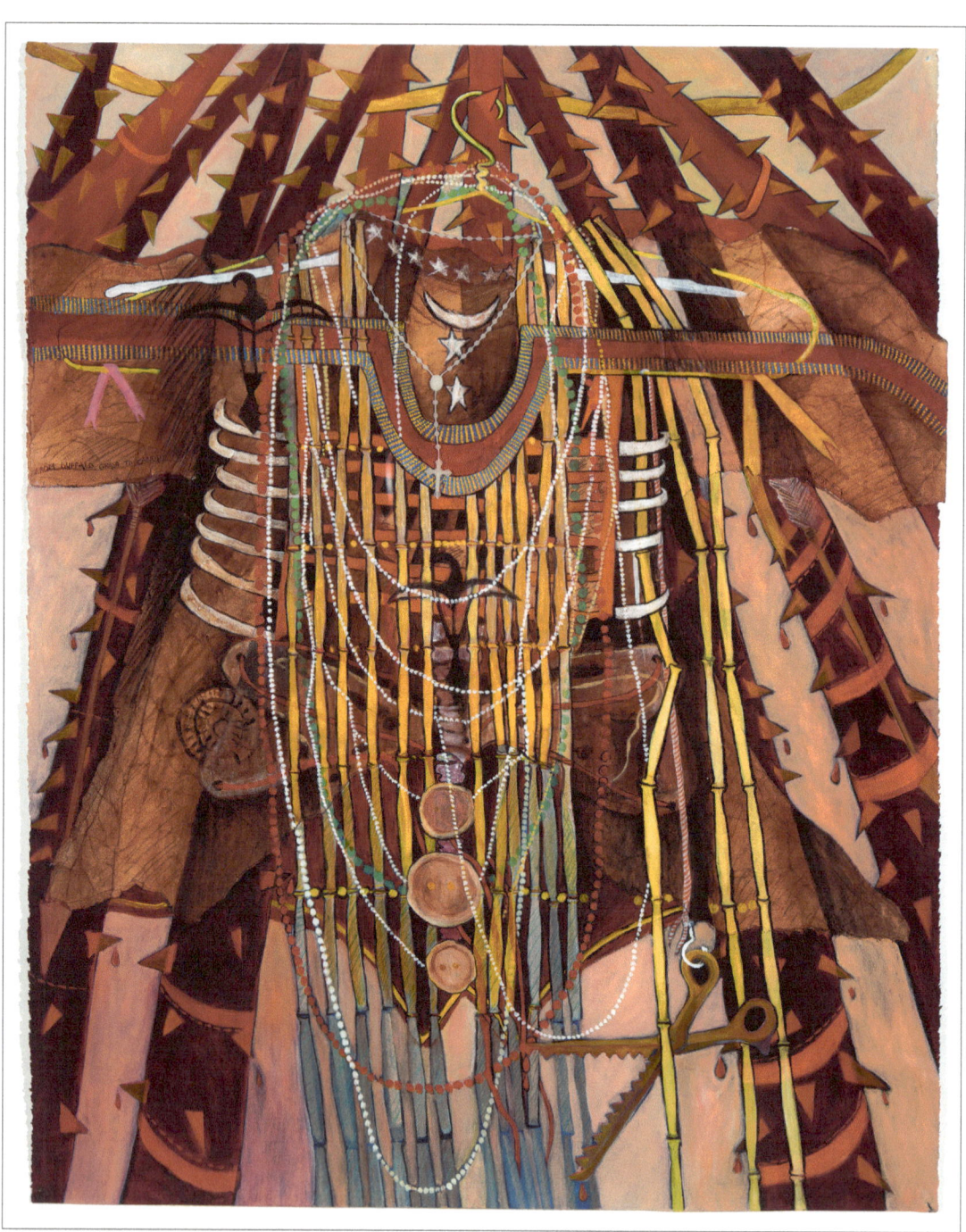

2. *Self Portrait Warshirt*, n.d.
152.4 x 101.6 cm
60" x 40"
Mixed media on paper
From the Estate of Joane Cardinal-Schubert

INTRODUCTION

"I would like to extend a formal welcome to you all to this part of the country ... in the words of John Snow, 'These Mountains are our Sacred Places.' It is a beautiful part of the globe – resplendent and bountiful and majestic."

– Joane Cardinal-Schubert, "Flying with Louis"
Making Noise! Keynote address, 2003

This publication was largely written and compiled on the traditional territories of the Blackfoot and the people of the Treaty 7 region of Southern Alberta. The works illustrated are drawn primarily from collections, both public and private, on this same land which includes the Siksika, the Piikuni, the Kainai, the Tsuu T'ina and the Stoney Nakoda First Nations. Dr. Joane Cardinal-Schubert, RCA affirmed herself as "Blackfoot-Blood" or Kainai. Cardinal-Schubert introduced herself and her work succinctly and aptly in Loretta Todd's film, *Hands of History* by simply stating, "I am Joane Cardinal-Schubert – and I play a lot."

Cardinal-Schubert melds this playfulness with astute observation and self-assured critique of the world around her based in exhaustive historical knowledge. This combination resulted in tireless engagement with the people and systems of which she was a part and to which she was in proximity. This engagement inspired, educated, intimidated, and even frustrated, but she left her mark and her stories nonetheless. People revel in telling "Joane

stories" and are fascinated by her work and her personality. I am one of countless people whose life paths have been altered by Joane. In 2008, I took a job with Masters Gallery, Ltd in Calgary because they represented her commercially. I helped with her last exhibition with this gallery in the summer of 2009 and together we reinstalled *The Lesson*, an installation and performance first realized by the artist in 1989 at Articule Gallery, Montreal (fig. 24). This installation created waves that reverberate still, and it is mentioned in several of the following essays. I was surprised by the number of people that were unaware of the history that it presented. I didn't understand it at the time but I have come to realize that Joane was good at planting seeds in just the right places; the commercial dissemination of her work allowed these seeds of subversiveness to take root in people's homes.

In October 2009, shortly after this exhibition, Masters Gallery, Ltd hosted a celebration of her life. In Tanya Harnett's article "Recollections" she states that in a First Nations construct, the spirits of those who pass before us remain. Joane certainly was there that day. I saw her smiling and heard her laughing. Teasingly, as if to say to everyone, "You know you're going to have to do this now, right?" We are all left to carry on where she left off and she knows it's hard work.

During her time in the physical realm, Joane Cardinal-Schubert found ways to simultaneously support and mentor those who struggled with the legacies of colonial histories and reach those who were unaware of how this system affected them. Indigenous people's and settler people's perspectives on Joane's work have been included here, with particular focus on the places where the personal, the political, and the artistic overlap.

The first essay is written by Mike Schubert, the artist's widower. He gives insight into the early years of the artist's life as he remembers and as it was told to him — most are from before she became the political powerhouse artist and activist that most people are familiar with. His stories allow us to know her more intimately and perhaps look at her art in a new light. Schubert shares how the artist's lived experience informed her work and how her work should in turn inform our lived experience.

Both Monique Westra and David Garneau offer writings that are cyclical in nature, mirroring Joane's work, oscillating around ideas, and getting new views

"I exist at the centre of a big circle.

My 'stories' are circular, the end and the beginning linked, referenced ... and I can cross over the circle and spin off into little circles rediscovering aspects I have missed or that remained undeveloped in previous works. Sometimes I cross that circle as a challenge to rediscover, to find out what I missed at first glance."

— Joane Cardinal-Schubert, *Galleries West*, 2002

around every bend. Westra offers a balance between art historical analysis of several of Joane's works and anecdotes about the artist. Formerly unpublished writings by Cardinal-Schubert about her own work, made available by Westra, allow readers to draw their own circles around the artist.

To tell the story of Joane Cardinal-Schubert, David Garneau reminds readers that "in the Indigenous worldview, time is non-linear and everything is related." Rather than focus solely on Cardinal-Schubert as a visual artist he focuses on her written calls to action, inspiring "us" to remember who is writing and for whom. Garneau points to the underlying politics at play in innocuous acts of being reader/viewer or creator. His analysis of the lasting legacies of Joane's writings calls on readers to "be good guests, allies, or even members."

3. *Warshirt for the Earth*, 1980
59.7 x 80.7 cm
23.5" x 31.75"
Mixed media/Acrylic on paper
Collection of the Red Deer Museum and Art Gallery

"Traditionally, the war shirt was worn to do battle against opposing forces threatening the existence of the individual family or tribe. This war was a fight to overcome a challenge which would then govern man's relationship with man and also his environment.

These war shirts symbolize the defensive covering, the armour, the heraldry; the concerns and challenges facing you, the pedestrian warriors of this time. No concern is too small! Each tree destroyed means less oxygen and increased erosion, every watershed disturbed means less furtile land, each animal destroyed means an interruption in the food chain, and pollution of the air and ground threatens man's existence and the environment as a life sustaining entity.

There is no time limit on the responsibility we have to each other and to the future of those who will use this universe for their lifetimes. Our actions today determine what the future will be."

– Joane Cardinal-Schubert, RCA
February 1986 "Genesis of a Vision – The Warshirt Series – A Declaration"

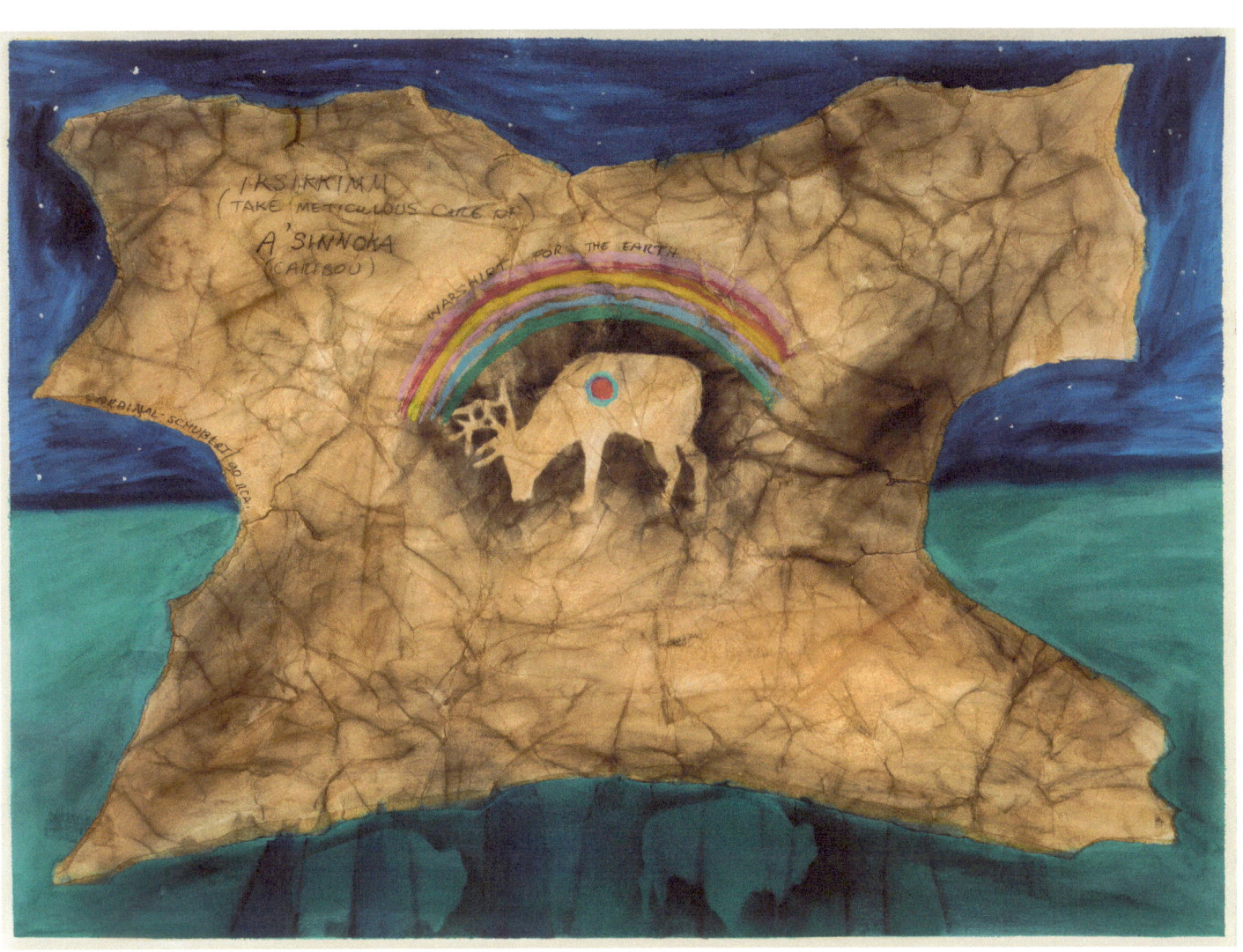

Joane Cardinal-Schubert's apprehensive and at times combative relationships with museums and institutions are drawn out in Alisdair MacRae's consideration of her works. Cardinal-Schubert rejected settler anthropological approaches to Indigenous culture that played out both inside and outside of museums and art galleries. MacRae outlines several of her ways of working that remind her audiences that Indigenous people are contemporary beings.

Keep Joane in the present tense.

The primary source material for Harnett's "Recollections" was an open call for stories about Joane Cardinal-Schubert. She allows those influenced by Joane a space to share their stories and contribute to the conversation about this monumental figure. In "laughter or lament" these stories are told and retold.

The last word, fittingly, is dedicated to Joane herself. In her own words she discusses her work with Gerald McMaster. This interview was recorded on the advent of her twenty-year retrospective in 1997, twenty years ago now. Her words still resonate, her observations are as current as ever. As Garneau would remind us, Joane circles round again.

Make reckless associations and contradictions in the following essays, cross-reference wildly between sections. See Joane Cardinal-Schubert's Calgary airport installation in MacRae's text as the embodiment of Joane's welcome in Garneau's; align the artist's rejection of a feminist label put forth by MacRae with Westra's analysis of her *Letters to Emily*; Harnett reminds us that Joane never labelled herself or her work as political; try to rectify that with the analysis of her work that every writer puts forth; join Joane talking about her own childhood with Mike Schubert's stories; align her rejection and utilization of institutions with those same institutions' utilization and rejection of her; criticize that artistic retrospectives and publications are linear and at odds with how Joane works.

Throughout the organization of *The Writing on The Wall*, Joane has led the way; I have merely followed. Here I have assembled what she has left behind and, hopefully, read the writing on the wall in a way that Joane would approve of.

– *Lindsey V. Sharman, curator*

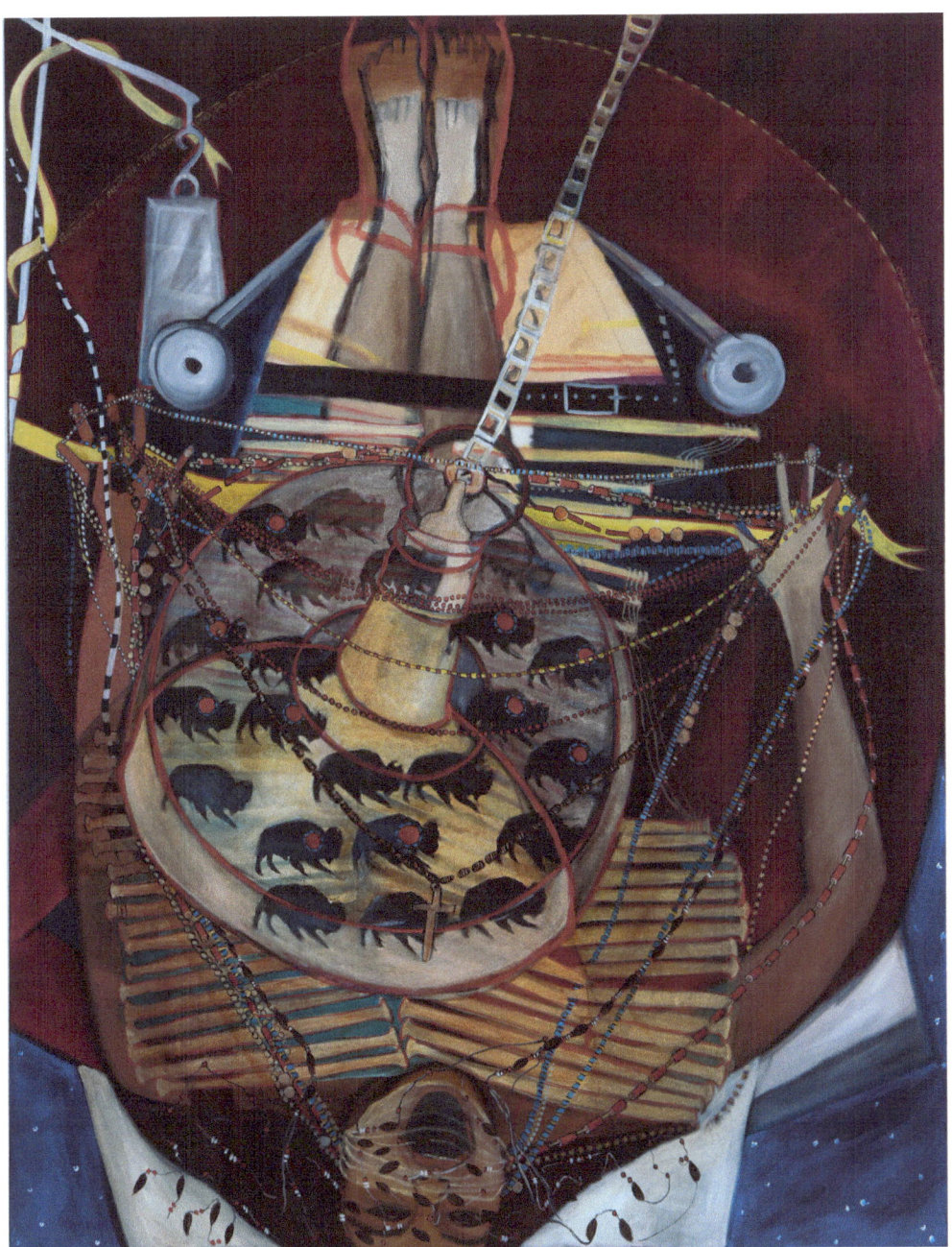

4. *Remembering My Dreambed*, 1985
149.86 x 114.3 cm
59" x 45"
Acrylic on canvas
From the Estate of Joane Cardinal-Schubert

In this work, the artist recollects the invasiveness of a medical procedure related to cancer treatment.

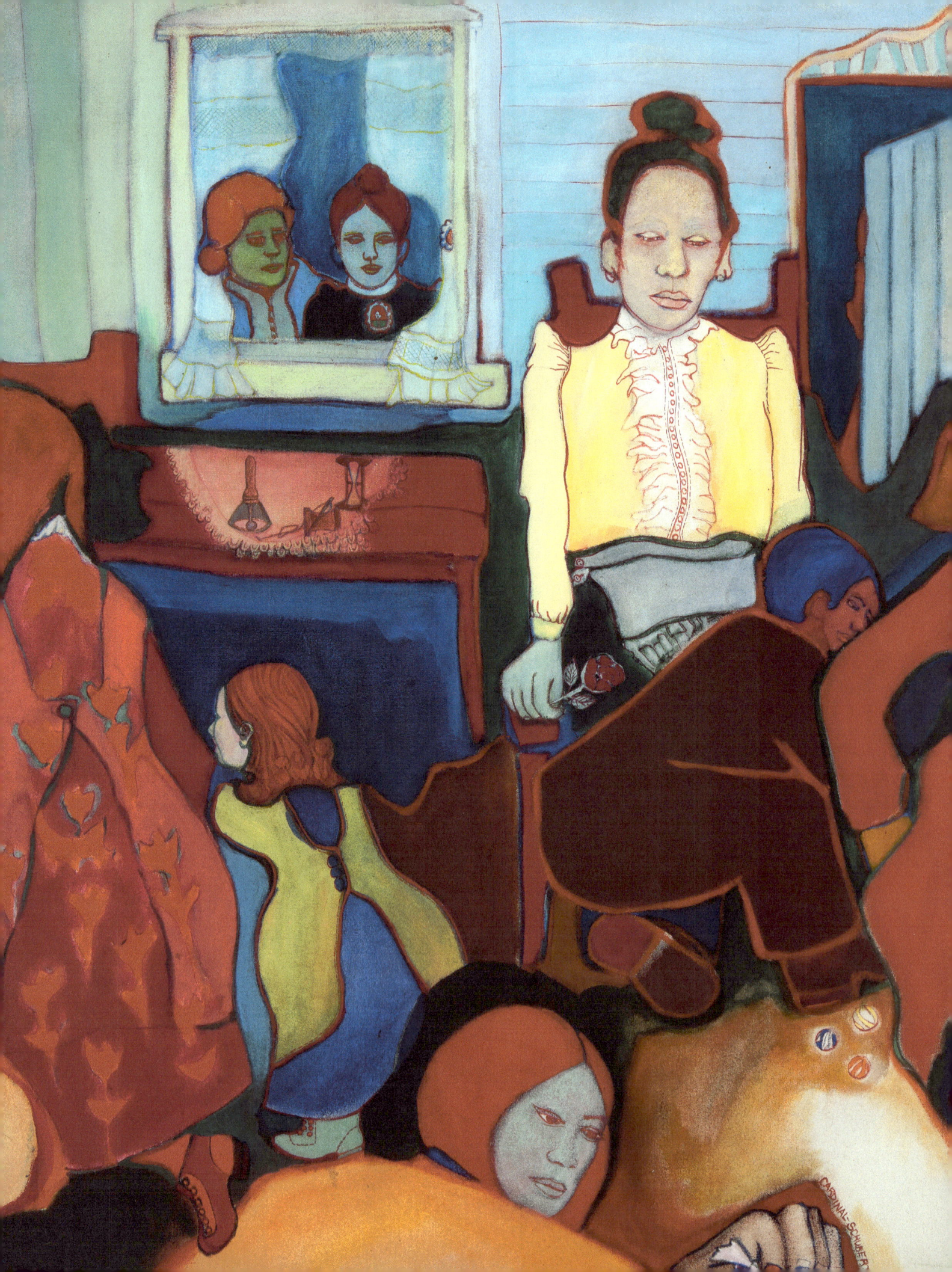

"I AM OUT OF THE WOODS NOW"
– JOANE CARDINAL-SCHUBERT

by Mike Schubert

Joane Cardinal-Schubert was born in Red Deer General Hospital on August 22, 1942. Her dad was a game warden for the Alberta Game Branch. Her mother was a nurse but had given that up to look after the children – Joane was the fourth of eight. They all talked about how their parents would show them things by drawing. I saw this teaching with the grandchildren too. Joane's dad would not hesitate to show Joane and her brothers by drawing in the sawdust on the woodworking shop floor or even in dirt levelled by hand while working in the garden.

 She and her family had moved a couple of times in Red Deer but by the time Joane started school they had moved to an acreage north of the city. It was a mink farm with a lake on the property. Joane's dad moved a small house onto the land for his parents. Grandpa Cardinal helped feed the mink. This home greatly inspired Joane and influenced her work. There were water lilies on the lake. She used those lilies in several of her paintings. Canadian Geese ate in the yard with chickens and kept the grass short. She loved to lie on the grass at night and look at the star constellations – but you had to be careful about the goose poop. She later painted many star paintings.

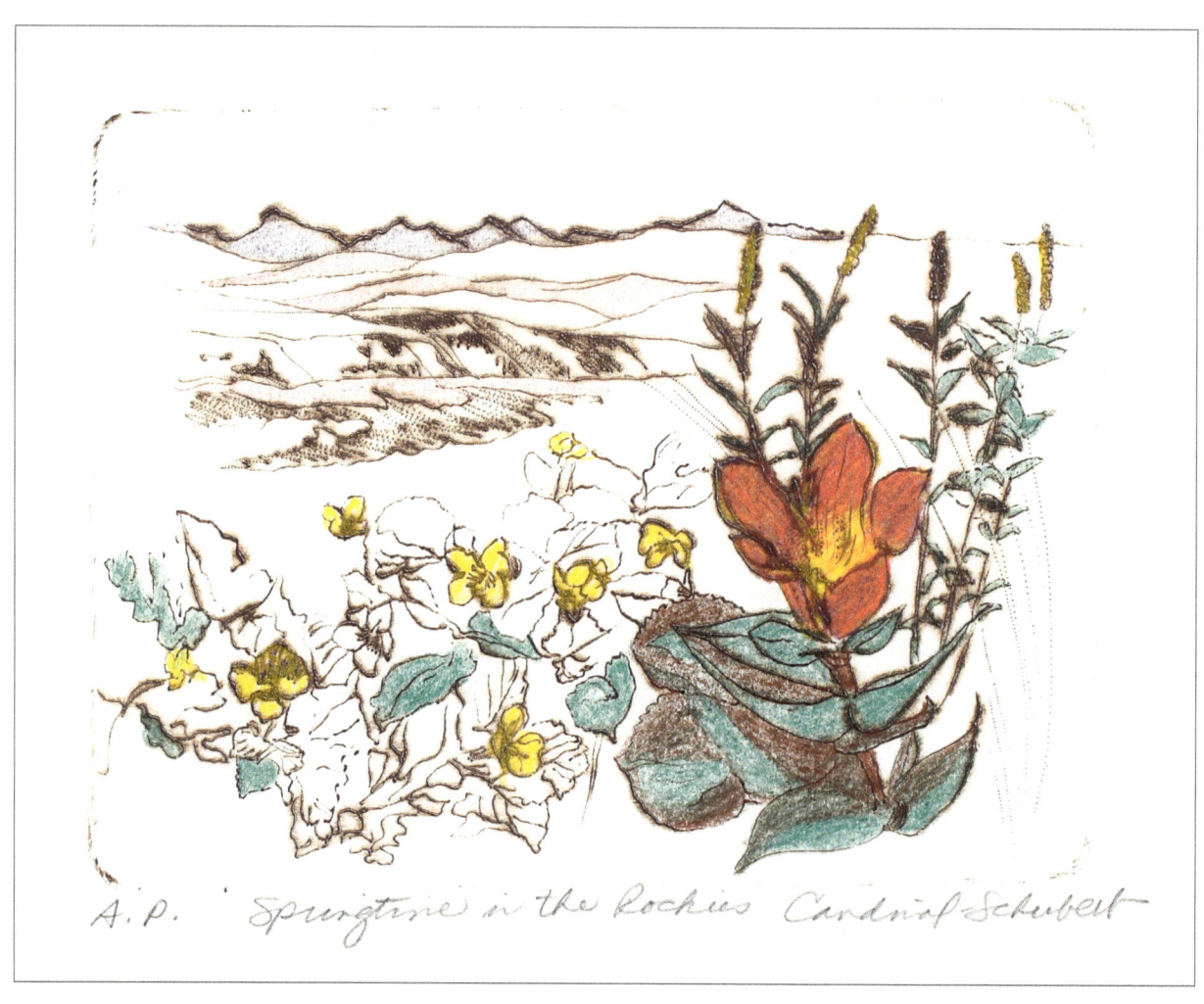

5. *Springtime in the Rockies*, 1977
24.9 x 28.2 cm
9.75" x 11"
Hand coloured plexi etching on paper, artist's proof
Collection of Glenbow; gift of Shirley and Peter Savage, 1995

Joane went to grade school at St. Joseph's Convent on the north hill at Red Deer until grade four. In her first days at the convent she remembered having to deal with the sisters. They put her in a very hot shower with slats in the bottom and brushed her down with a long handled broom assuming because she was Native she must not be clean and could have lice. They were not aware that Joane's mom was a nurse and a stickler for cleanliness. Joane missed many weeks of class in her first four years of school due to chronic bronchitis. In her fourth winter at the convent, having just come out of the hospital, she sat in a one room school house with a potbellied stove on one side of her and a leaky door on the other. Her dad came into the school while at work and in uniform to see how she was doing. When he saw the situation he immediately told her to get her coat and he took her and her three older brothers out of the school and registered them in the public school board.

In those days if you were Catholic you had to go to the separate school and pay separate school tax. You could not chose one or the other. There was a court case over this and Joane's dad won. The law was changed for everyone to have a choice. Joane thrived in public school. She took home eight or nine books every day from the Red Deer Library and every night her parents checked her bed to see if she was reading with a flashlight under the sheets. Anne of Green Gables was her favourite book. Why Joan with an "e"? Because her favourite book, Anne of Green Gables, was Anne with an "e." By the time she was eleven Joane had read all the books in the Red Deer children's library. She was amazed when the librarian told her that she would have to start on the adult library. It was all this reading, as well as her good fortune to have two very good grammar teachers in grade school, that made writing come very natural to Joane.

She did well in grade school and junior high school. She went to high school at Lindsay Thurber Comprehensive High School – she did not do well in her courses there. However, she excelled in extracurricular activities. She was the editor of the yearbook and she was on the cheer leading squad (I was on the football team). One night I heard there was a Teen Town dance at the community hall but I was too shy to go by myself so I talked my next older sister Gesine in to going with me. She had

taught me how to jive. We took the family car, a brand new VW Beetle. As soon as we walked into the dance hall I noticed these legs dangling from a table across the floor and I would later learn this was Joane. With my sister's coaxing, I went over to ask her for a dance. My sister told me she would walk home and Joane and I and another couple all piled into our VW and went to the local A&W. I had not been introduced to anyone yet so I said my name was Eckehart. They all laughed (you have to remember this is Red Deer in the 1960s.) So someone decided I should get a new name. Potential names thrown out were Iggy, Ike, Egg. Joane seemed to be horrified at these suggestions and blurted out "How about Mike" and that has stuck now for approximately fifty-five years. We had grade ten science class together, where she did not do well. The instructor kept throwing chalk at her and he told her to take up knitting. I remember she could not graduate with me because she was three credits short – a miscalculation by the school.

I can remember when I picked her up for a date her mother would answer the door and Joane would have disappeared into the bathroom and I would end up visiting with her mom until she got enough nerve to come out. I do know some of this time was used to put on makeup, which she was very good at. For our entire married life the first thing she did in the morning before I could look at her was put on eyeliner, because she felt her eyes looked too round. When I passed her in the hall at school she would turn beet red. Although Joane's family had the money to buy her the clothes she wanted she had taken sewing in Home Ec and was very good at it. If she saw a piece of clothing in a fashion magazine she liked and could not buy it in Red Deer she would often get a pattern at some store in town and make it. Often when I came to pick her up for a date I would have to wait for her to finish a new outfit before we could leave.

After high school Joane worked at the Red Deer Provincial Training School for a few months but she found it too depressing. One day the following summer, Joane's dad said to the family "Let's all go to Banff for the weekend." Brother Doug was home from Texas and he came along. To Joane's surprise they stopped in at the Alberta College of Art (now the Alberta College of Art and Design) while going through Calgary.

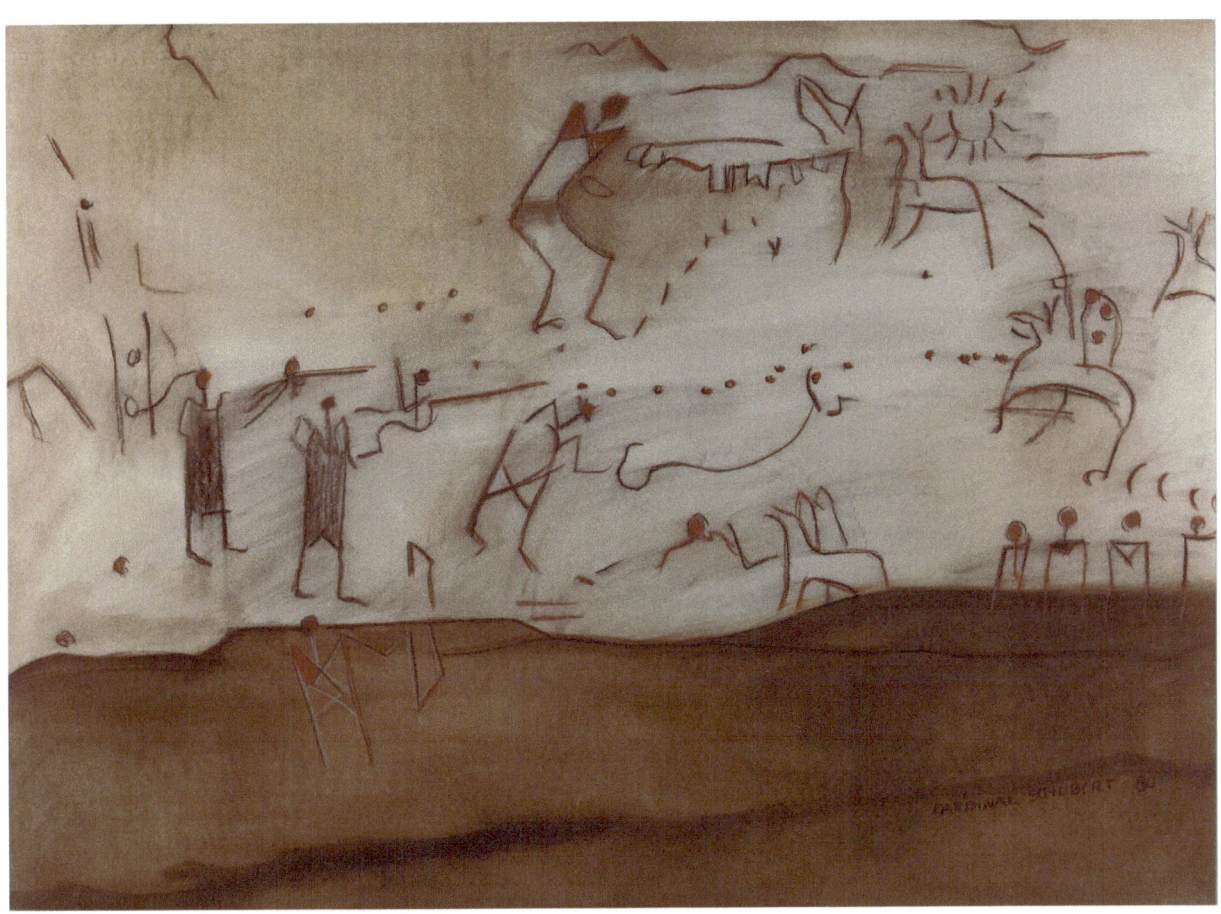

6. *Pictograph – Writing On Stone*, 1980
54.4 x 73 cm
21.5" x 28.5"
Conté and oil on paper
Government House Foundation Collection

Cardinal-Schubert felt very connected to the pictographs at Writing-On-Stone. Her work is not only a reaction to their power but an act to record many images that already have vanished from the area because of vandalism and erosion.

Doug spoke about his career with the registrar and at the end of the conversation the registrar turned to Joane and asked, to her great surprise, if she was ready to buckle down and study. In the previous few months she had toyed with the idea of going to the Parsons School of Design in New York to become a dress designer. Her dad would have none of that after Doug's long stint at University of Texas in Austin; he was not about to send his favourite daughter to school that far away. At the end of first year at ACA she was asked not to come back; her report card read: talent low, imagination low, flighty attitude. What the teachers at ACA did not realize was that she was very, very shy. At the end of first year when Joane went into the office to get her locker money back Stan Perrot, then Director, looked at Joane and said, "Joane you are a funny girl when are you going to come out of the woods?" A couple of years later, Joane went back to ACA and there was Stan Perrot, still in the same office and Joane said, "I am out of the woods now, Mr. Perrot and I would like to come back to ACA." He said, "OK just go down the hall to the art history class in room 5." That's how she got back into ACA. She took two more years there and I had to move to Edmonton with my job. About three jobs later I ended up in Edmonton again working for Alberta Environment. By this time we had two little boys, Christopher and Justin. When Justin was about two and a half years old Joane was itching to get back to post-secondary education. She wrote the adult entrance exam for University of Alberta and got one of their highest marks ever. She started in the Faculty of Arts. We were one of the first tenants in the new married housing called HUB. It was great because there was a daycare in the same building. In the new year I started a new job with Federal Environment in Calgary. I commuted every weekend between Calgary and Edmonton until Joane was finished at the end of May. Joane transferred to University of Calgary into third year painting, and we moved into married student housing here. Joane did well at University of Calgary because she was already established as a painter. She was at odds with her instructor though. The rest of her class would come to her with painting problems. At the beginning of the year most of her classmates were painting mud on mud. They basically learned how to mix paint from Joane. The course required students to paint ten paintings during the course, Joane painted twenty. She was by far

7. *14 Raiders*, 1981
49.53 x 72.39 cm
30" x 41"
Oil stick and conté on paper
Collection of Glenbow; anonymous donation, 2015

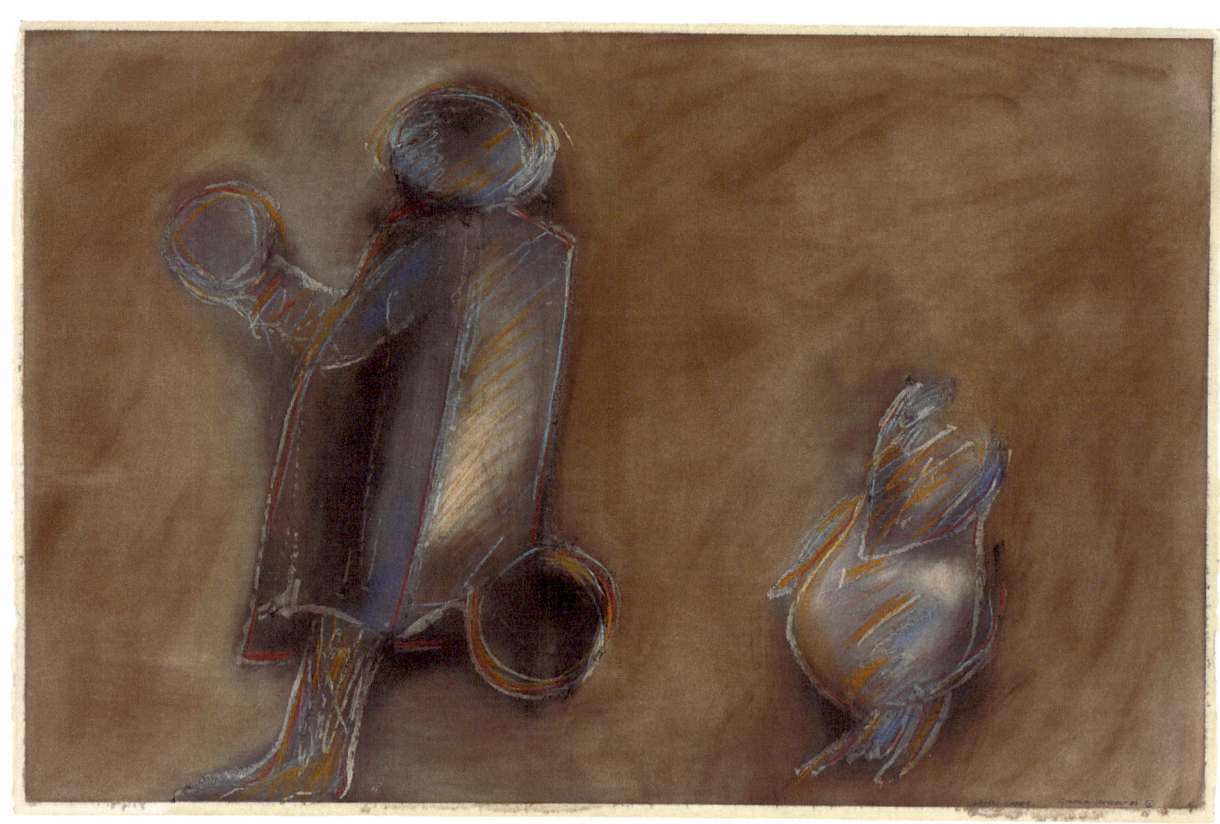

8. *Grassi Lakes*, 1983
81.3 x 121.9 cm
32" x 48"
Watercolour and oil crayon on paper
Collection of Glenbow; purchased with the support of the Canada Council for the Arts Acquisitions Assistance Program/oeuvre achetée avec l'aide du programme d'aide aux acquisitions du Conseil des Arts du Canada, and from the Glenbow Collections Endowment Fund, 2000

the best painter in the class. Her instructor gave her a B- for the course and a couple of the students who Joane taught how to mix paint got A+s.

During the seventies and eighties, even when our children were little whenever we had time for a short holiday we would go camping, sometimes with her Native relatives and sometimes we would visits sites like Writing-on-Stone Provincial Park, Grassi Lakes, or the Milo medicine wheel, Grotto Canyon, or Willow Creek to look for pictographs and petroglyphs. By seeing pictographs and petroglyphs at Writing-on-Stone and from seeing the archives records at the Glenbow Joane realized that many of the pictographs and petroglyphs had been defaced, removed, and eroded. The Glenbow had good black and white positive slides of most of the Writing-on-Stone art from around 1900. Joane felt she needed to recreate these images on paper, hence all the pictograph, petroglyph drawings.

The other places we used to visit were residential schools and early agricultural training schools like the Dunbow Ranch south of Calgary. We had a friend who had a friend who owned the Dunbow Ranch, which is on the river flat next to the Highwood River. We were given permission to look at everything on the ranch. Some of the graves in the cemetery next to the river and the ranch were being washed away into the Highwood but we were not allowed to try and stabilize them. We found attendance records and trunks full of books and many sad carvings on the inside of the barn walls and on the ladders – "I miss my parents" and "I want to go home." Joane had found a letter written by Father Lacombe to the Indian Affairs office in Ottawa, asking whether they could do something about the disparaging presence around the school. That presence was the parents of the kids who were at the school, camped there to see them. The Dunbow School was only open for four years (this is another very long story, but not for here). One of the boys ran away to go home and was later found dead. The official explanation was that he had died of scarlet fever. His body was buried south of the Stampede grounds. This was where most of the Blackfoot camped when they came to Calgary, and later when they attended the Calgary Stampede. When Barlow Trail was built through the prominence many years later they had to move

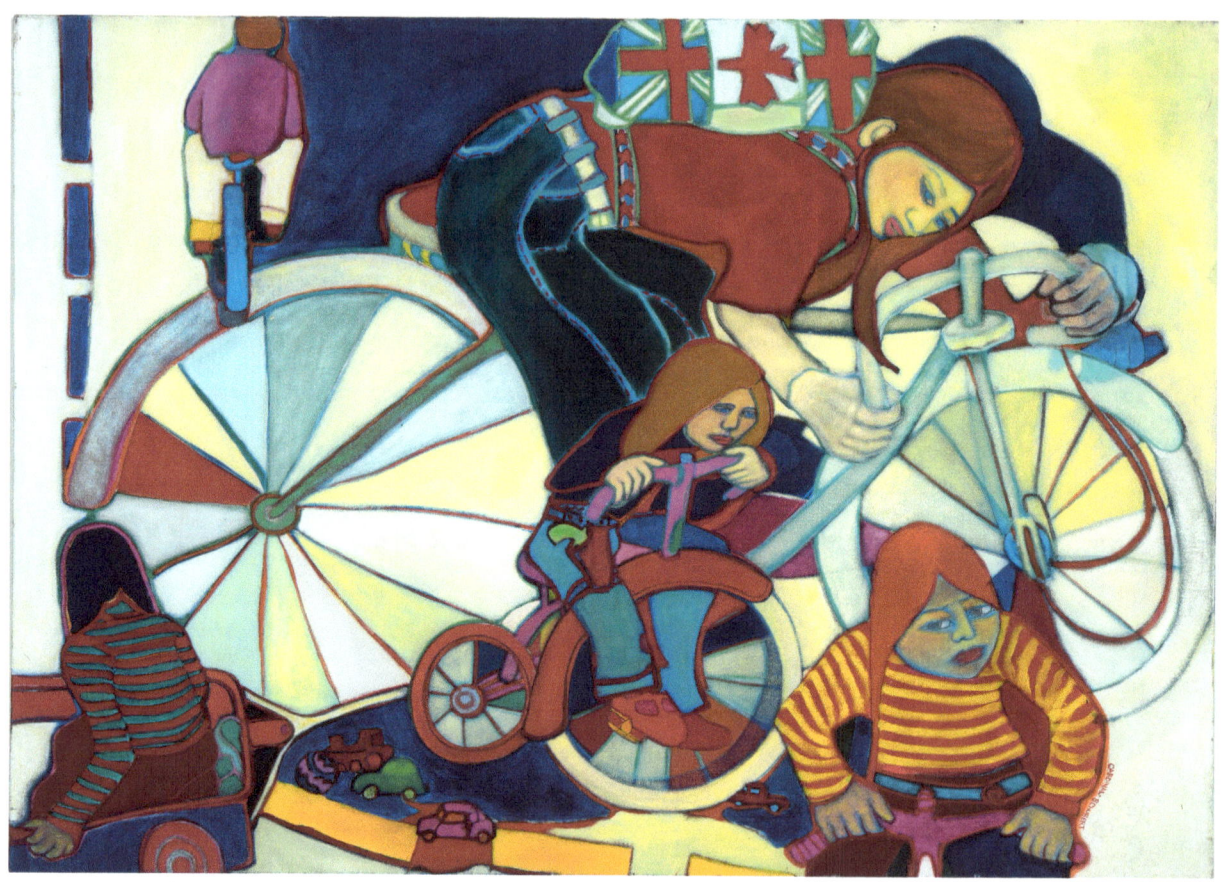

9. *Girl on a Bicycle*, 1973
121.9 x 182.9 cm
48" x 72"
Acrylic on canvas
From the Estate of Joane Cardinal-Schubert

While living in student housing at the University of Calgary Cardinal-Schubert saw this woman biking everyday and was inspired to render her in paint. The vibrant colour palette is typical of the artist's early painting. Not wanting to follow or emulate, after her style and colour palette was likened to Gauguin Joane immediately abandoned it.

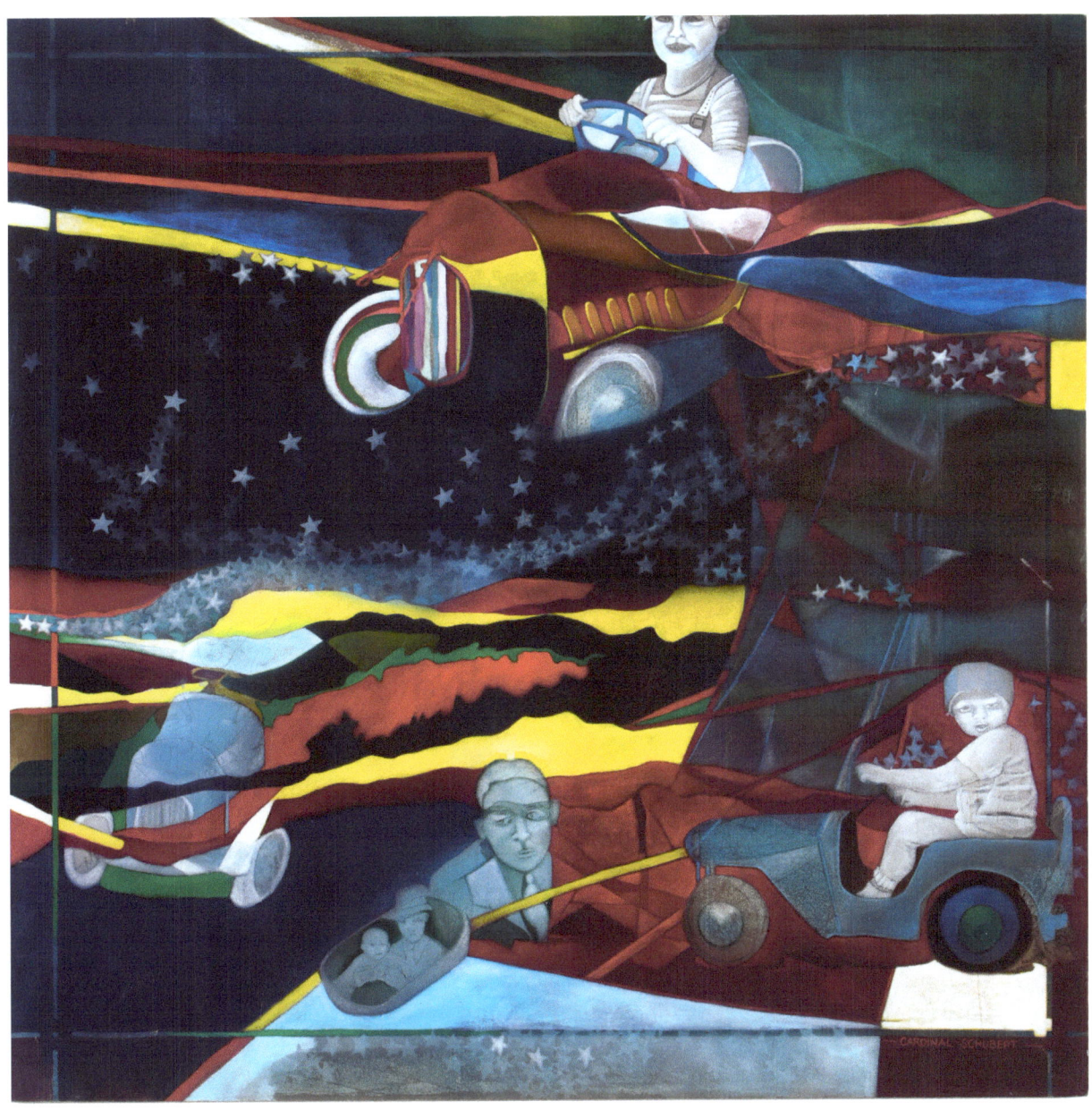

10. *Carousel (Portrait of Christopher and Justin)*, 1977
121.9 x 182.9 cm
48" x 72"
Acrylic on canvas
From the Estate of Joane Cardinal-Schubert

the grave and those who dug him up discovered he had a bullet hole in his forehead. It was things like this and more research at the Glenbow and old Calgary Herald stories that gave us all insight into racism from pre-1900 to well into the 1950s. This was the impetus to do pieces on the residential schools like *The Lesson* (and others), which put a spotlight on Canadian histories that aren't often told.

Something that never gets discussed is Joane's early paintings. These paintings are very colourful, a lot of bright reds and yellows. One day someone said these paintings look reminiscent of Gauguin and she changed her colour style. We still have some of them in the basement. One of my favourites was painted after we visited an old Mennonite church east of Aldersyde, just south of Calgary. We bought some church pews from the last remaining parishioners and because we showed an interest in what it was like before the First World War they told us of how they use to have Sunday dinners in the basement of the church.

Those parishioners even showed us this huge cast iron stove and asked us if we wanted to buy it. It was way too big for anyone's house. They also gave us an old ladder back chair and one their bibles.

After that visit Joane painted what she felt these Sunday dinners were like. Her grandmother was prominent in the middle with a yellow blouse and her hair done up and the children running around had faces like her brothers and sister (fig. 11).

The more Joane learned about her culture the more she realized she should be painting Canadian heroes. Early on Joane painted world "heroes," people that she read about and watched in the movies. We have a wonderful room divider (a triptych) about Lawrence of Arabia that she painted after we saw the movie. She also took great interest in First World War movies and flying aces like the Red Baron. There is a large painting that depicts an air battle which features the baron in his Fokker Dr.I triplane. Joane painted mostly white heroes, even Columbus and Samuel de Champlain. Then she realized she should paint Native heroes and Métis heroes because no one else had ever done that. She painted figures from the Riel Rebellion – Poundmaker and Crowfoot and Big Bear and Big Plume and Louis Riel and Gabriel Dumont and Peter Lougheed's grandmother and her

BY MIKE SCHUBERT

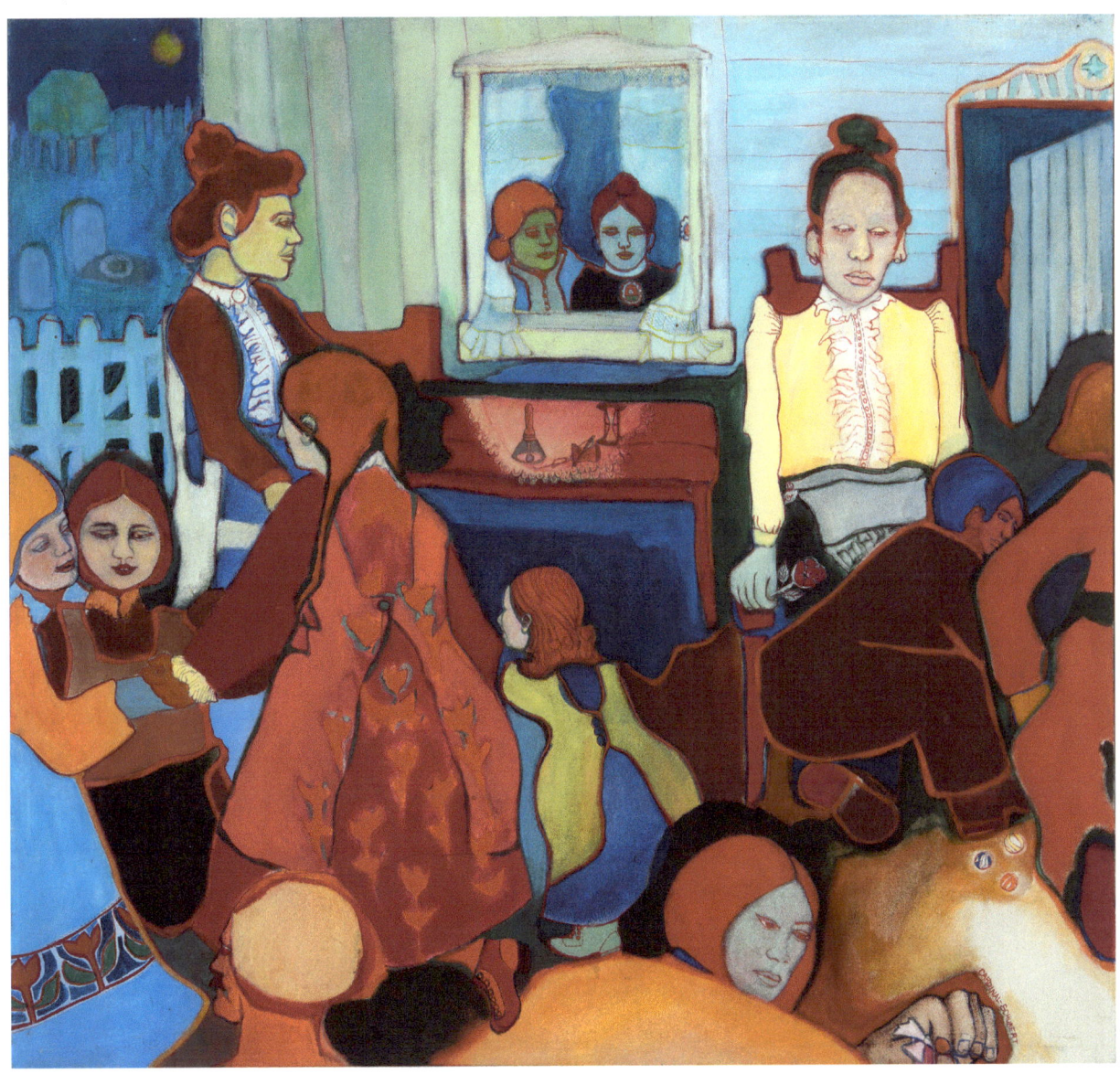

11. *Sunday and the Gossips at Mountview Mennonite Church*, 1975
91 x 93 cm
35.75" x 36.5"
Acrylic on canvas
From the Estate of Joane Cardinal-Schubert

great-grandfather Samuel Lee. It was after learning about those largely unknown heroes that she started to paint cultural Native subject matter like sweat lodges and sundance structures. We still have paintings of Mrs. Lougheed and Kootinay Brown and Crowfoot and of course Lawrence of Arabia.

When Joane went to ACA she went there as a white student artist, but at the same time she was researching her family at the Glenbow and we did a lot of our travelling around southern parts of the province to learn more about her culture and meet relatives she did not know she had. There were some of her older classmates at the University of Calgary of European background who tried to make her feel uncomfortable by asking her "you're Native aren't you?" and they would ask about her tribal affiliation and she would shoot back with only a second of hesitation "Blackfoot-Blood." Because she painted things about her newfound culture her contemporaries would say she is an Indian artist, it always came up; so she thought to herself if everyone calls me an Indian artist I must be one.

In her final year at the University of Calgary Joane had already fulfilled her required undergraduate courses so she applied for a graduate level painting course. She was given a very large studio, shared with one other Master's student who was never there. This is where the four paintings of "Great Canadian Dream" series were made (figs. 44, 45, 46). She was working part-time as a technician at the University Art Gallery (now Nickle Galleries) on the main floor of the library block. Brooks Joyner was the director, and there were three technicians plus a secretary named Ruby Fong. The two other technicians had also graduated with a BFA with Joane and they shared curatorial and technician duties. About a year into the operation, Brooks Joyner having some gallery time available said, "Why don't we have a staff show?" Joane was given the large section to the right of the door. She hung the "Great Canadian Dream" series among many other paintings. At the opening, I was looking after the door because everyone else was busy. The first people that showed up were Mary and Buck Kerr. Buck stood in Joane's section and rotated slowly and I could see tears coming down his cheeks, I heard him say, "To think we almost lost her" referring to the fact that Joane was asked not to come back after first year at ACA.

12. *Sick Father*, 1969
50.8 x 91.4 cm
20" x 36"
Acrylic on canvas
From the Estate of Joane Cardinal-Schubert

After seeing this image of a sick man and his family in a now-unknown magazine, Joane Cardinal-Schubert painted this work. It was Cardinal-Schubert's first work created as a reaction to something that disturbed her.

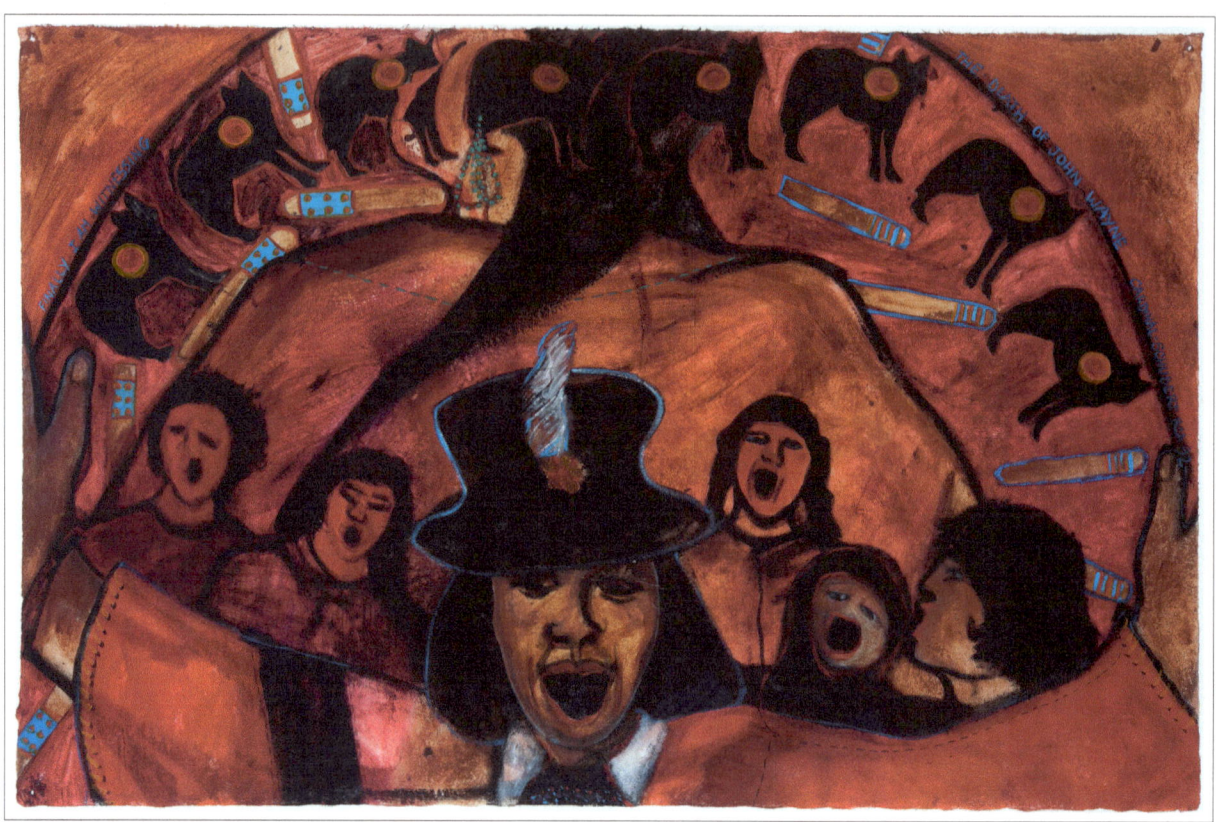

13. *Finally, I Am Witnessing the Death of John Wayne*, 1979
59.7 x 90.2 cm
23.5" x 35.5"
Acrylic on paper
Collection of Greg Younging

This work commemorates the 1979 death of John Wayne. Dubbed by many Indigenous people as "The Indian Killer," Wayne's hatred for Indigenous people transcended his films and on-screen persona. The era of Western films uncoincidentally was simultaneous to the residential and boarding school era. Such films create an image of Indigenous people as savage obstacles to American and Canadian progress.

This early work utilizes what would become the artist's signature colour palette of reds and ochres. For Cardinal-Schubert reds were blood, and encompassed multifaceted associations with life, death, and womanhood.

In her last year at the University of Calgary I remember one incident; someone in her class got the idea of writing a poem about Leon the Frog on the kick plates of the steps in the fire escape in the social sciences building. In those days, the art department was on the twelfth floor of the social sciences tower. One stanza of the poem per floor for each student in Joane's painting class. Leon the Frog and his escape from dissection, crucifixion, sexual harassment, and an attempt to sell him insurance, have become ingrained in campus lore at the University of Calgary.

When the Nickle Arts Museum was built there was no curator, just Joane – who was by then an assistant curator. She picked out the wall and ceiling colour, the lighting, carpeting, and furniture. She made the architect take out a bunch of doors on the north wall. The whole wall was doors, which is not good for gallery space. She also made them close off the loading dock to acclimatize crates of artworks, and set up a separate room for framing prints and a large art storage vault. The interim director of the museum was an art history professor by the name of Bill Mitchell. To raise money, the university let a travelling art salesman sell classic art reproductions of old masters at the Nickle. At the opening, Mitchell told Joane that because she was the curator she had to introduce the art salesman. Because she was forced to, she did a good job. Up to that point Joane had been very shy but after this you could not shut her up.

In the next couple of years the University of Calgary sent her to an eight day arts administration course at the Banff Centre put on by a group from Harvard. All these things gave her confidence in speaking. She was also still painting full-time in her studio. She kept her painting and her curatorial job scrupulously separate. No one knew she was also painting. When she left the Nickle, she did a lot of public speaking and usually became an activist wherever she was showing her art.

Between 7th and 8th Street and 7th and 8th Avenue in southwest Calgary, there used to be a two-story building that had a bar called "The Eye Opener" on the main floor, and a bunch of office space upstairs. At the top and back of the building Nicolas Grandmaison Jr. had a studio and frame shop, and a large spare room that he sublet to Joane. One of Nick's friends was the

artist Robert McInnis and when he came to visit Nick he saw Joane's work and liked it. The next time Robert was at Masters Gallery Ltd he made Peter Ohler Sr. aware of Joane and her work and suggested that he should have a look at it. In those days Joane was painting a lot of sweat lodge drawings with different elements in them. Peter picked out about a dozen drawings. About two weeks later he phoned up Joane and said "I don't know about those hamburger drawings but I've sold them all and you better bring me some more." That was how he described the sweat lodge shapes in many of Joane's works (figs 14, 15, 16). Ever since, Joane has been represented by Masters Gallery Ltd – her most successful commercial gallery. A few years later, when the art market was booming in Calgary due to beneficial tax laws, Joane had a sale and I was asked to line up for an art buyer for Montreal who wanted to get the first crack at this one particular piece. In those days they would hang the work on Wednesday and have viewing Thursday and Friday and a "first-come-first-served" sale on Saturday. I got there at 6:00 am and there were already four or five people waiting at the door sitting on lawn chairs. The first person in line bought the piece the buyer wanted. It was a very nice piece about Poundmaker. Needless to say the art buyer from Montreal never spoke to me again.

Even since Joane passed away on September 17, 2009 I have continued to sell her work through Masters Gallery Ltd. All the staff at Masters have become like family. When Joane passed away they offered to host the wake at the gallery. It was just how she would have liked it.

– *Mike (Eckehart) Schubert*

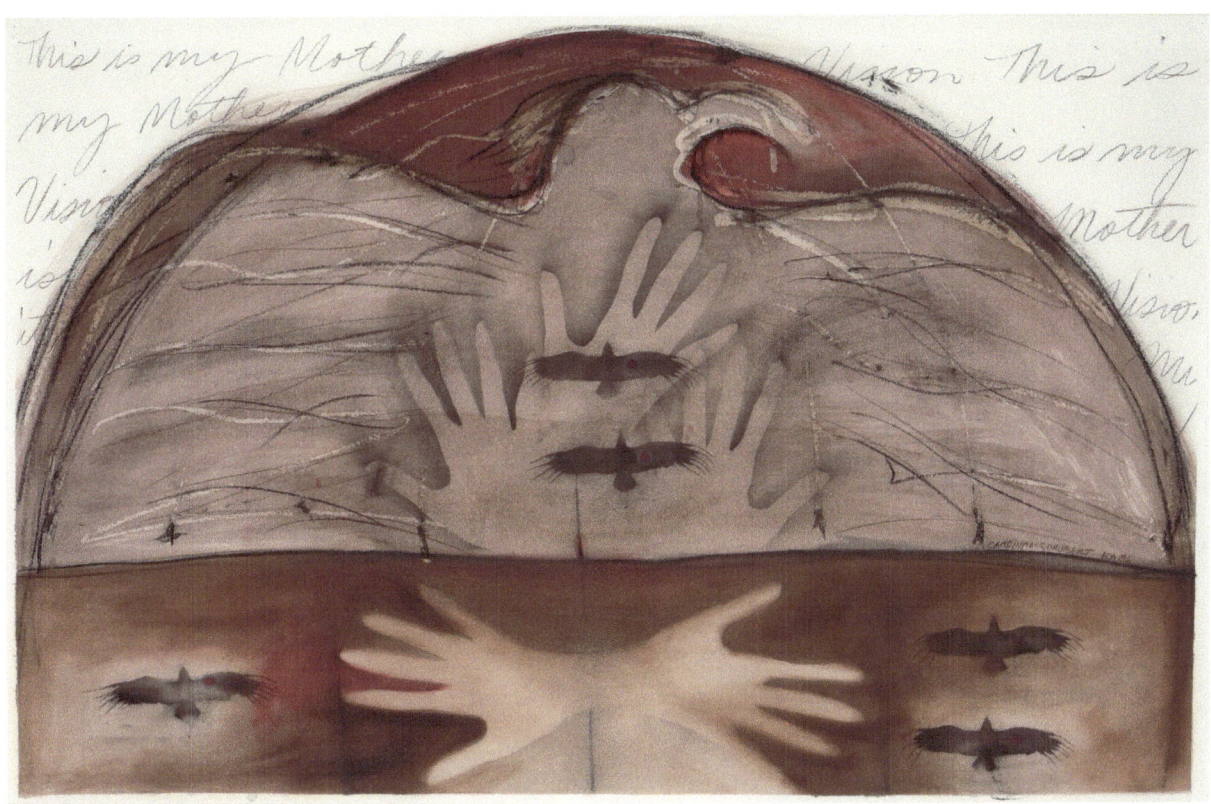

14. *This Is My Mother's Vision*, 1987
51 x 101 cm
20" x 39.75"
Oil and conté on paper
City of Calgary Civic Art Collection, gift of the Calgary Allied Arts Foundation, 1988

Many works of Joane Cardinal-Schubert include references to the sweat lodge structure. Many also depict a vision her mother had while in a sweat. Because Cardinal-Schubert's mother was not particularly religious or spiritual her mother's experience and vivid vision was made so much more memorable, leaving a significant impact on both her and the artist.

15. *Ceremonial Mound*, 1982
60.96 x 81.28 cm
24" x 32"
Acrylic and pastel on paper
Private collection, Calgary

BY MIKE SCHUBERT

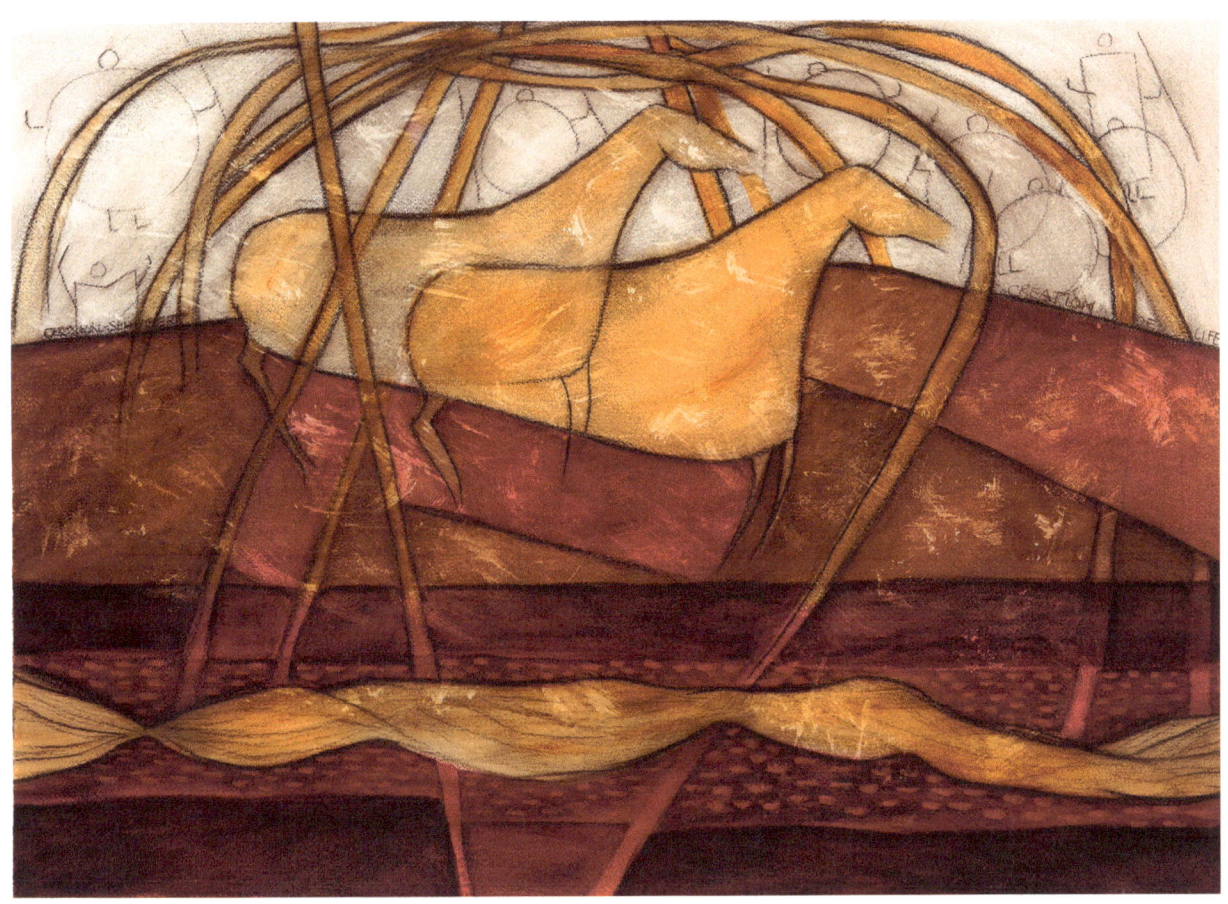

16. *Creation of Life*, n.d.
54.6 x 74.9 cm
21.5" x 29.5"
Chalk and mixed media on paper
Joan and David Taras Collection

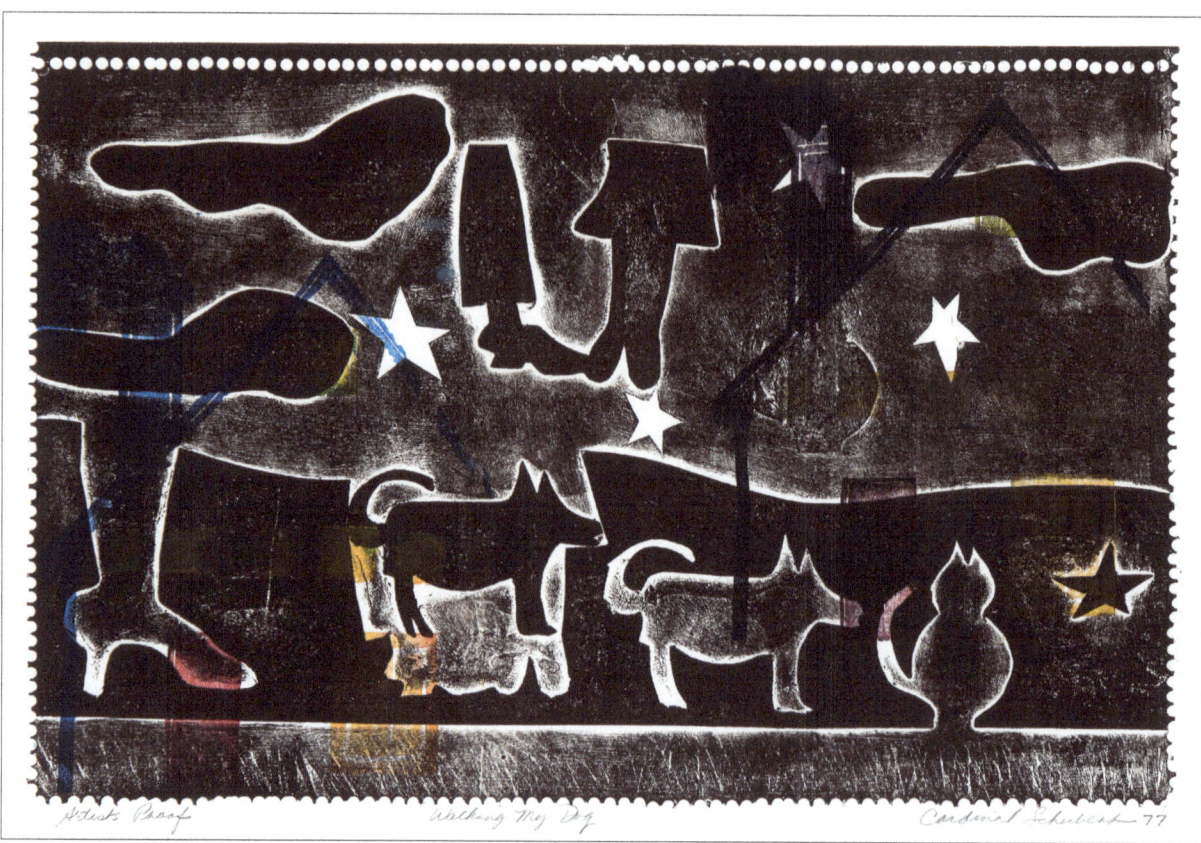

17. *Walking My Dog*, 1977
38.1 x 58.42 cm
15″ x 23″
Intaglio, artist's proof
From the Estate of Joane Cardinal-Schubert

Cardinal-Schubert is widely recognized as a painter and installation artist, but she first worked with printmaking. Many of her works of various mediums reference the processes of printmaking.

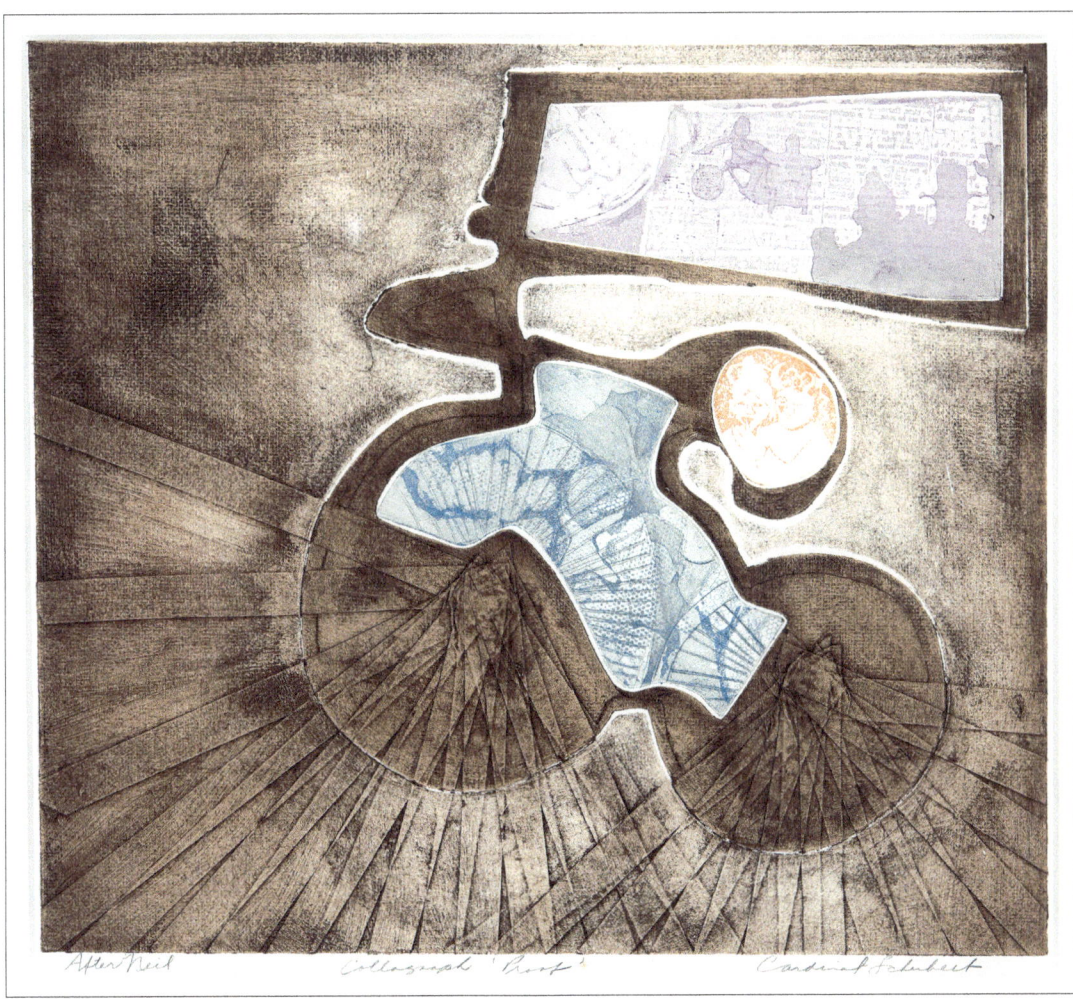

18. *After Neil*, n.d.
40.6 x 44.45 cm
16" x 17.5"
Intaglio, artist's proof
From the Estate of Joane Cardinal-Schubert

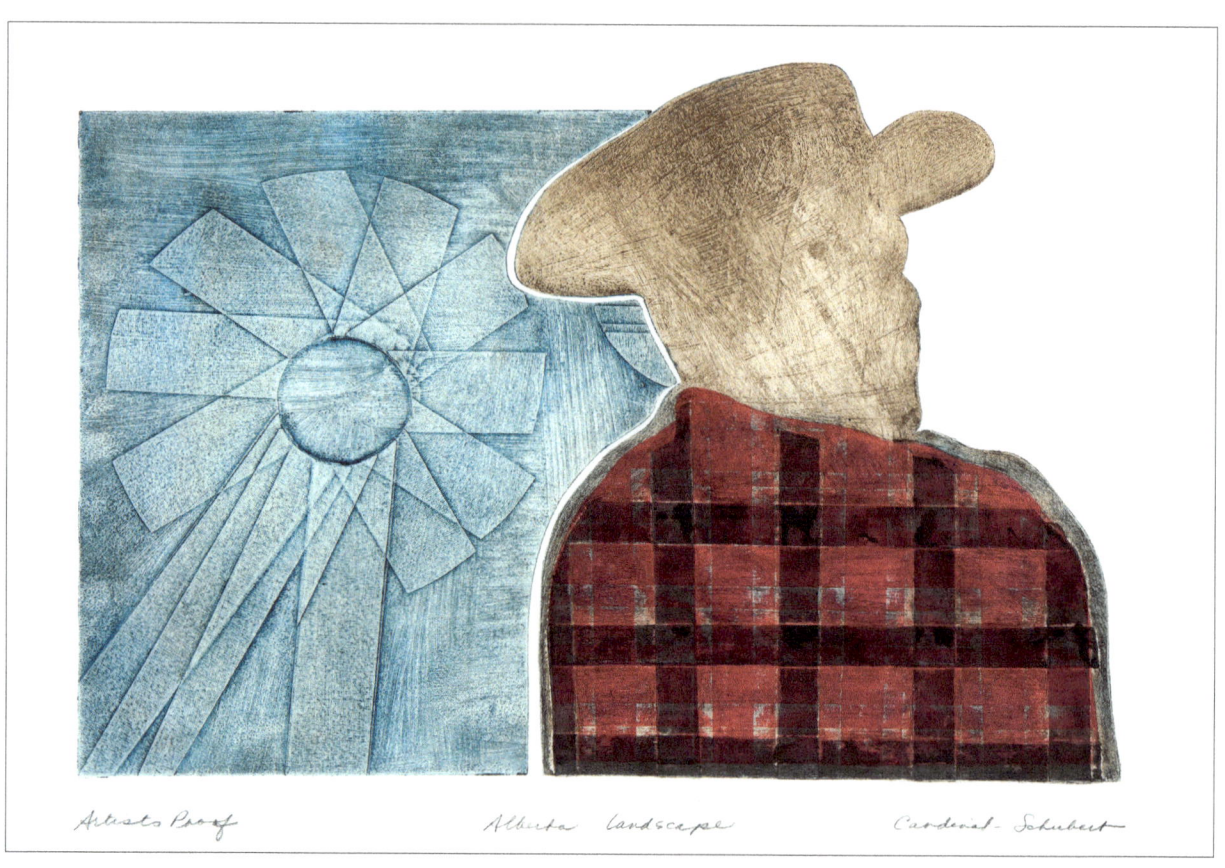

19. *Alberta Landscape*, n.d.
34.29 x 53.34 cm
13.5" x 21"
Intaglio, artist's proof
From the Estate of Joane Cardinal-Schubert

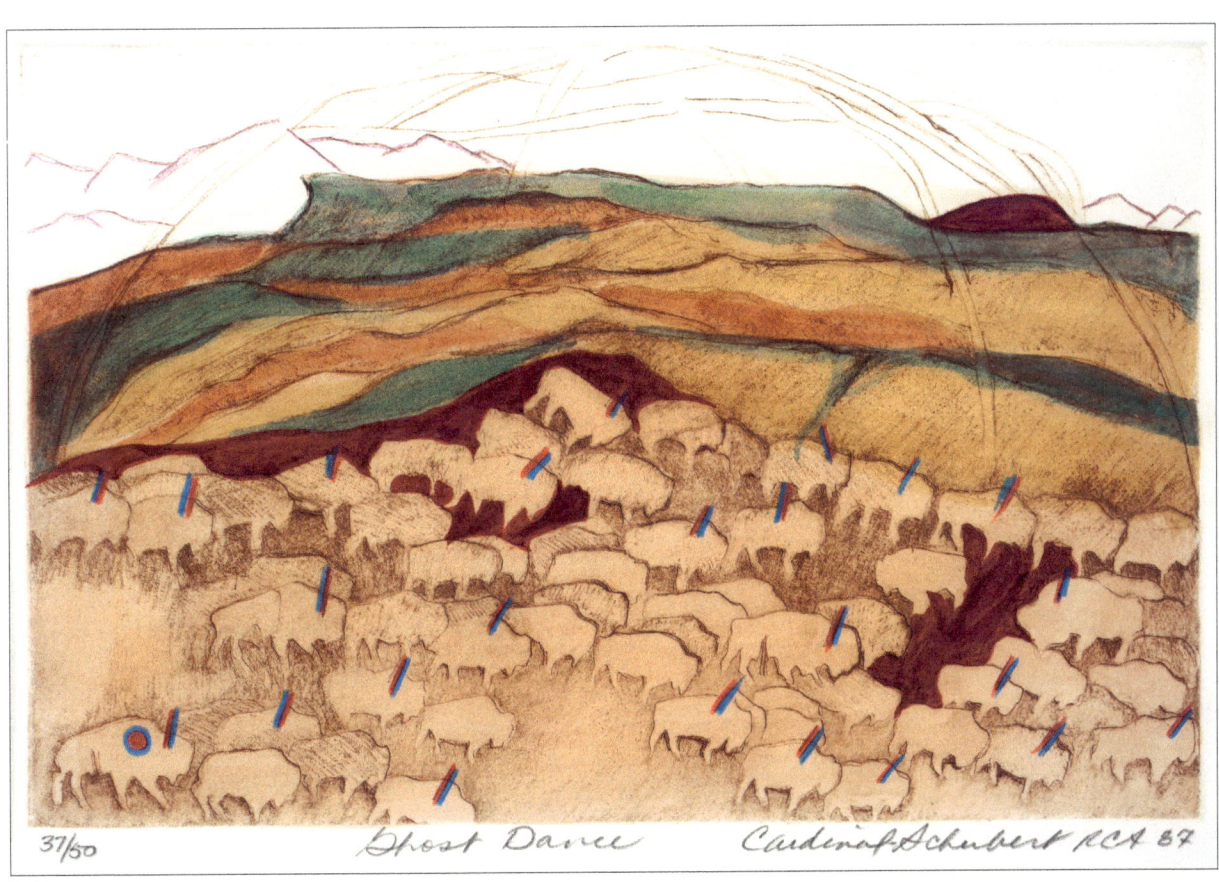

20. *Ghost Dance*, 1987
40 x 49.53 cm
16" x 19.5"
Hand-tinted etching, 37/50
From the University of Lethbridge Art Collection; transferred from the Native American Studies Department, 2004

21. *Self Portrait*, n.d.
33.02 x 35.56 cm
13" x 14"
Intaglio and woodblock
From the Estate of Joane Cardinal-Schubert

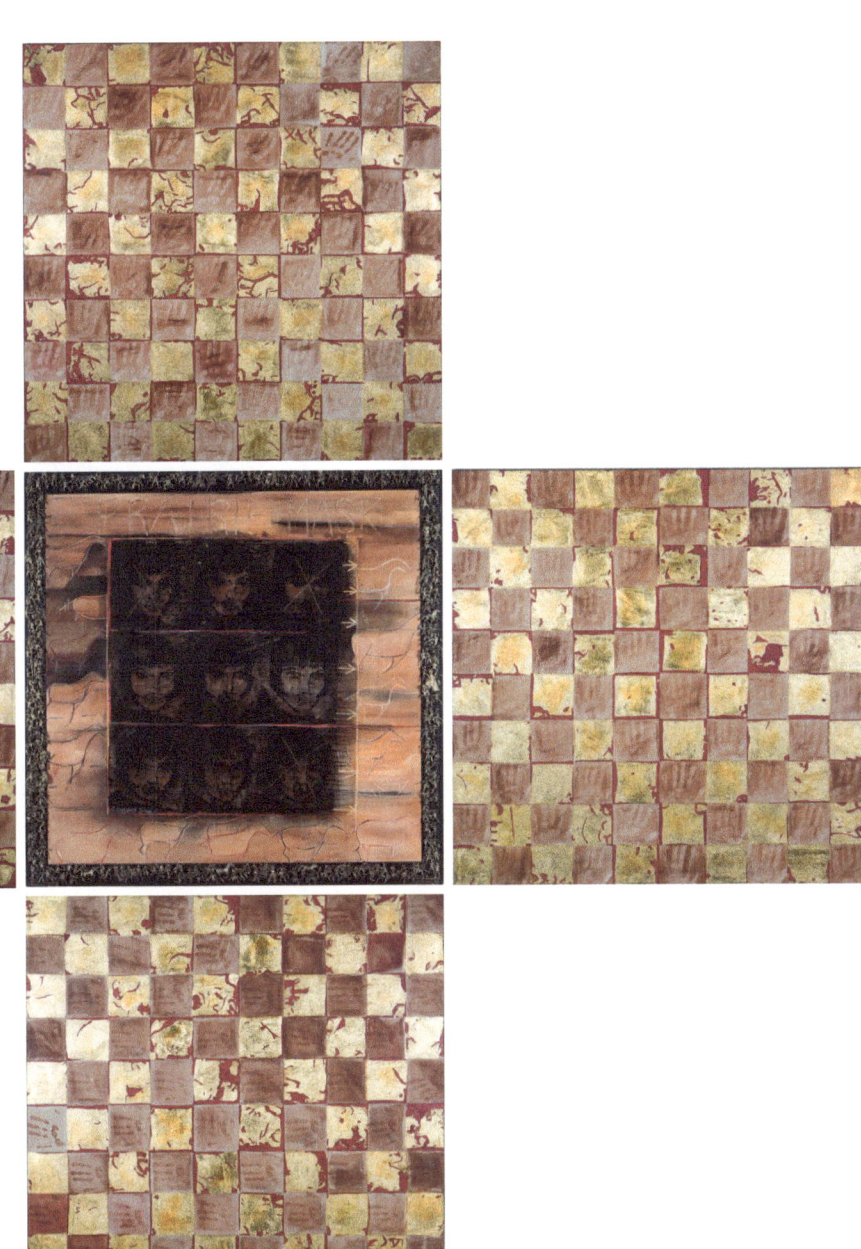

22. *Kitchen Works: sstorsiinao'si*, 1998
411.48 x 411.48 cm
162" x 162"
Mixed media installation of five 54" x 54" panels arranged in cross.
Prairie mask contact sheet as centre piece.
From the Estate of Joane Cardinal-Schubert

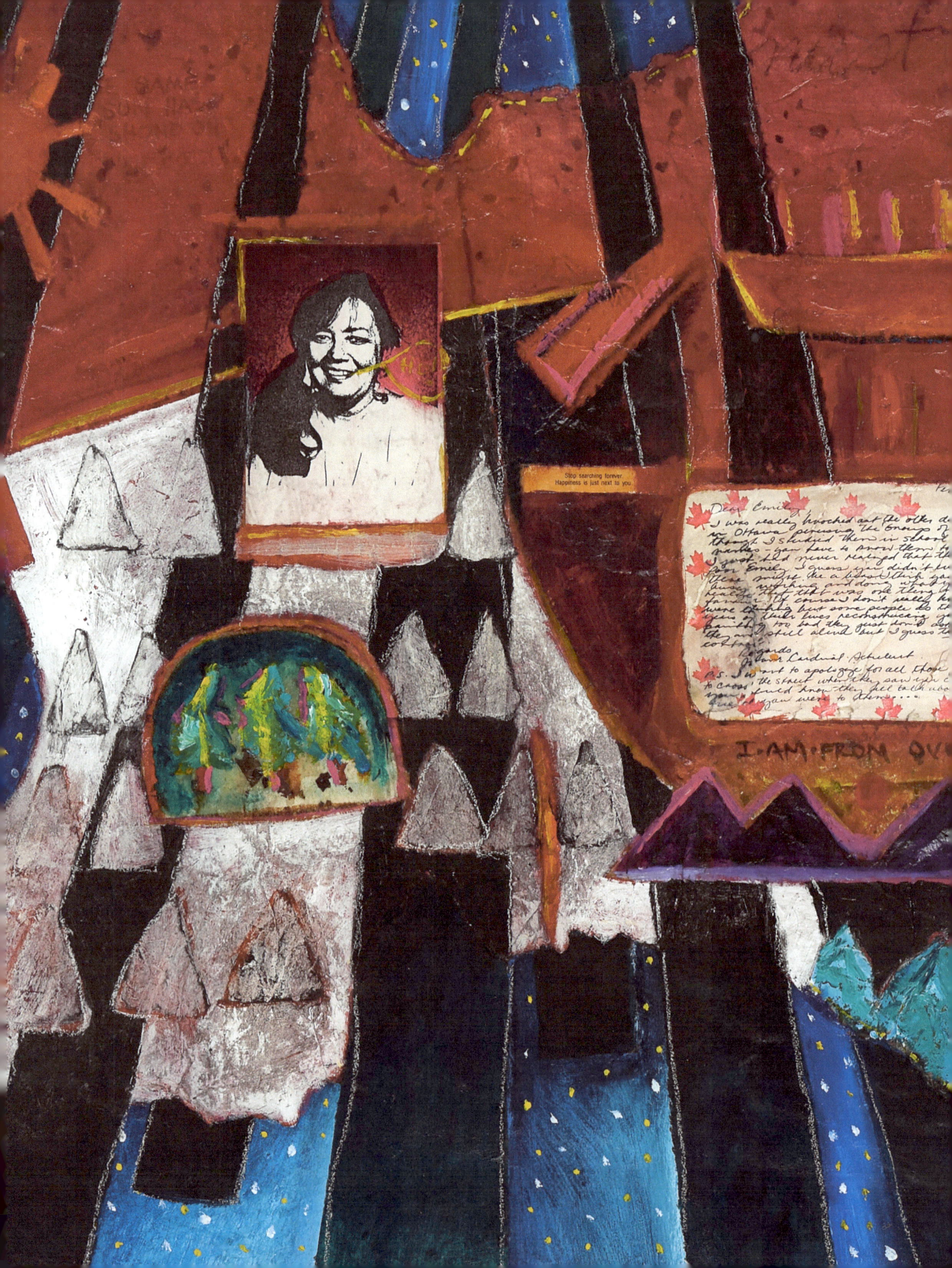

REMEMBERING JOANE CARDINAL-SCHUBERT[1]

BY MONIQUE WESTRA

I was never an intimate friend of Joane's. It would be more accurate to characterize our association over a thirty-year period as respectful, collegial, and warm rather than close. I first met her in 1977 as a newcomer to the city of Calgary. Joane was a curator at the University of Calgary Art Gallery where I gave a series of lectures. Over time, we had many meaningful conversations and I came to appreciate her acuity of mind, her wit, and her chutzpah. During her lifetime, Joane was a formidable presence in the art community of Calgary. Everyone knew who she was and what she stood for. She was widely held in great esteem. Even people who were cowed by her intellect, acerbic wit, and assertive personality greatly respected her. It is no exaggeration to say that Joane Cardinal-Schubert was a larger-than-life cultural icon. So when news of her death at the age of sixty-seven spread, it seemed impossible that this irrepressible and indefatigable woman was gone. Gone but not silenced, for her powerful voice continues to resonate. Indeed, although she died less than ten years ago, her legacy is already undeniable. Joane Cardinal-Schubert is studied in university courses and art colleges across the country. Her life and work is the subject of an academic dissertation, scholarly books, and articles. Her art is in major collections across Canada and elsewhere.

Remarkably, when Joane was already fatally afflicted with cancer in 2009, she organized *Narrative Quest*, a huge and significant exhibition of contemporary Indigenous art for the Alberta Foundation for the Arts. After she died, it became clear that the exhibition represented more than a survey of contemporary art. It revealed Joane's tremendous impact, especially among First Nations artists. In a panel discussion, a number of artists spoke about the extraordinary extent of Joane's influence on their lives and art. For many younger artists, she was a true friend, confidante, and mentor who actively encouraged them to embrace their identities as Indigenous artists. Her influence extended far beyond art and the vagaries of style. Indeed, her role was seminal in affecting the outlook of a whole generation of artists: Joane Cardinal-Schubert nurtured consciousness, instilling a sense of identity, pride, and self-awareness.

Her prodigious body of work, produced over a period of more than forty years, encompasses many mediums in the visual arts including painting, sculpture, mixed media, video, and installation. In addition to being a great artist, Joane was also a prolific writer. Like Vincent van Gogh and Emily Carr, she wrote extensively about her own art. She also wrote short stories, poetry, prose, commentaries, critical essays, and plays. She was a curator, lecturer, writer, and set designer. And throughout her life, she was passionately engaged with First Nations issues as a fervent activist and outspoken lobbyist. Known for her fierce intelligence, humour, and compassion, she could also be feisty and combative. Hers was a life lived to the fullest, with the intensity and passion of someone who knew who she was.

Although her productions were many and various, Joane Cardinal-Schubert may be best remembered for her visual art, striking for its depth of meaning, its beauty, and complexity, its idiosyncratic symbolism, narrative focus, its layers, vibrant colours, and intricate compositions. Joane's art was often incisive and provocative. Although she did not hesitate to express outrage and anger in words and images, these were not the primary emotions that propelled her life's work. She wanted to share her joy and celebrate the positives of Indigenous peoples through art. She was able to absorb and derive meaning from memories, stories, events, people, objects, and experiences, and use them as raw material for her art. In 1992 she described her inclusive process in the following way: "I pour in all those

experiences, the good with the bad, and within the composition, their energies are transformed into beauty and a new truth."[2]

I have always been struck by the intensity, beauty, and complexity of Joane's art. In spite of its variety, it is a cohesive body of work. With its myriad connections and overlaps, the conceptual framework of her art is circular: "I exist at the centre of a big circle. My 'stories' are circular, the end and the beginning linked, referenced … and I can cross over the circle and spin off into little circles rediscovering aspects I have missed or that remained undeveloped in previous works. Sometimes I cross that circle as a challenge to rediscover, to find out what I missed at first glance."[3] I believe that this is contemporary art at its finest: profoundly meaningful, nuanced, intensely personal yet universally relevant, aesthetically beautiful, and enriched through a unique lexicon of iconographical symbols and metaphors.

One such example is *Self Portrait as an Indian Warshirt* (fig. 23), a 1991 mixed media work on paper. With high value contrasts and dynamic compositional structure, it is visually intriguing. Like most of Joane's work, this is not an easy read. It contains numerous elements, integrated into the composition, each of which needs to be examined to derive meaning. Collaged in the upper left quadrant is a black and white photograph. It shows a young woman with a broad grin, looking out at the spectator with perky confidence. She seems lively and gutsy, an impression enhanced by the asymmetry of her thick black hair gathered into a ponytail that falls over one shoulder.

This photograph was first seen as a multiple, mounted on a huge blackboard that was a part of a large installation entitled *Preservation of a Species: DECONSTRUCTIVISTS*. It was created for *Indigena*, a groundbreaking exhibition of First Nations contemporary art organized by the Museum of Civilization that toured around the country in 1991–92. The installation required viewers to look uncomfortably through awkwardly placed red and clear glass windows in a wall to see works within an enclosed space, alluding to the artist's interest in peering into walled-in construction sites. Enclosed by several blackboards, each inscribed with handwritten messages in chalk, the installation also invoked the experience of a traditional schoolroom. One blackboard featured photographs of the artist, in different sizes, arrayed in an orderly manner on the surface. The pictures

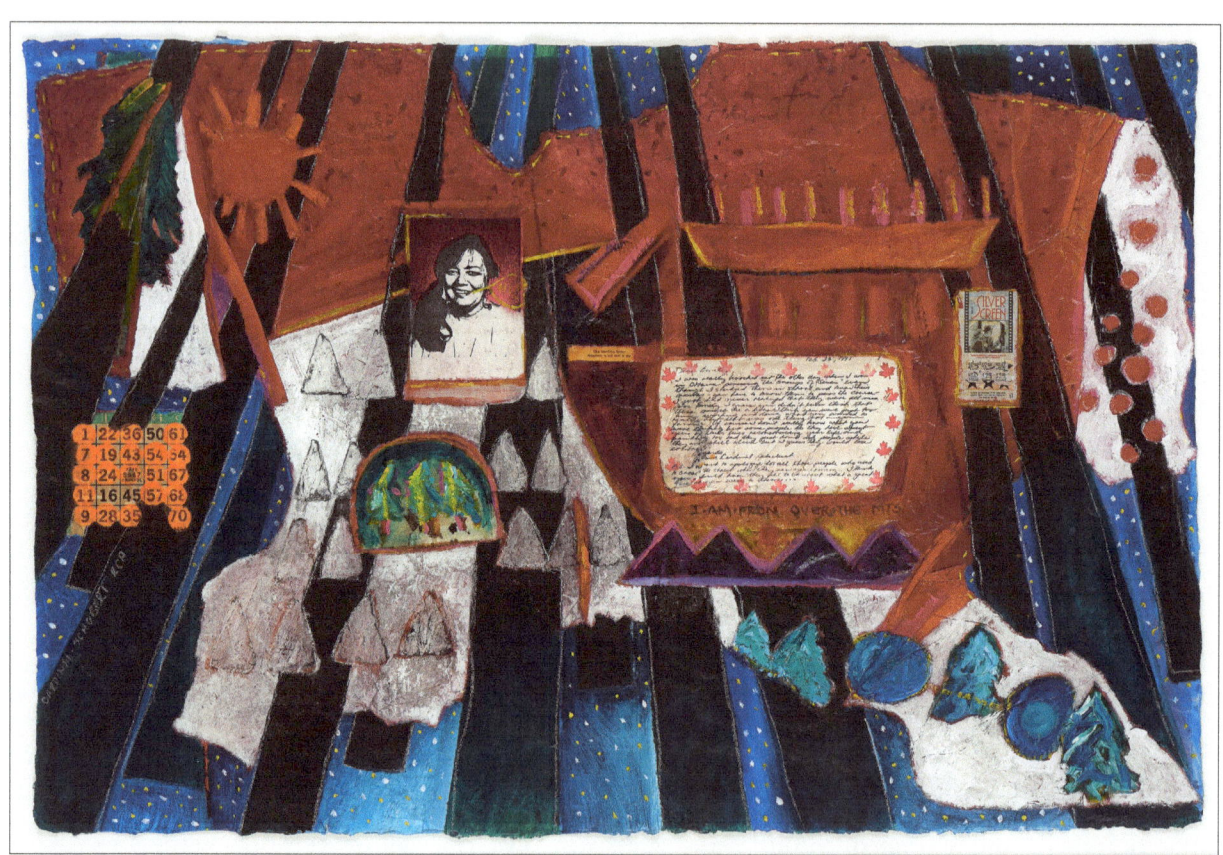

23. *Self Portrait as an Indian Warshirt*, 1991
93.5 x 121 cm
36.75" x 47.5"
Mixed media on paper
Collection of Glenbow; purchased with the support of the Canada Council for the Arts Acquisitions Assistance Program/oeuvre achetée avec l'aide du programme d'aide aux acquisitions du Conseil des Arts du Canada and with funds from Glenbow Collections Endowment Fund, 2000

are the kind of fun photographs that we used to have taken in a photo booth at Woolworths. Other photographs show the artist's parents and herself as a little girl with her mother. These familial images seem benign and ordinary, reinforcing the idea of the artist as someone just like me and you. But what sets her apart is her designation as a non-status Indian. The brief text, angrily scrawled in chalk, is a searing indictment of the racism implicit in Canada's Indian Act, with its outrageous rules to determine by degree the authenticity of one's Indianness, as it were. The message is powerful and intended to make the viewer both physically and psychologically uneasy.

The setting of the schoolroom is significant because it vividly recalls the devastating residential school experience of Indigenous people in Canada, a wrenching issue Joane addressed in a compact but emotionally charged installation created one year earlier, in 1989, on site in Montreal at the Articule Gallery. It was called simply *The Lesson* (fig. 24). *The Lesson* depicts a claustrophobic classroom, with chairs tied together with ropes, their seats topped by apples pierced with screw hooks, and chalkboards covered with strident texts written by hand about many of the past and present injustices that took place in such classrooms. *The Lesson* was reconstructed in nearly twenty venues across Canada and the United States. In one venue at the Toronto International Powwow in 1999, installed ten years after it was first created, more than 2,500 people viewed the exhibition. One of the chalkboards, the "Memory Wall," invited Indigenous people to write their names and thoughts on the board. Many of the visitors, Indigenous and non-Indigenous, left in tears. *The Lesson* was recreated by the artist for the last time at Masters Gallery Ltd in June, 2009, a few months before the artist's death.[4]

The use of the blackboard and schoolroom setting appears in another work of the early 1990s entitled, ironically, *Where the Truth is Written – Usually* (fig. 25). It shows an American flag with maple leaves instead of stars as an unframed painting on raw canvas attached to a flag pole of lodgepole pine, flanked on one side by a column of handwritten inscriptions in chalk; there is no discursive text here – just label copy, as in a museum display.

The artist returned to this image years later, reworking it in a 2008 painting called *Flag II*. The image of the stars and stripes is part of the modernist canon, and was made

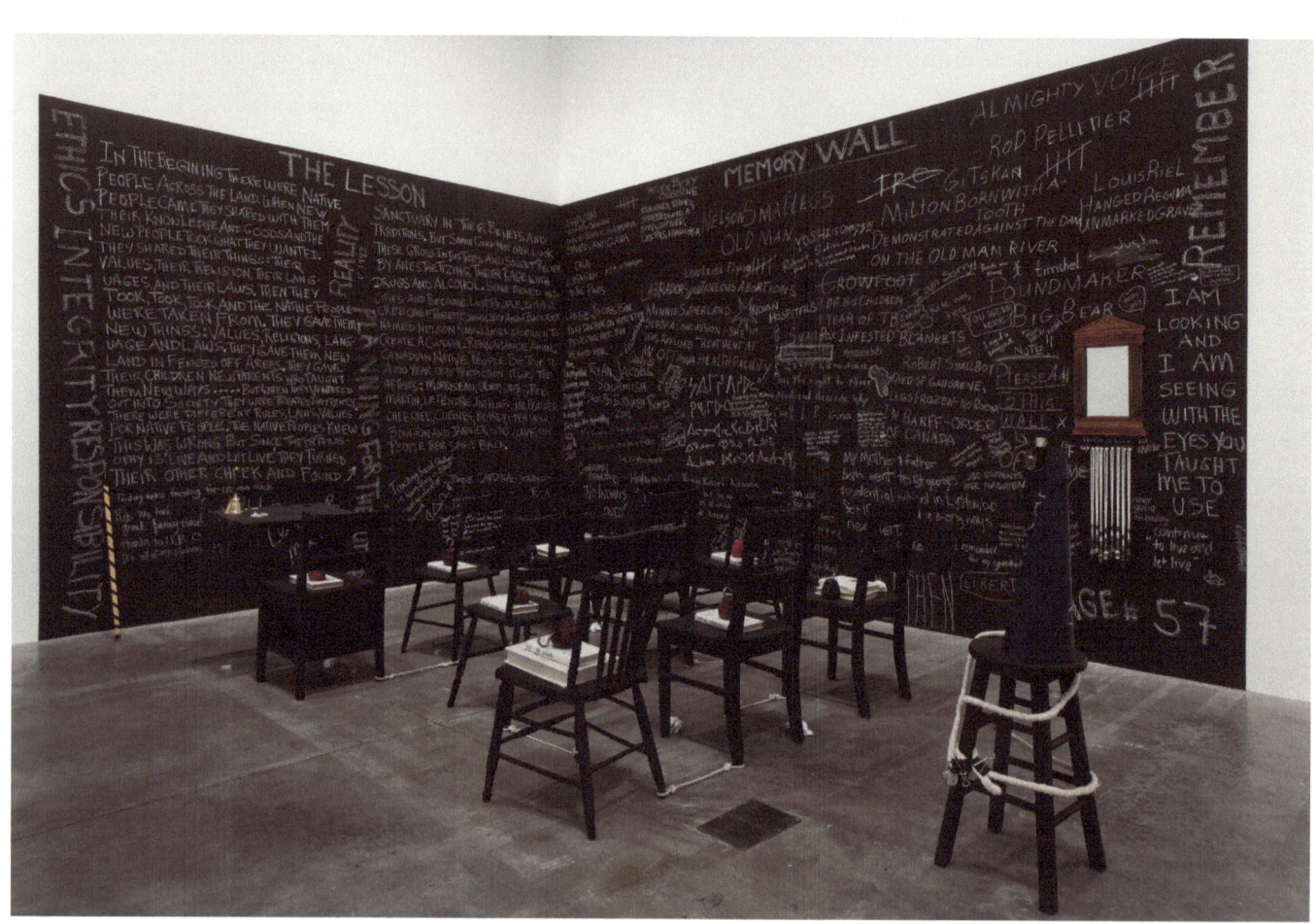

24. *The Lesson*, first installed 1989
Installation, dimensions variable
chairs, whistles, books, apples, rope, mirror, chalk
Installation view, Witnesses: Art and Canada's Indian Residential Schools
(September 6-December 1, 2013)
From the Morris and Helen Belkin Art Gallery, UBC.

BY MONIQUE WESTRA

famous by Jasper Johns, who stripped the American flag of meaning and reduced it to formal elements – design, colour juxtaposition, balance, and composition. But Joane's *Flag II* subverts the simple elegance of the modernist emblem and turns it into a biting and ironic commentary. By substituting Canadian maple leafs for American stars, Joane is subtly drawing attention to the increasing encroachment of America into Canada which she describes as "the innocuous erosion of our power base as individuals and possibly of our sovereignty." The integrity, rigidity, and regularity of the horizontal strips are broken by uneven edges and the integration into the design of two large triangles, representing both mountains and teepees. The red and white stripes are further disrupted with the silhouettes of wolves.

> I am interweaving its stripes with historic realities, piercing it with aspects of history, adding truth, i.e. the introduction of Canadian wolf populations to American parks subsequently shot by ranchers when wolves left the park boundary is not unlike the historic fate of many American Indians who followed the Buffalo, or strayed from designated land … In honour of those wolf spirits I am returning the stars to their place dispersed sporadically in the sky as the milky way or as the Blackfoot refer to it "the wolf way." But the placement of the hands and the maple leaves contain a warning.[5]

Further reference to the decimation of Indigenous populations is also contained in the aforementioned *Self Portrait as an Indian Warshirt*. The red dots along the right sleeve are symbols for smallpox and act as a reminder of the fate of many Native populations as a result of European contact.

When she created this work, various events taking place in the artist's life were profoundly upsetting. Her studio had been robbed, leaving her feeling violated, angry, and vulnerable. During this time she was writing a play with a group of Native women where heated discussions arose about racism, representation, and social injustice. Both the bingo card and the "Silver Screen" movie ticket in *Self Portrait as an Indian Warshirt* reference First Nations

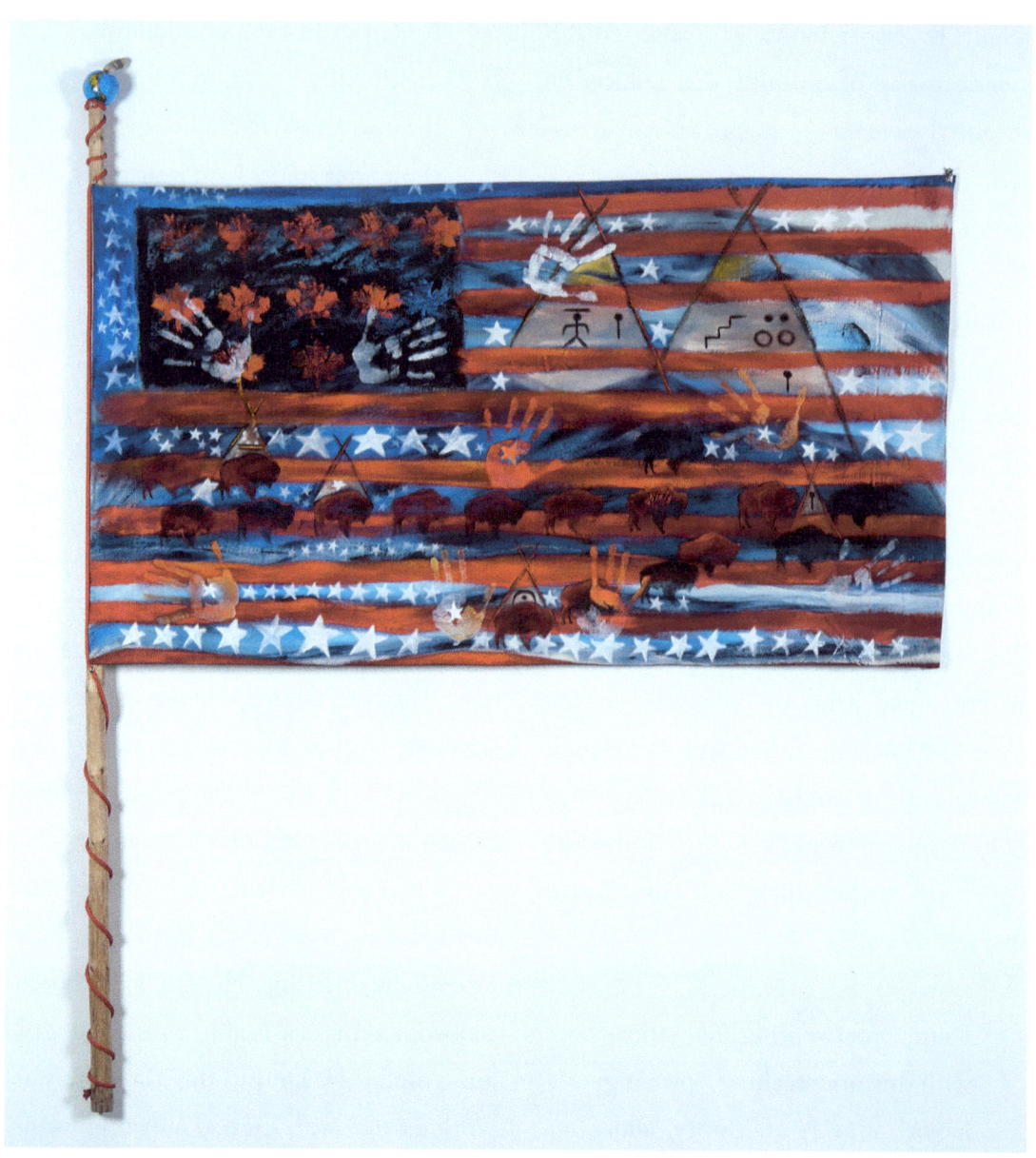

25. Detail of *Where the Truth is Written – Usually*, 1991
76.2 x 152.4 cm
30" x 60"
Oil on canvas flag with lodgepole pine flag pole
From the Estate of Joane Cardinal-Schubert

stereotypes, and are remnants of research for a character in the play she was writing.

Most prominently sited within the painting is a collaged letter, its circumference bordered by stencilled maple leaves. This work is part of her *Letters to Emily* series, which Joane described as "diarized recordings of the day" in both text and images. Instead of "Dear Diary," she addresses Canadian artist Emily Carr in a series of letters — as if Carr were still alive to receive them. I became familiar with this piece as art curator at the Glenbow Museum during preparations for our 2007–08 Emily Carr exhibition. Joane and I exchanged emails about *Self Portrait as an Indian Warshirt*, which was already in the museum collection. As this collage was part of her *Letters to Emily* series, it seemed an appropriate addition to the exhibition. In this letter to Emily, Joane wittily comments on the predominance of men in Canadian art history; she makes mocking references to academia and art historians who presume to know, and reminds Emily of the small-mindedness and intolerance of neighbours who mocked and ignored her in Victoria.

Dear Emily,

I was really knocked out the other day when I was in Ottawa perusing the Group of Seven even though I studied them in school and know their names — you have to know them to pass the course — I just had never realized that they were all men. Poor Emily. I guess you didn't even think about that there might be a bias. I think that you were just too busy working and doing what you wanted to realize that that was one thing not in your favour. Of course I really don't know what you were thinking but some people do. They have spent years of their lives reconstructing your life and painting. Too bad they just didn't ask people while they are still alive but I guess they would lose control.

Regards,

Joane Cardinal-Schubert

PS I want to apologize for all those people who used to cross the street when they saw you coming. I think you should know they all talk about what a great friend you were to them.

Joane Cardinal-Schubert relates to Emily Carr as a strong-willed, unconventional woman but also as someone who, like herself, loved nature, and was hyper-attuned, if you will, to the sensory stimulation and beauty of the land of her birth. The letters to Emily continued throughout Joane's career. *Emily in Raven Hat Mode* (2007) is another whimsical painting of Emily Carr. In her explanation of this painting, Joane wrote:

> Long fascinated with the life of Emily Carr, I have been writing her letters for several years. Some of these are text based, some paintings, some installations. The approach is that Emily, an "unconventional artist," housekeeper, gardener, traveller is just far away and that the past, present, and future meld into one … Here she is envisioned, just back from France and England, throwing off her learned Western European art regimes, she looks at trees coloured by a coastal view – while wearing one of her hats.

The text of the letter to Emily included in the painting reads:

> *The question remains with me, Emily. Would you ever have understood how to paint the cathedrals of the forest, as they pierced the Sky, without the interventive use of the visual text of the poles? Or were you as some have referenced – just engaged in stealing horses?*
>
> *Regards, jcs*[6]

The notion of stealing horses is a pun. It refers both to a historical Native practice, and also to the contemporary idea of cultural appropriation, a contentious concept within postmodern ideology. Emily Carr was criticized because of her extensive use of First Nations images, especially totem poles. There is also a certain irony here because Joane's schematic representation of horses is itself derived from an earlier source, namely the petroglyphs in Writing-on-Stone Provincial Park. Joane made an extensive study of this imagery, among the earliest known drawings by Native peoples in North America. She made copies on site and looked at archival photographs to find

scenes, eroded by time and no longer legible on the rock face. She was fascinated by the stories and images of her ancient forebears and adopted many of the simplified conventions into her own art.

Joane's stylized representation of horses in motion is a primary example. They are always shown in profile with heads thrust forward and tailless hind quarters rounded. Many of the shorthand, simplified graphic images, derived from Writing-on-Stone, were incorporated into her own expansive iconography and symbolic lexicon. The horse image recurs in hundreds of her works because of the importance of horses to First Nations peoples. She has written about how she was affected by horses: "Their physical beauty and form, unsaddled, unbridled within the landscape, close up and within the stories of horses told by my parents — both horse people."

Joane's schematic representation of horses gains power through repetition, variations in scale and colour, groupings, and strategic placement within the composition. Although she understood the potency of multiples in her works, she also created many works focused on a single object surrounded or surmounted by symbolic elements hovering or floating in its sphere.

In one stunning 1996 series, the central object is a magnified detail of a huge vessel. Joane refers to it as a Gourd, a direct reference to a Native prophecy, known as the Gourd of Ashes, that foretold a nuclear explosion. "They said the gourd of ashes would fall from the air. It will make people like blades of grass in the prairie fire and things will not grow for many seasons." In this sequence of highly charged images, we see amphorae decorated with horses, bears, and deer in profile processions, and sketchy drawings of warriors derived from pictographs, set within a fiery realm as nuclear towers rise ominously in the background.

Another series that takes as its focus a single object, rich in meaning and associations, is based on the warshirt, as in the early *Self Portrait as an Indian Warshirt*. In creating a self portrait, Joane continues a long art historical tradition. She does not paint herself by looking in a mirror but instead presents herself both directly through the collaged photograph and also indirectly through metaphor. The title of the work — and titles are very important in Joane's work — is declaratory. In this work, she identifies herself as a creator, and specifically as a woman artist like Emily Carr. She also represents herself as a garment

specific to culture and gender. Traditional Plains First Nations warshirts were awarded to men who demonstrated acts of bravery and reflected personal achievement. Here, it is appropriated by a woman as an emblem of pride.

In *Self Portrait as an Indian Warshirt*, the red shirt is shown as interwoven, like a tipi hide, onto black lodgepole pine. The converging black poles create a dynamic compositional structure, enlivened by asymmetry and high contrast. The visual clues laid out across its surface reveal aspects of the artist's identity, related to her life and also to Native cultural traditions and history. Below her photo is an image of a landscape protected by an arch, the sacred sweat lodge shape. The imagery grew out of the artist's dismay about the thousands of Native artifacts and sacred objects having been removed from the lives of the people they represent, and languishing in museum collections around the world. By creating her own warshirt, she reconnected to her ancestral history. In this painting the garment is red, the colour of life. In other works, it is pale umber and textured to resemble tanned hide from which they were made. In many paintings in the warshirt series, the shirt is monumentalized, splayed across the pictorial surface. It is presented frontally and flattened out to form a bold symmetrical pattern superimposed with objects that extend its meaning, including symbols that are both universal and personal. "Many years ago, I decided that we all wore warshirts – indicators in our dress of our personal powers that almost serve as fair warnings. Historically, aboriginal people have been viewed with an 'anthro/ethno gaze' as dead people and I wanted to change that."[7]

Among the more visually complex works in the Warshirt series is the spectacular *My Mother's Vision, The Warshirt Series in the Garden II*. In a highly charged field of vivid red on a black ground, under the protective dome of the sweat lodge, is a dazzling array of overlapping, intertwined images including warshirts, intersecting lodgepoles, silhouettes of bears, and twenty hands. The powerful thrust is centrifugal, pushing outward in all directions, directed by the splayed fingers of the hands. The imprint of the open hand is one of the oldest symbols of humanity, first seen in the spray-painted negative images in prehistoric caves. As the title says, this painting was inspired by Joane's mother. Joane was profoundly influenced by both her parents.

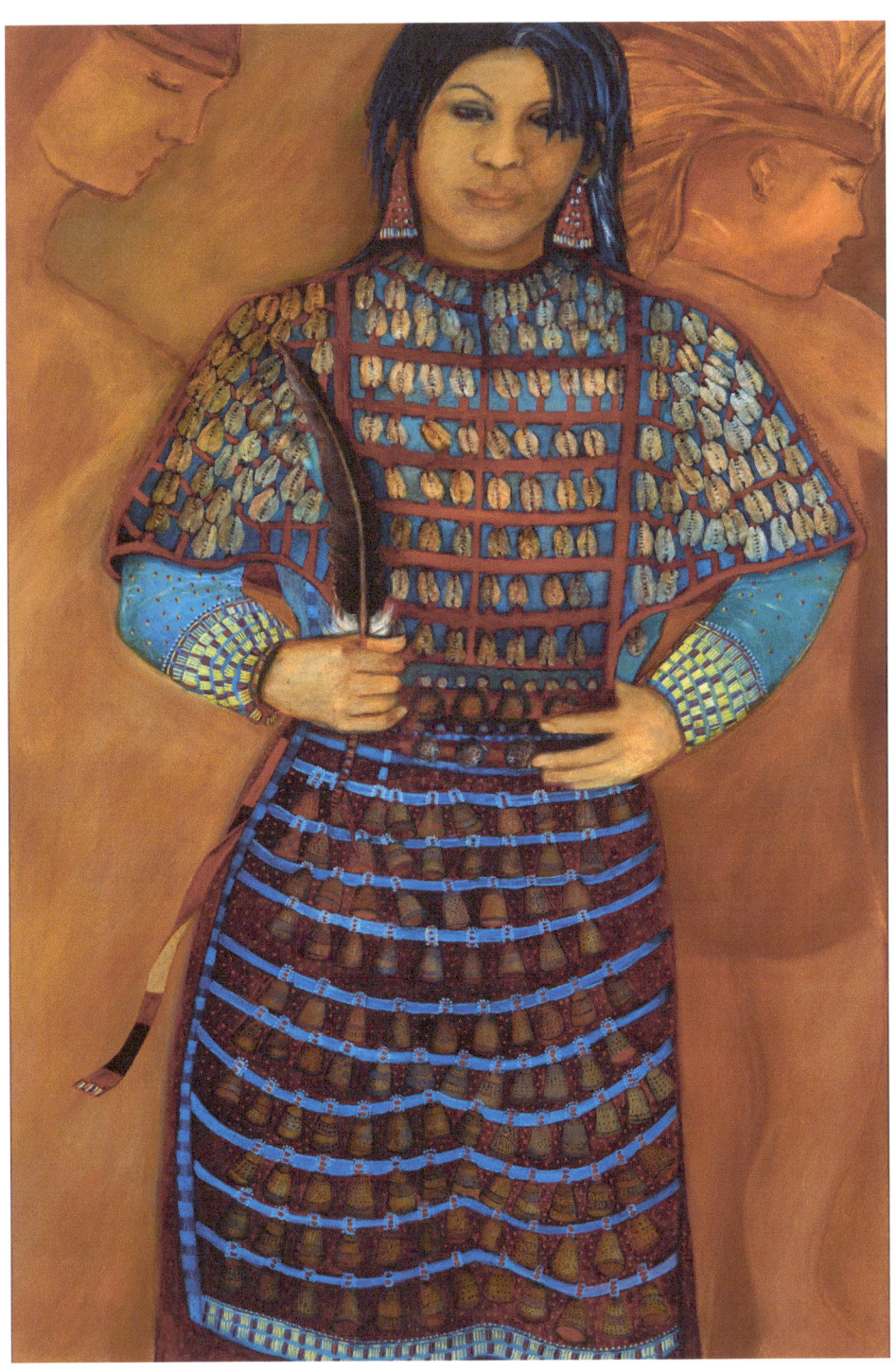

26. *Modern Dancer – Grandmother's Thimble Dress Dream*, 2006
119.38 x 81.28 cm
47" x 32"
Oil and acrylic on canvas
Private Collection

27. *When We Saw Our Grandmother's Dress*, 2007
121.9 x 80 cm
48" x 31.5"
Acrylic on paper
Fulton Family Collection

This Kainai dress, now in the collection of the Royal Alberta Museum, was obtained by James Carnegie, the Ninth Earl of Southesk while on a trip through western Canada from 1859-1860. Although the primary goal of the trip was to hunt big game, Carnegie also collected objects from the communities he encountered during his travels. The "Southesk Collection" had been kept in the family's castle in Scotland for nearly 150 years before being offered for sale in May 2006 at Sotheby's auction house in New York. With letters of support from Métis and First Nations leaders in Alberta and Saskatchewan, and with financial help from the Department of Canadian Heritage, the Alberta Historical Resources Foundation, and the Ministry of Aboriginal and Northern Affairs, the Royal Alberta Museum was able to purchase this dress, along with several other Blackfoot, Plains Cree, Métis, Nakoda and Anishinaabe items. This dress accounted for nearly half of the $1.1M raised by the museum.

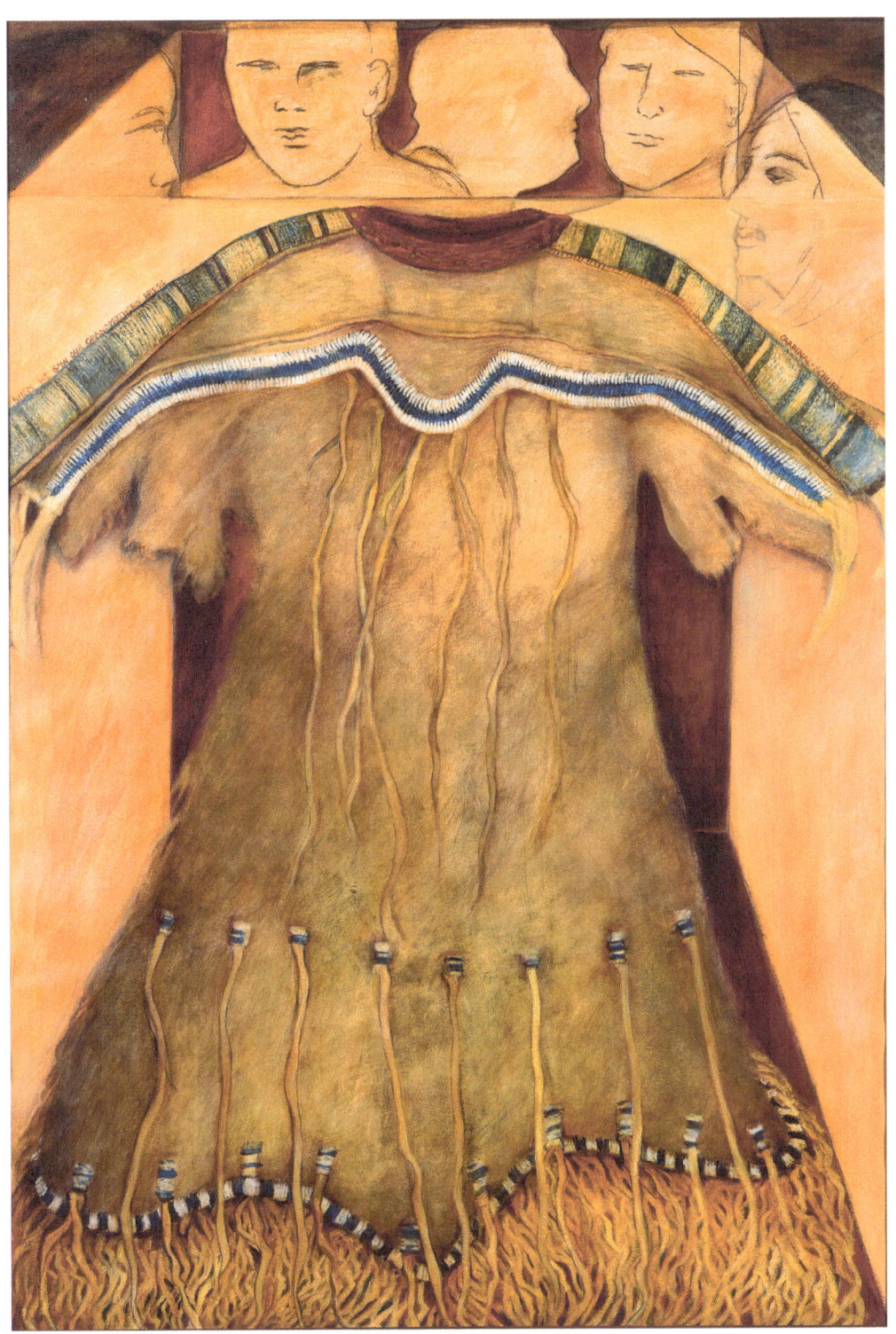

She spoke often in our conversations of how inspirational they were for her: "My parents taught us to look at each day as a new beginning. That tomorrow is a new day – I hold this belief close – it has served me well. No recriminations, just belief that things change, things get better and I have a part to play in that – I take the responsibility seriously." In particular, she acknowledges a great debt of gratitude to her father: "I was pointed at an early age toward the direction of creating things. It was my father who literally placed me in art school. I am looking and I am seeing with the eyes he taught me to use."

Joane's grandparents also played a seminal role in her life and helped her to understand and love her heritage. "There is nothing more powerful than to know who you are ... the people you come from." *Modern Dancer – Grandmother's Thimble Dress Dream*, 2006 (fig. 26) is less a portrait of than a tribute to her grandmother, and takes as its point of departure a simple thimble that belonged to her grandmother. The thimble is a reminder of sewing and handicraft associated with women. The painting depicts a close-up of a young female dancer dressed in a jingle dress in a powwow. Although she is a dancer, we do not see her legs, yet her swaying movement is subtle and graceful. The figure is cropped at the top and bottom, brought very close to the picture plane and monumentalized. The focus of our attention is on the dress and its encoded symbols. In her unpublished writing, Joane provided a detailed explanation of each decorative element in the painting:

> The cowrie shells on the upper bodice are symbolic of change and travel, holding the ocean, they reached the prairie through trade, dance and commerce. The thimble notations on the skirt were influenced by my Grandmother's thimble, found in the drawer of her treadle machine, many years ago. Like myself she was a sewer, constructing her own dresses of her design. The dress hem and sleeves are trimmed with a traditional porcupine quillwork. The small bead dots on the dress sleeves are a memory of my grandmother's dress. The dancer carefully holds an eagle feather – it is a wing tip feather – part of the hand of the

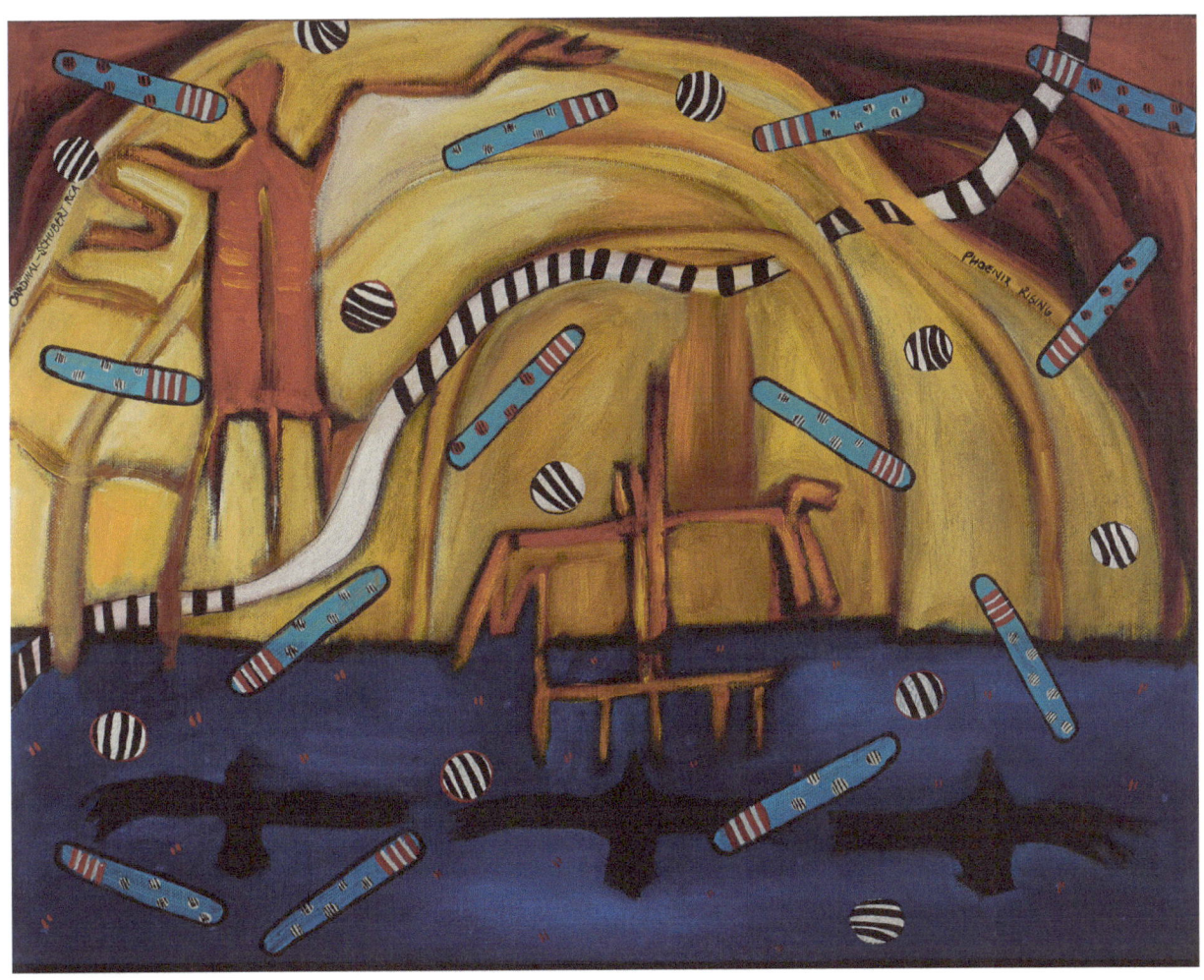

28. *Phoenix Rising*, c. 1999
50.8 x 40.6 cm
16" x 20"
Oil on canvas
Collection of Glenbow; gift of Tamar Zenith, 2008

eagle … that allows the eagle to soar … This is an actual feather that was given to me as a gift … The dancer lightly, carefully holds it.

The eagle is featured in many of Joane's works, symbolic of power, strength, and freedom, as in the brightly coloured 1999 painting *Phoenix Rising* (fig. 28) in the collection of the Glenbow Museum. Eagles are represented as black silhouettes in the lower blue section. As birds can move between the earth and the sky, they are transformative. The main symbolism in this painting is a sweat lodge – which is a traditional place of healing and purification. The wavy lines and the red on the outside could be interpreted as heat and power emanating from within. The figure in the centre of the composition is in the same place as the fire would be in the sweat lodge. It is also very birdlike – the arms are outstretched like wings and the parallel lines at the base are like tail feathers, another reference to transformation. The other, elongated red figure is the "phoenix rising," traditionally associated with rebirth and the emergence of life from death. Both figures are painted in the simplified style of the petroglyphs at Writing-on-Stone. They each have a strong central vertical line, which is like a soul or spirit line. Overall, the painting projects a powerful message about healing and transcendence.

The Glenbow Collection includes another beautiful and haunting work called *Dawn Quilt* (fig. 29). In this 1999 painting, the eagle becomes a part of the repetitive checkerboard pattern on a quilt. In this way, the artist brings together inside and outside, power and fragility by portraying the eagle within the comforting, protective embrace of the blanket. The eagle is also associated with Joane's mother, because of a vision she had seen during a sweat. Through its flight into a higher realm the eagle symbolizes transcendence. The flat, repetitive pattern of the counterpane quilt is set against an expansive, luminous sky – a magical indigo realm gradually ascended by sketchy, ghostlike creatures. The buffalo is associated with the First Nations of the plains, and is frequently represented by the artist. We recognize the familiar recurrent profiles of the horses, which now seem to be less galloping than floating. The sketchy, concentric arches at the top of the picture are a reference to the domed sweat lodge. Commenting on this painting in the

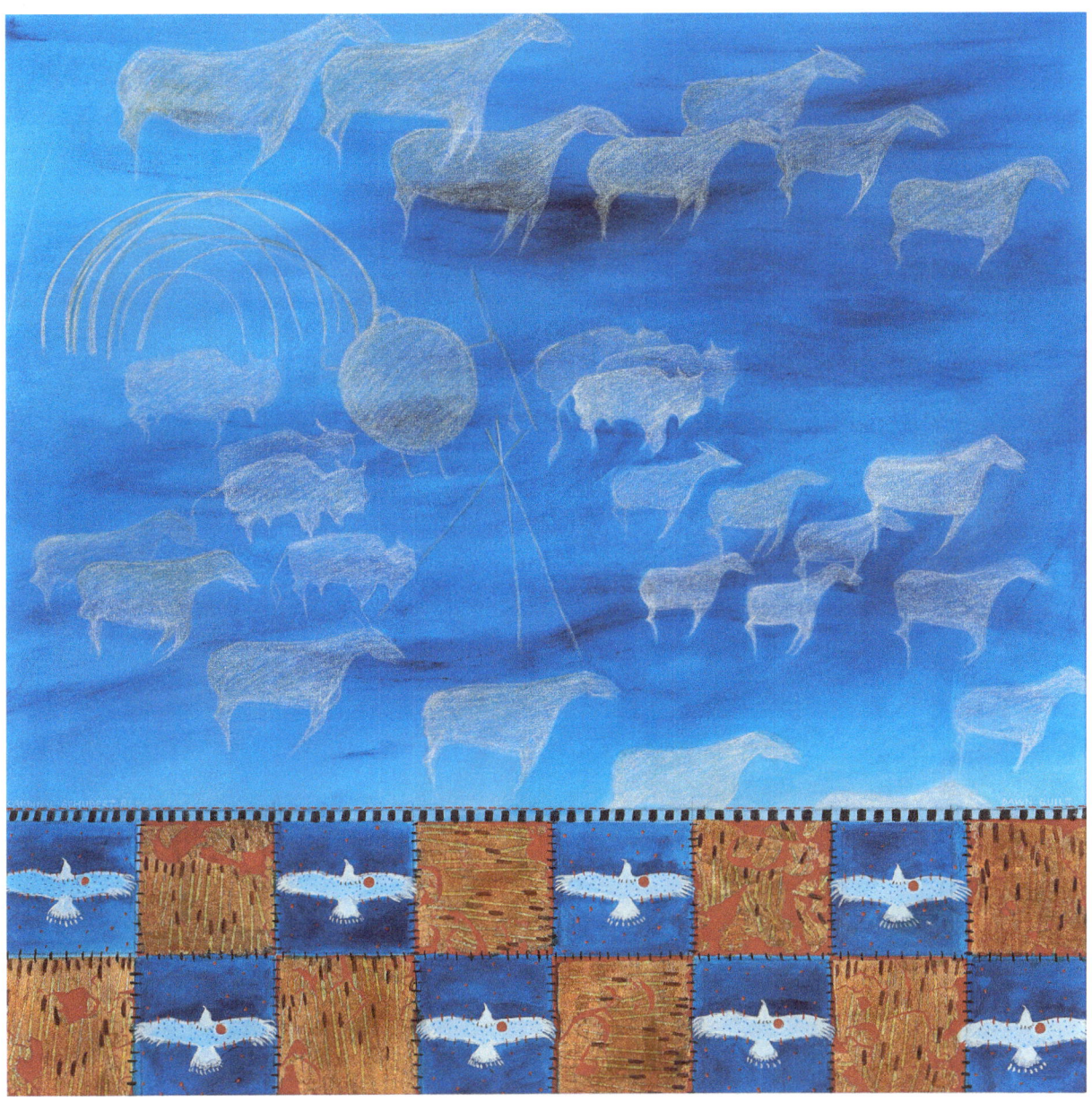

29. *Dawn Quilt*, 1999
124.5 x 125 cm
49" x 49.5"
Acrylic, oil pastel, gold foil on canvas
Collection of Glenbow; purchased with the support of the Canada Council for the Arts Acquisitions Assistance Program/oeuvre achetée avec l'aide du programme d'aide aux acquisitions du Conseil des Arts du Canada, and from the Glenbow Collections Endowment Fund, 2000

exhibition catalogue of *Honouring Tradition* at the Glenbow Museum in 2008, the artist wrote:

> The Counterpane series relates in part to my time as a sick child. Confined to bed for many days of each year until I was 10 or so, I learned to entertain myself by imagining that my bedcovers were roads and hills and lakes and rivers … Here the Counterpane, with its checkerboard format, serves primarily to symbolically honour the beading and the quilting practice of the Kainai. We, as the horse messengers, journey into the future, protected by our ancestors who remain with us always.

It is significant that both of these paintings, with their messages of transcendence and healing, were created shortly after Joane was diagnosed with breast cancer. The paintings remind me of a conversation I had with Joane in 1999. I remember an unusually warm evening in early spring. There was a raucous opening party at the Illingworth Kerr Gallery at ACAD and I slipped out for some quiet and air. Leaning against the parapet of the landing outside the doors, was Joane Cardinal-Schubert, smoking a cigarette. I had known her for a long time and was happy to see her. The casual greetings we exchanged and our light banter took a serious turn when Joane told me that she had breast cancer. She stated it as a matter of fact, without drama, and did not seem overly disturbed. She was surprised when I told her that I too had breast cancer, diagnosed one year earlier. I talked about the treatment I had received. Joane was adamant that she would refuse all medical interventions. She said this with a certain equanimity. Unlike me, her trust and faith was not with the medical establishment. It seemed to lie elsewhere. Although I admired her courage and her conviction, I remember thinking at the time that her attitude was incomprehensible. But now I understand more. Seeing the art she was creating then, with its potent images of healing and transcendence, I think that art was her therapy, her heritage, her salvation.

NOTES

1. This text was adapted from a lecture given at MOCA, Calgary in 2012 and at Masters Gallery Ltd in 2015. It is based primarily on unpublished writings by Joane Cardinal-Schubert generously loaned to me by Masters Gallery Ltd, my own response to her work, and personal recollections. Most of the texts cited throughout this essay are taken from Joane's extensive unpublished writings in which she articulated eloquent exegeses of her own work.

2. Jennifer Macleod, "Joane Cardinal-Schubert, at the Centre of her Circle," *Galleries West*, December 31, 2002.

3. Ibid.

4. *The Lesson* has been recreated several times since Joane Cardinal-Schubert's death under the supervision of Justin Cardinal-Schubert, the artist's son.

5. Unpublished writings of the artist from the archives of Masters Gallery Ltd, Calgary.

6. Ibid.

7. Ibid.

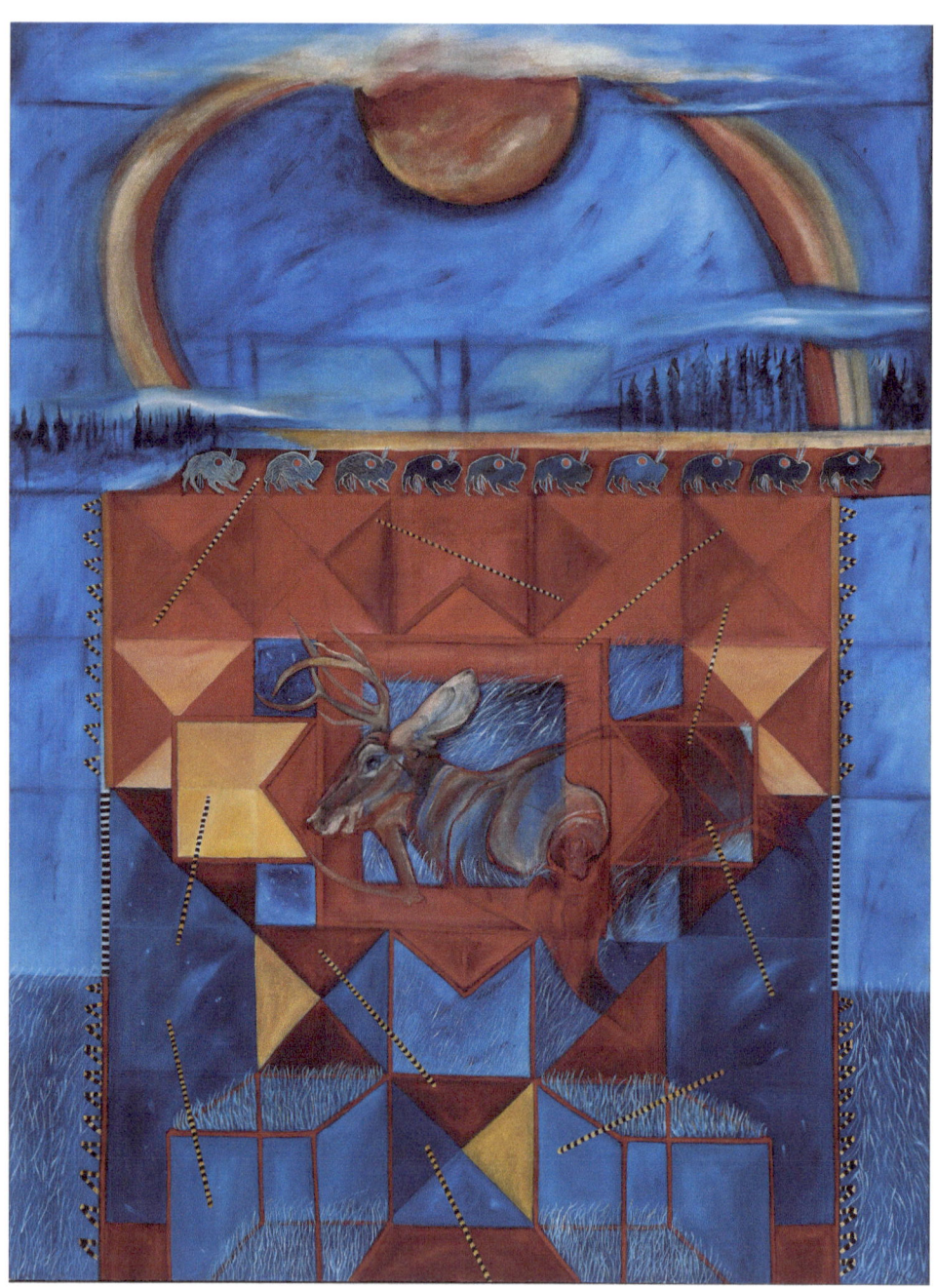

30. *Dream Bed Lover – Tipi Flap*, 1999
220.9 x 161.3 cm
87" x 63.5"
Acrylic on canvas
Collection of Glenbow; purchased with funds from the Suncor Energy Foundation, 2008

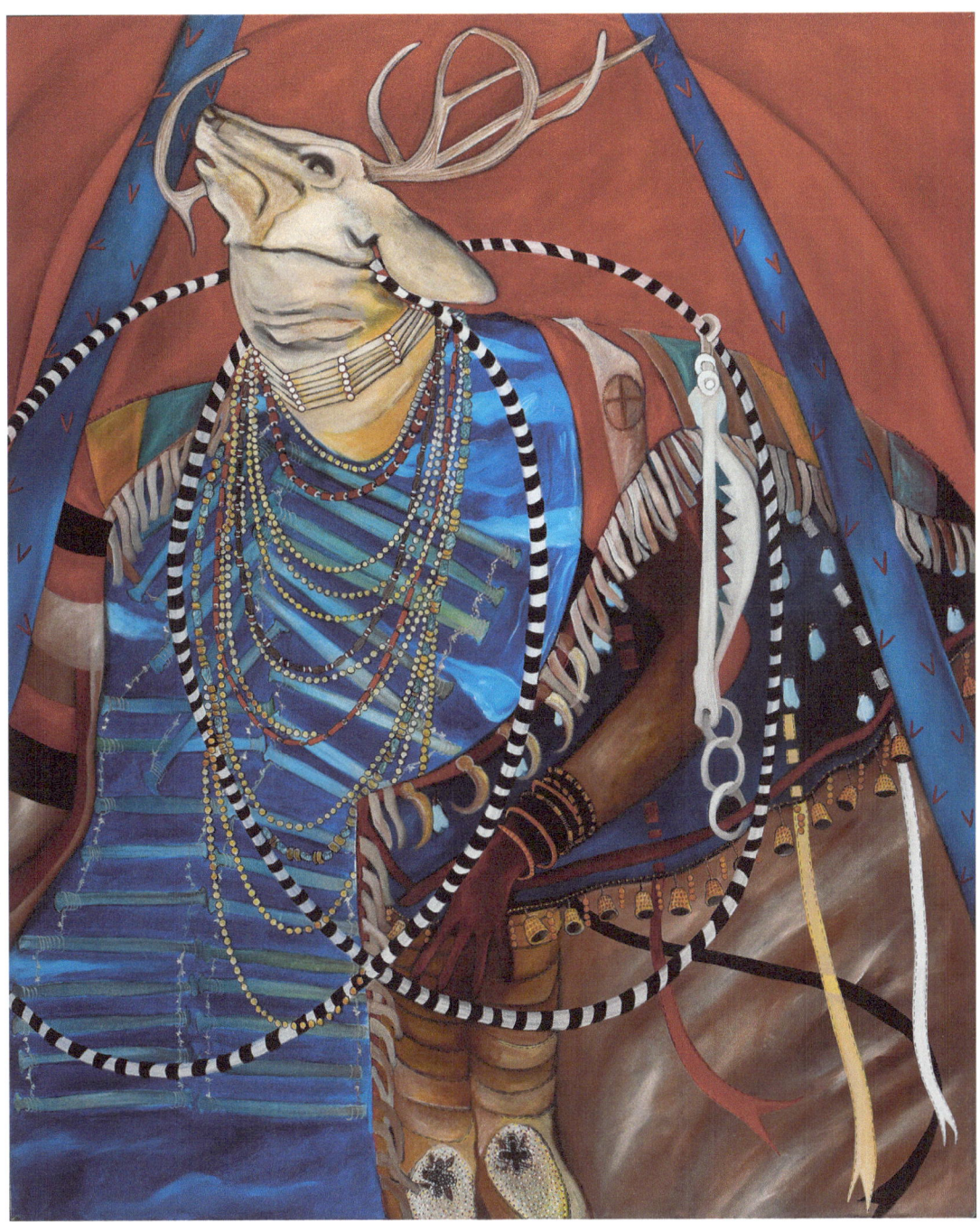

31. *Song Of My Dreambed Dance*, 1995
152 x 122 cm
60" x 48"
Acrylic on canvas
Collection of the National Gallery of Canada: 41762; gift of the Alberta Foundation of the Arts, Edmonton

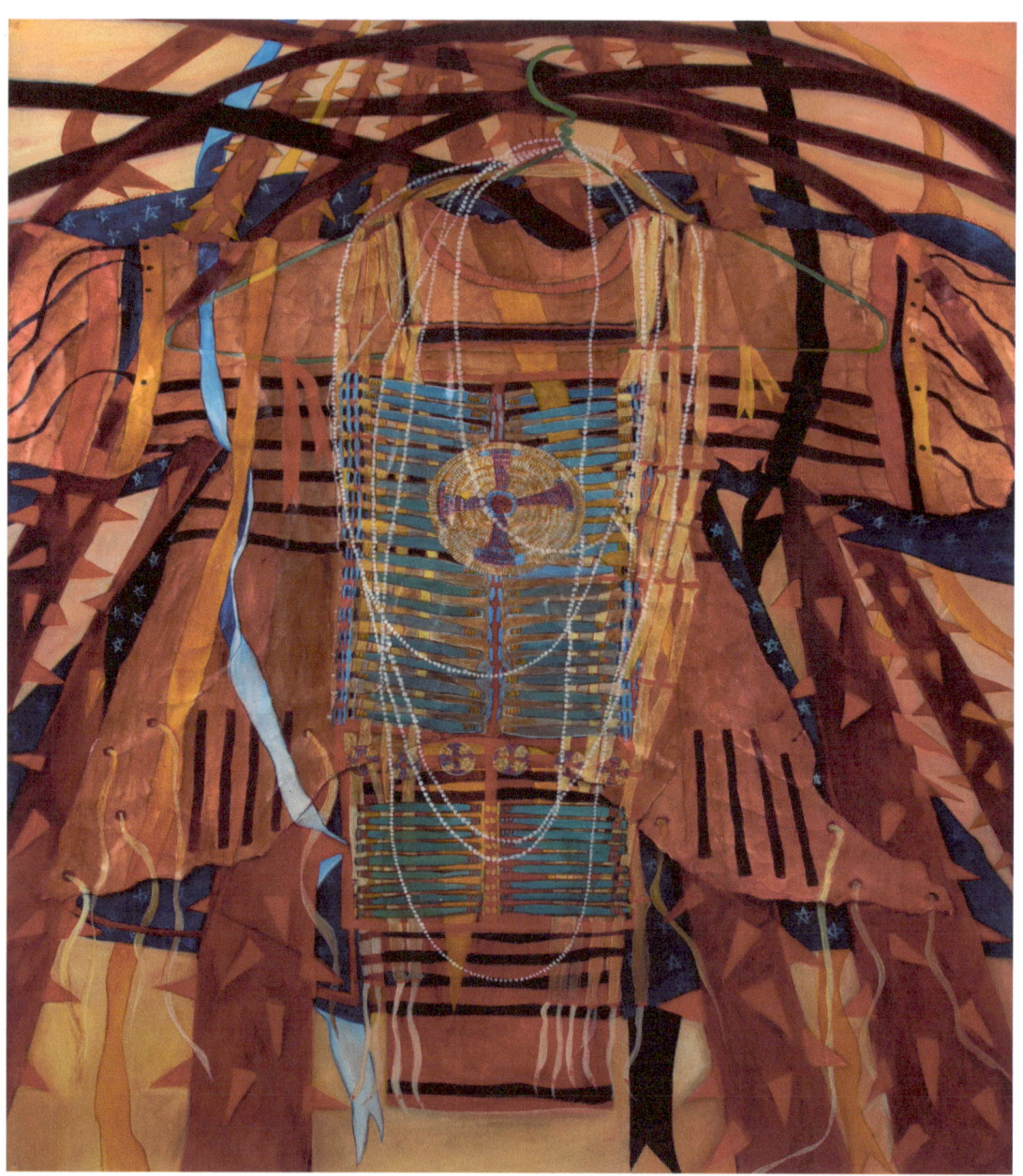

32. *Warshirt for Clayoquot Sound*, 1994
125 x 97 cm
49" x 38"
Acrylic and mixed media collage on paper
Collection of the Thunder Bay Art Gallery, purchased with the support of the Canada Council for the Arts Acquisition Assistance Program/oeuvre achetée avec l'aide du programme d'aide aux acquisitions du Conseil des arts du Canada, 1997

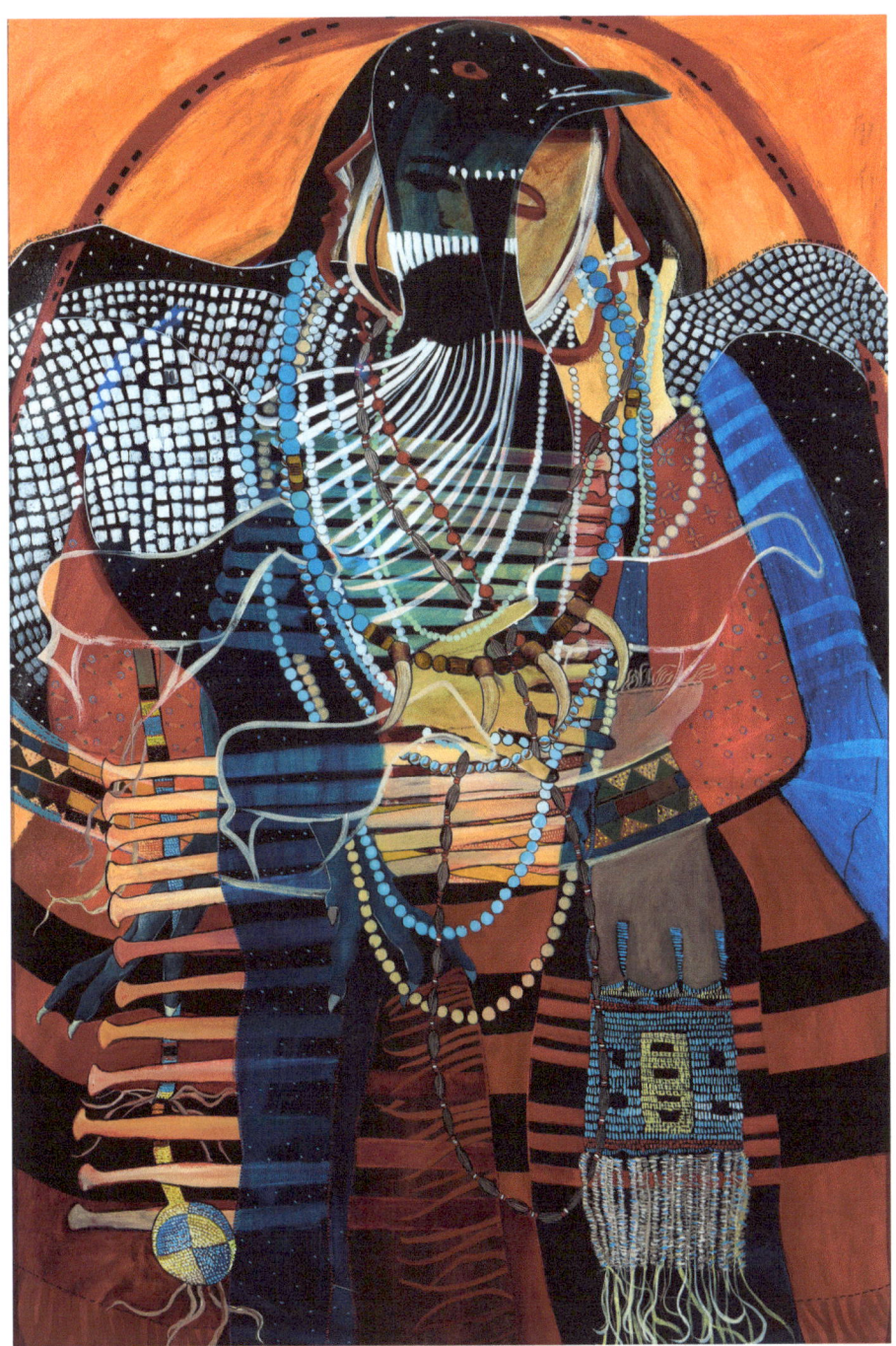

33. *I Hear the Call of the Loon from My Dream Bed*, 1995
121.92 x 81.28 cm
48" x 32"
Mixed media
Collection of Ranchmen's Club, Calgary

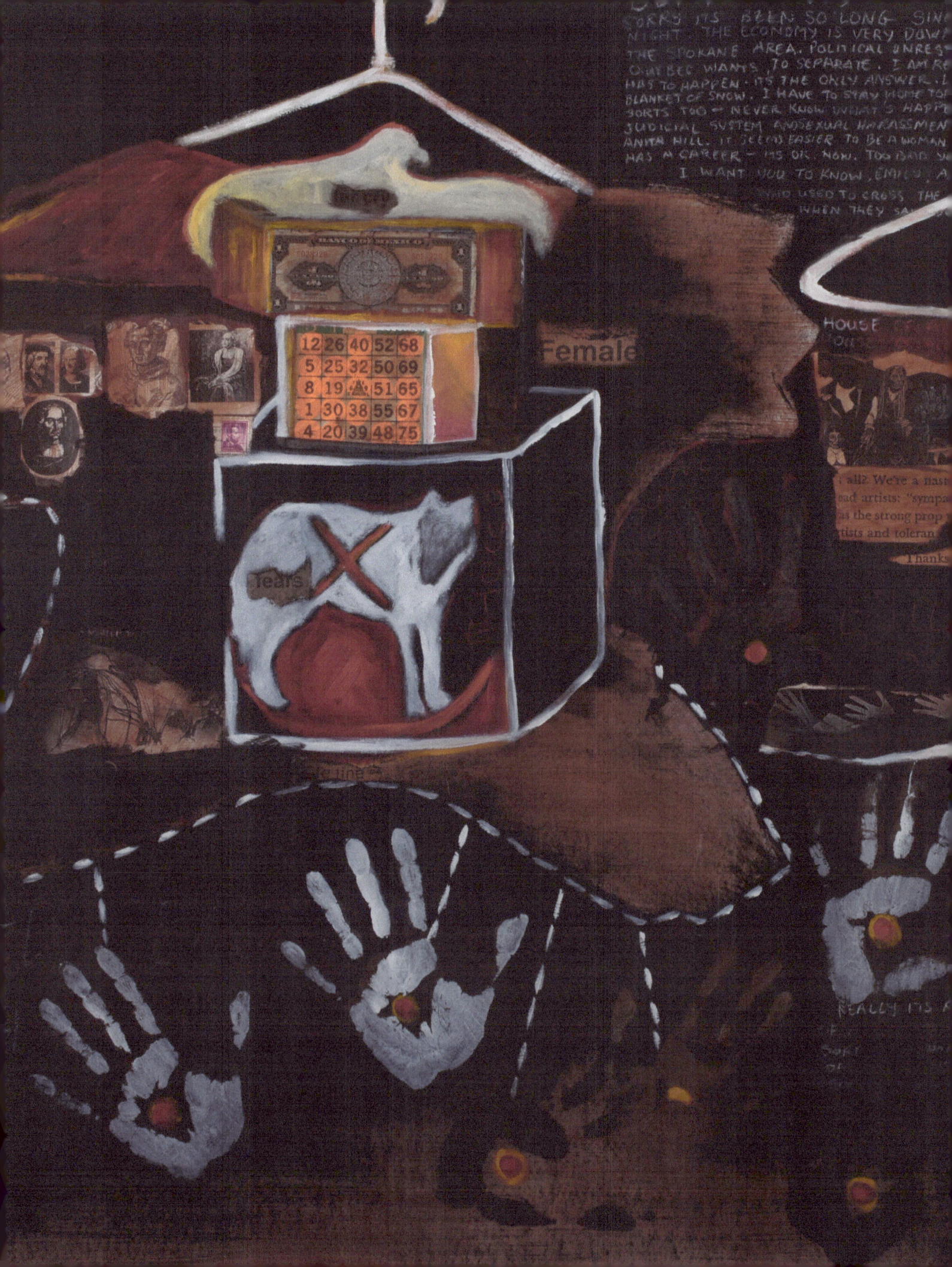

"TERRIBLY BEAUTIFUL":
JOANE CARDINAL-SCHUBERT'S
"INTERVENTION OF PASSION"

BY DAVID GARNEAU

A Native woman sits on a park bench; her infant son wrapped in a blanket and her arms. A white woman approaches, smiles at the scene, and declares: "What a cute baby!" "Cute now," says the mother, "but when he grows up you might not like him so much."

Joane Cardinal-Schubert told me this story. Like her paintings, the narrative combines the beautiful and the terrible. It lingers in the mind as a parable demanding the occupation of an Indigenous point of view. The homey tragedy is infused with Joane's ironic humour and urge to unearth the disturbing realities lurking beneath the seemingly innocent and mundane. I often watched with surprise as she turned a sweet scene or compliment into an acidic teaching: "I like turning over rocks to see what is under them … moving carcasses, turning them over, seeing what they are helping create. I am driven by not understanding how people have all this power. I pour in all those experiences, the good with the bad, and within the composition their energies are transformed into beauty and a new truth. So, you might say my art heals me. I was taught to believe that there is always something good to be found in bad."[1]

34. *Once I Held a Rabbit (Mary)*, 1974
91.4 x 50.8 cm
36" x 20"
Acrylic on canvas
From the Estate of Joane Cardinal-Schubert

This self portrait as Madonna with rabbit invokes notions of fertility and the "rabbit test," a pregnancy test developed in the 1930s and used until the 80s that required the killing of a rabbit.

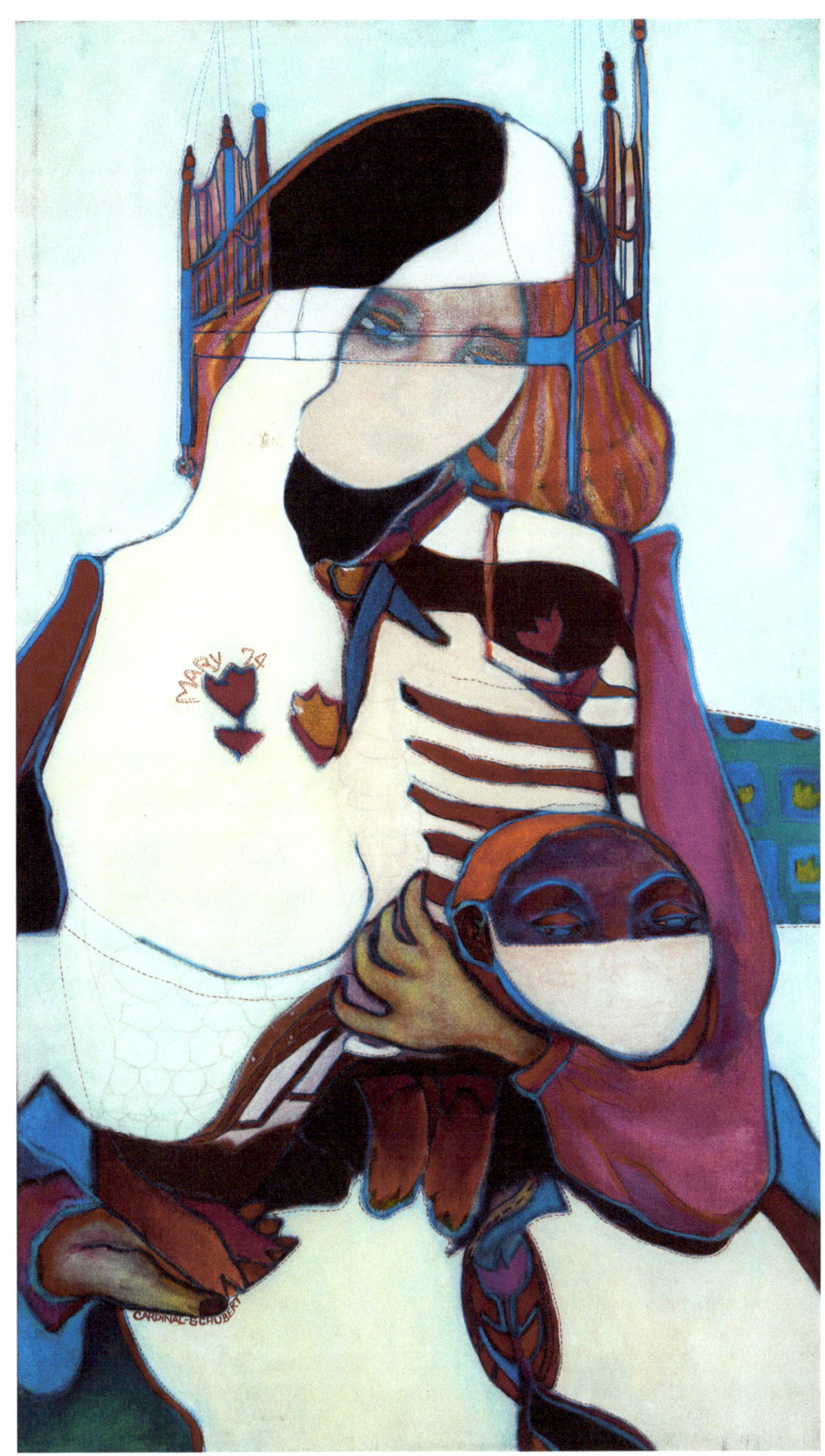

Joane was an empathetic witness driven to creative activism by a sense of justice. She was fuelled by her convictions, energized by art's ability to inform and transform, and centred by cultural knowledge and community. Through this personal remembrance, and a visit with her essay "Flying with Louis,"[2] I hope to convey some of Joane's passion and outline her vision for the future of Indigenous art.

She told me her dark Madonna story thirty years ago as we walked across the University of Calgary campus from my studio – I was a first-year art student – to the Nickle Arts museum, where she was a curator. I don't know how or when we fell into this communion. Our acquaintance consisted of one conversation divided into bundles and strung in a spiral whose beginning and end are indeterminate. I hear her still. Did we meet at the Muttart Art Gallery in 1979 while I was in high school? I think so. Were we friends? She was my casual mentor, then colleague. We showed together,[3] I curated her work,[4] and reviewed her survey exhibition.[5] She helped me cast a video and provided the location.[6] And, a year before she died, Joane collected one of my paintings for the Alberta Foundation for the Arts. We met, say, fifty times over a quarter century,[7] and never had a small talk. We visited each other's homes only once or twice, and didn't break bread outside of a group setting until a few months before her death when I took her to dinner to thank her for her positive role in shaping my life.

Her story was followed by a long pause, which I silently filled with possible meanings while we walked. I knew the tale was autobiographical – she was the mother and Christopher or Justin the son – and enough not to ask questions. Our conversation was a river, mostly rapids, mostly her talking and me ruminating; asking questions only during portages. We were still in the water. "All kids are cute," she finally explained, her expression shifting from smile to pain, "Indian babies especially. But then they grow up and their very existence is a problem for mainstream society." Joane worried about her sons' future: smiled upon while darling, helpless, and mute – but what about when they grew up, and spoke up? Perhaps she was also talking about herself and her art – her unsettling messages in beautiful bundles.

Many considered Joane difficult. The difficulty being she was a strong, intelligent Indigenous woman fallen into a

racist, colonial, patriarchal society. Even on the sunniest days she felt the shadows. She knew where the bodies lay. Joane was the first artist I knew who not only talked about Indian residential schools but made public art about it.[8] Despite her many successes, she did not place herself above anyone. She always considered who was missing from the table, and who would be helped or harmed by this or that decision. She didn't just want to support Indigenous people, she wanted to comprehend, expose, and fix oppressive systems so Indigenous people could support themselves.

Joane challenged privilege, even at the risk of appearing rude. She could be diplomatic, play ball, if that is what it took to make positive and lasting change: "I too have toed the mark – sometimes, if you can believe it."[9] But she could also be counted on to blow the whistle if the playing field was uneven. I once invited her to the University of Regina to be the external examiner for a First Nations MFA candidate. After she had discharged her duties, Joane spent an extra half hour deconstructing the institutionalization of art and schooling the faculty on the difficulties First Nations, Inuit, and Métis students face in the colonial education system. It was a rough ride, and no student or university was better served.

A visionary leader rather than a dreamer, Joane not only saw what needed doing, she did it. She worked tirelessly to achieve her goals: attending meetings, cajoling colleagues, founding societies, writing letters and grants, lobbying politicians and bureaucrats, making the calls and the coffee. Well, not just *her* goals. Joane's mission was not a solo act. She saw it as a collective responsibility that included her: "As Aboriginal people … we have a sense of urgency to fix things," and as artists "we see an even greater urgency to do so."[10] She knew how things should be, and she was as impatient with Indigenous people who were not awake to their history, duty, potential agency, and destiny as she was with non-Indigenous art-world power brokers who refused the obvious fact of Indigenous oppression and their continuing role in the colonial enterprise. What she said of the path-making artists who preceded us is true of her: "they are our heroes. They had the vision; saw the need for an intervention of passion to achieve the benefit of equality. No one can deny this fact."[11]

The voice in Joane's paintings sings. Swoon over her undulant, melodic lines.

35. *In the Garden*, 1986
111.76 x 111.76 cm
44" x 44"
Acrylic on canvas
Fulton Family Collection

"I was certain that I did not like red plaid ... McDonald I think ... I had a little plaid dress with a lace collar ... I passionately hated it ... why ... I believe the reason to be the colour ... but that is curious as I adored red all my life ... so perhaps is was only that my Mother decided when I would wear it and hung its hanger fullness on the bottom of my crib ... a signal to me that that would be the dress of choice next morning ... perhaps it was not the colour at all I hated ... but the scratchy label as the back of the neck ... perhaps it was my long hair worn loose before the age of four that got caught in the buttons ... I never thought about it before ...

But I had had it with that dress ... one too many times feeling powerless as it hung there on the end of my crib outlining how my morning would turn out ... I managed to smuggle a cardboard tube of lipstick to bed with me ... how does a four year old do this ... getting washed, teeth brushed ... into the Dr. Denton's sleepers ... how did I do it ...

I have a memory of a clenched fist ... in any case I awake and fussing around in the dark with my smuggled lipstick ... ooooh it tasted so good too and felt ever so creamy as I drew all over my face with it ... tracing down my nose ... around my eyes ... around my lips ... taking the occasional bite ... all of a sudden the light above my crib was pulled on and my father announced to the dark room behind him ... quick Mom come and take a look at this.

I must have been a vision.

Was it that early possession of power ... of colour, texture, and vessel of pigment that I had passionately schemed to investigate on my own time that began my practice? ... I don't know."

– Joane Cardinal-Schubert, RCA
"Surface Tension" from the artist's personal documents

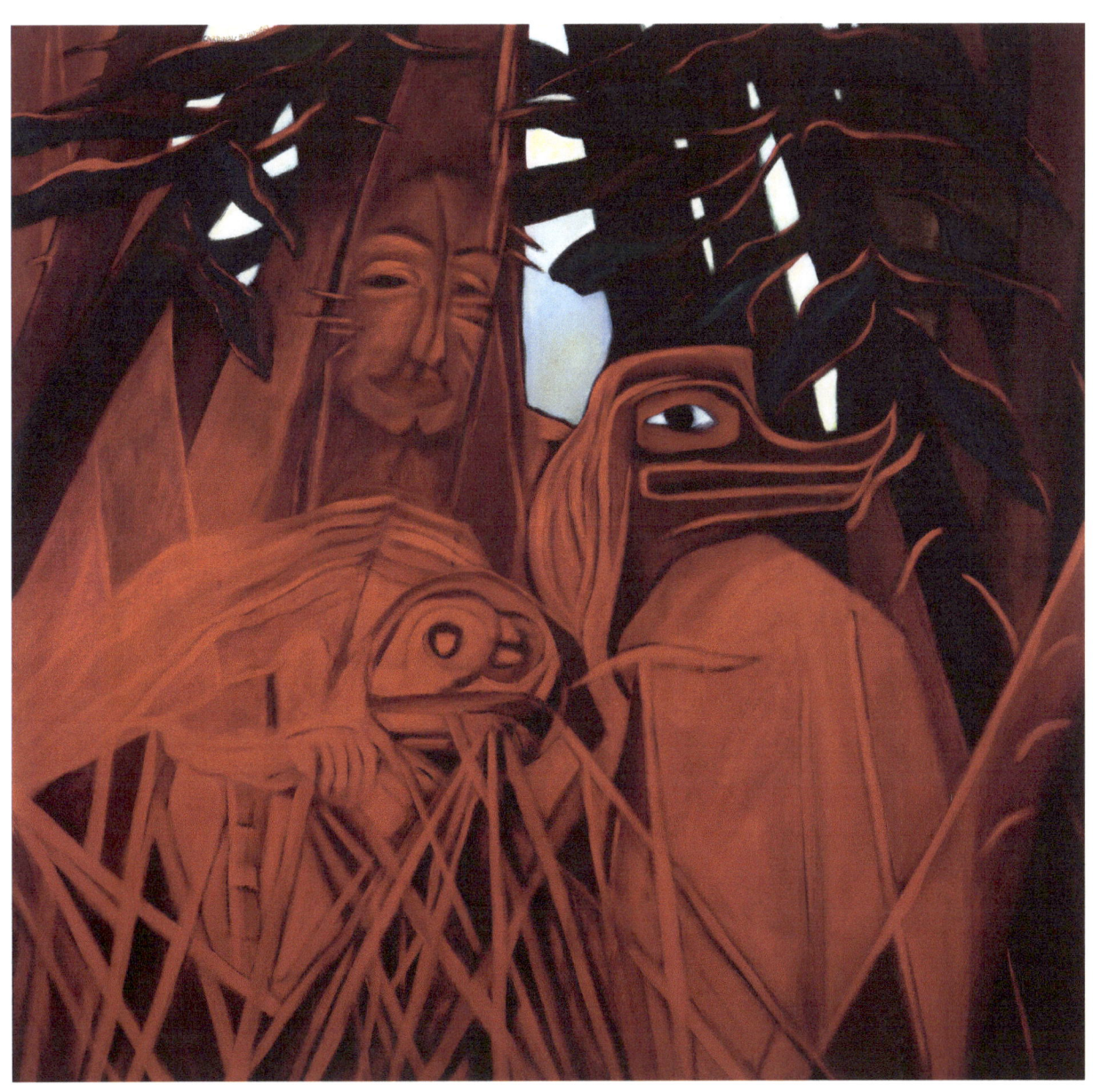

"Terribly Beautiful" 69

Rise with her high notes as they emerge from the dark, moist earth to meet the sun. Luxuriate in her luminous colours – oxidizing blood reds and browns, sulfurous yellows mellowing to ochre, and blues that know every sky and cool mood. Marvel at her research with elders, on the land, and in the museum vaults, and their embodiment in her canvases. The voices in her installations are louder, angrier, instructive, daring. But there is always care, craft, and beauty in these subversive devices: "What I usually try to do is make something terribly beautiful so that if people don't get it on an intellectual or emotional layer, then they'll get it on the personal layer of 'it's nice to look at.' Then, when they finally figure out what it's really about, it gives them a double whammy because they probably feel guilty for thinking it was beautiful in the first place – it's part of the strategy."[12]

Much as I want to swim in her bittersweet paintings, drawings, sculptures, installations, and videos, I am compelled to remember Joane Cardinal-Schubert the writer, the theorist, and the poetic warrior. I feel called to direct your attention there by Joane herself, who asks that we write our own art history in our way: "It is time for a huge wake-up call regarding practice. We have an arts history within a greater history that has not been recorded by ourselves, not been embraced, not been written about by us. When will that begin?"[13] A consideration of her life's work is incomplete without at least a glance at her intellectual legacy.

Joane Cardinal-Schubert was not a prolific writer, but what she did publish had an impact that continues to reverberate. Her exhibition essays not only offer a glimpse at Indigenous curatorial thinking in the recent past, but also reveal insights about issues that hound us still. She insisted, for example, on linking contemporary Indigenous art with customary First Nations creative works, objects that at that time were still deemed craft or ethnological artifacts. She wanted to show that contemporary Indigenous art was part of continuous cultures, and that American modernist artists (Jackson Pollock, Barnett Newman, etc.) owed as much to Native American art as contemporary Indigenous artists learned from those modernists. And her essay "In the Red" (*Fuse* 1989),[14] about the misappropriation of Indigenous culture by settler artists and commercial industries, was incendiary, sparking national debates that continue to flare up.

On the occasion of a survey exhibition of two decades of her work, Joane told a First Nations reporter: "I seem to work in a big circle with smaller circles spinning off of it. I can cross over the circle, too, and redo things, rethink and readdress what I've tried to express before."[15] In the Indigenous worldview, time is non-linear and everything is related. I am a Métis man who grew up in the city, mostly detached from Indigenous life ways. Now that I primarily associate with Indigenous people and strive toward a non-colonized personal state, I increasingly feel the truth and power of this worldview, and Joane's presence and prescience.

I am, at this moment, experiencing time looping and the intimate complexity of our connections. "Flying with Louis" was the keynote talk at the groundbreaking gathering *Making a Noise!: A Forum to Discuss Contemporary Art, Art History, Critical Writing, and Community from Aboriginal Perspectives*, held at the Banff Centre in November 2003. I am writing this text at that same place thirteen years later. Tomorrow I co-lead the latest iteration of the Indigenous Arts Residency, a program made possible, in part, by Joane's lobbying. She and Edward Poitras were its first artists (1988).

Candice Hopkins, my co-facilitator, helped organize *Making a Noise!* and, six years earlier, had been one of my students. Our residency symposium springs from the *Making a Noise!* publication. I have had two Indigenous art-world mentors, Joane and Bob Boyer (1948–2004). Joane's essay is in that book and that book is dedicated to Bob. Our Indigenous art community is like intricate, looping beadwork, "a big circle with smaller circles spinning off of it." I feel it.

"Flying with Louis" begins with a formal welcome to the territory and conference, and previews the journey. The second section is a "soap opera," a fictional gathering of Indigenous artists and others set on the Concorde. The large third part reviews recent advances made by Indigenous artists and curators in the mainstream art world. Well laudable, Cardinal-Schubert laments that as individuals we – including her – have been tricked and seduced by mainstream rewards, and distracted from the goal of collective self-determination. Indigenous artists, she explains, should now attend to our own communities and develop an art history and art theory apart from the Western tradition. The fourth section returns to the Concorde allegory, with Louis Riel as pilot and Pauline Johnson as

co-pilot. The conclusion reinforces Cardinal-Schubert's call for a shift from demanding space within the dominant culture to improving sovereign aesthetic practices and institutions on and with our own terms.

The essay's opening is both unsettling and settling: it unsettles settlers and sites First Nations, Inuit, and Métis (as) readers. Cardinal-Schubert offers a "formal welcome to this part of the country;"[16] matter-of-factly explaining that Banff, the Park, these sacred mountains are Indigenous country and, as a Blackfoot person, she has the responsibility of welcome/declaring territory. This sort of address — one that reminds rather than petitions — often surprises non-Indigenous people who identify as Canadian rather than experience Canada as something pulled over their territory, community, and selves. This welcome/reminder applies not only to settlers, but also to First Peoples from other places — thus disturbing a pan-Indianist imaginary before it can get going. Significantly, the welcome not only includes the conference participants of thirteen years ago, but also the present reader who soon discovers that the book, too, is an Indigenous space — one that they have to re-figure themselves in relation with.

This formal welcome is a non-colonial protocol rather than an anti-colonial strategy. It does not confront colonialism, but does an end-run around it to link one Indigenous person (the author) to another (the reader) in an Indigenous space. This (re)addressing is perhaps even more profoundly felt when you discover that the text assumes that the reader is Native. The "I," "you," "us," and "we" in these pages are all figured as Indigenous. Most texts, even those authored by First Peoples, comport themselves to a "general" reader — read "settler." By Indigenizing the space of reading, Cardinal-Schubert produces an oscillating alienation/empathy response in settler readers, and provides Indigenous minds a singular yet collective Indigenous reading consciousness rather than the "double consciousness" that settler texts usually compose/impose.[17] By addressing readers as "we" and "us," Cardinal-Schubert leads us into community or alliance. The Indigenous "we" can picture our participation in her vision.

The next part, the Concorde section, is over-stuffed with hilarious characterizations of Native artists of the era, insider-jokes and references that only an Indigenous hub personality like Cardinal-Schubert would

fully catch. Like her welcome to the country, it lets readers know that they are visiting the land of an/other – even if the reader is Native, this is a rarefied space. The more respect we give to its keepers, the more we listen, the more understanding we gain, the more members we know, and the more we identify with the cause and companions, the more likely we are to be good guests, allies, or even members.

The conceit of the Concorde allegory is that First Nations, Inuit, and Métis artists "have been placed in an imposed holding pattern, barely visible to others on the global radar, without runways and land bases formerly familiar in our journey through history."[18] Invasion, land theft, broken treaties, forced removal, and aggressive assimilation, especially Indian residential schools, prevented Indigenous people from either following their natural course or achieving "parallel equality" with Western culture in shared territories. So, here we – the "we" of the text's construction, contemporary Indigenous artists raised in the Western tradition – are suspended above our land and traditional ways, seeing but not quite engaging. However, Cardinal-Schubert provides an alter-native reading in which Indigenous pilots, Louis Riel and Pauline Johnson, take the wheel and repurposed the flight. Instead of being in suspense, the group is on a "final historic voyage of destiny"[19] – and will soon be landing, be grounded.

Indigenous artists – in First Class! – sip Saskatoon berry juice, swap professional stories, gossip, and ideas. The raucous scene suggests that despite being "in a holding pattern" and "barely visible to others," an exciting intellectual, political, and creative culture has fermented in this chamber. The back of the plane is filled with "Aboriginal art viewers and patrons" who sleep "the deep sleep of boredom, and disconnectedness." Between the Indigenous artists and their public are "the directors, administrators, curators, historians and critics."[20] Typing and talking on phones, they are awake but not a community, and not attuned to the excitement in front of them.

The image of the awakened Indigenous artists and their sleeping audiences separated from each other by the dominant art world is meant to trigger an association familiar to most Plains people. Answering her own question about why Louis Riel is the pilot, Cardinal-Schubert explains that he was "far-seeing," a visionary reported to have said: "My people will sleep for a hundred

years; when they awake it will be the artists who give them their spirits back."[21]

Next, Cardinal-Schubert details many ways Indigenous artists have fought for mainstream recognition and inclusion: "We have kicked down doors having to assume dual roles of curators and historians lobbying with governments, educational institutions, funding agencies, galleries, and even our relatives, friends and peers."[22] We have secured special funding for Indigenous arts, won curatorial internships at museums, learned Western critical theory and museum conservation. We have been, she writes, "a bunch of really 'good' Indians." However, it is time for a turn, "time for a communal act of faith; a leap into "self-determination."[23]

Her "soap opera" ends with Indigenous audiences waking up. Curious about what's happening in the forward cabin, some push past the blinkered denizens of the dominant art world. They are thrilled by what they see – the vital artists and their work. Two kids go back and rouse their parents exclaiming "I WANT TO BE AN ARTIST." They see figured in the artist an ideal of contemporary, self-determined yet communal Indigeneity: "No one tells them what to do or how to do it!" Approaching the runway, Riel announces "MISSION ACCOMPLISHED."[24] Cardinal-Schubert's mission is that the future of Indigenous art not consist of success within and recognition by the dominant art world, but of reaching and awakening Indigenous people with our art, and of restoring their spirits and their desire for collective self-determination.

In the next section, Cardinal-Schubert describes the recent (1980s) history of Indigenous artists fighting their way into the mainstream – battles in which she often participated – only to achieve, she thinks, Pyrrhic victories because they lead to individual achievements at the expense of community. Though she does not use the term, she cautions that Indigenous art programs assimilate Indigenous people into the mainstream art world. Speaking of the second wave of artists who fought for inclusion in the established art spaces, "I maintain that our efforts have been misunderstood; we have been co-opted."[25] Indigenous contemporary art, she argues, is now consumed and celebrated by non-Indigenous audiences in Canada and overseas but has little presence or impact on local First Nations, Inuit, and Métis communities. If we continue to pour most of our energies into global exhibitions and group shows curated

by non-Indigenous people for non-Native audiences, all of which are "too far away" from local communities, it contributes "to a further identity crisis"... and "we will not be able to advance an Aboriginal art theory."

Cardinal-Schubert explains that our new role is "to give back the spirit, to wake everybody up." Culture and its people are not lost, just asleep. Awakening requires that we refresh ourselves by looking not to Western art history and institutions, but to "our own art theory," creating "our own language of art: 'Aboriginal Art Speak'"[26]; recover what we can of our aesthetics, modes of making, and display from the time before we were asleep, before contact. The purpose of this work is to make aesthetic things and sites that are relevant and revelatory for Indigenous audiences. She says: "Let us not be too eager to fit into Western European art paradigms, to continue to see our work acceptable only on those imposed terms ... We must continue our process, begun from inside our own cultural contexts, to further examine our art forms in relation to the existing repositories of this cultural knowledge and acknowledge it as contemporary continuum of the people we come from – the people we still are."[27] This means linking contemporary Indigenous art with the art of past generations, but also blurring the lines between customary work and Western-style modern and contemporary art.

She also maintains that by turning from the lure of art stardom, our humility might make us receptive to the intelligence woven into customary and seemingly naïve work. "Sometimes one of these relatives teach us by the work ... and we find ourselves humbled within our acquired wisdom."[28] Cardinal-Schubert does not fall into the trap of seeing customary work as the only site of cultural authenticity. Colonialism seeps into traditional culture, if only in its commercial incentive program that encourages folks to regurgitate past art forms without engaging the practice as a living form of existential inquiry. She is as demanding of local artists as she is of international ones: "In this country, some young Aboriginal artists are working with absolutely no knowledge of (their) art history or how that art history provides a place for them that they presently enjoy."[29] "We need time to internalize, to rethink, to digest our own material, to write, to publish, and to celebrate and share knowledge within our own communities – first."[30]

Throughout "Flying with Louis," Joane Cardinal-Schubert describes the need for

autonomous Indigenous art history, theory, and exhibition spaces. Exhausted by perpetual lobbying for temporary spaces to exhibit Indigenous art within mainstream artist-run centres and public art galleries, in 2001 she founded a small gallery within the already Indigenous space of the Calgary Aboriginal Arts Awareness Society's office, where she was a volunteer. She christened it the F'N Gallery(!) – which eventually featured a café, literary society, and theatre group. "It is not unreasonable to think that shortly Aboriginal public galleries and museums and universities will be the new normal, staffed by Aboriginal people."[31] Even at the time of her writing, sovereign Indigenous aesthetic spaces existed. On the plains, F'N Gallery was preceded by Indigenous artist collectives and centres: Sâkêwêwak Artists' Collective (Regina), Tribe (Saskatoon), and Urban Shaman (Winnipeg). And the First Nations University of Canada (Regina, Saskatoon, and Prince Albert) has been a reality since 1976.

Thus the sort of rebirth Cardinal-Schubert envisioned was already underway. She noted that there were very few Indigenous studio professors in Canada in 2003. That number has grown to more than a dozen. There are perhaps six First Nations, Inuit, and Métis tenure-track art historians, and many Canadian universities and colleges are making concerted, public efforts at Indigenization. The art, exhibition, and scholarship that they are producing and facilitating are just beginning to swell. The renaissance was underway but she was calling for a deepened criticality and history building, apart from colonial formation and institutions. That struggle continues.

Always critical, Joane's Concorde passengers are cacophonous rather than melodic. In her conclusion, she argues that it is no longer enough to make a noise. Our new sounds must be our own and "more than an annoying noise."[32] As always, hers is a call that our interventions of passion be beautiful.

Several months before Joane died, upon the invitation of curator Gerald Conaty (1953–2013), I was surveying the Glenbow Museum's rich cache of Métis material culture when I had a rush of feeling. Twenty-five or so years earlier, I saw Joane after she had spent time with the Blood First Nation war shirts at the Museum of Civilization. She was, characteristically, both profoundly moved and outraged – moved at the power and beauty of the shirts, outraged that they were not in the hands of

their rightful keepers. She was particularly disturbed that these sacred things were in plastic bags on a shelf. Her encounters with the shirts inspired numerous paintings and an installation, *Preservation of the Species* (1988), that commented on the difference between Indigenous use and Western fetish for the object and conservation (of things belonging to seemingly extinguished peoples). The rush of memory and affect rhymed with my experience with the Métis clothes. I was impelled to call Joane up. I felt the need to share my experience, our parallel quests, but more importantly to let her know how much I valued her work, advice, and friendship. We had a beautiful meal. She was sore from house renovations, happy for the break. We resumed our endless conversation.

Joane's sons are now grown men, and the many artists she mentored and blazed trails for have also come of age. We are fulfilling her vision while pursuing our own. Thinking back on her park bench story, I feel that while Joane was anxious about how the world might treat her mature children, perhaps she anticipated reasons for this beyond their Indigeneity. She may have been concerned that they would inherit her outspokenness and sense of justice – qualities that do not make for an easy life.

The Indigenous "renaissance"[33] that began in the late 1960s continues. Like the Italian Renaissance, ours will not only revive sleeping cultures, it will respond to new conditions and relations. And, in Joane Cardinal-Schubert's words, the sounds we make "will truly be our noise, not a bad imitation"[34] of either our traditional cultures or adjacent ones. Joane's paintings embody her vision. Through this legacy we can see the complexity of her thought and the depth of her heart.

NOTES

1. Jennifer Macleod, "Joane Cardinal-Schubert: At the Centre of Her Circle," *Galleries West* Spring (2003): 10–11.

2. Joane Cardinal-Schubert, "Flying with Louis," in *Making a Noise! Aboriginal Perspectives on Art, Art History, Critical Writing, and Community* (Banff: Walter Phillips Gallery, 2003), 26–49.

3. *Alberta Biennial*. Curators: Catherine Crowston and Cathy Mastin. Glenbow Museum, Calgary, AB, 1999; Edmonton Art Gallery, AB, 1998.

4. *The End of the World (As We Know It)*. Calgary ArtWeek '99. Barron Building, Calgary, AB. 1999.

5. David Garneau, "Eyestreaming." *BorderCrossings* 17, no. 1 (Feb. 1998): 53–7.

6. *Black Pepper* (1999, 4 min.) was shot on the exterior wall of the CAAAS (Calgary Aboriginal Awareness Society), where Joane's studio also was.

7. We were closest from the mid-80s through the 90s, before I moved to Regina in 1999.

8. *The Lesson* (1989). See: http://www.glenbow.org/collections/stories/joane-cardinal-schubert/index.cfm Also: http://vandocument.com/2013/09/the-lesson-witnesses-art-and-canadas-indian-residential-schools/ Accessed Jan. 18, 2016.

9. Joane Cardinal-Schubert, "Flying with Louis," *Making a Noise*, 28.

10. Ibid., 47.

11. Ibid., 28.

12. Jackie Bissley, "Joane Cardinal-Schubert: An Artist Setting Traps," *Windspeaker* 17, no. 2 (1999), http://www.ammsa.com/node/22163. Accessed Jan. 15, 2016.

13. "Flying." 47.

14. Republished: Joane Cardinal-Schubert, "In the Red," in *Borrowed Power: Essays on Cultural Appropriation*, eds. Bruce Ziff and Pratima V. Rao (New Brunswick, NJ: Rutgers University Press, 1997), 122–33.

15. Gerald McMaster, *Two Decades*, Muttart Gallery, 1997.

16. "Flying." 27.

17. See, for example: Dickson D. Bruce Jr., "W.E.B. Du Bois and the Idea of Double Consciousness," *American Literature* 64, no. 2 (June, 1992): 299–309.

18. Ibid., 27.

19. Ibid., 29.

20. Ibid.

21. Ibid., 28

22. Ibid., 27.

23. Ibid.

24. Ibid., 32.

25. Ibid., 42.

26. Ibid., 34.

27. Ibid.

28. Ibid.

29. Ibid., 41.

30. Ibid., 44.

31. Ibid., 40.

32. Ibid., 47.

33. Ibid., 41.

34. Ibid., 48.

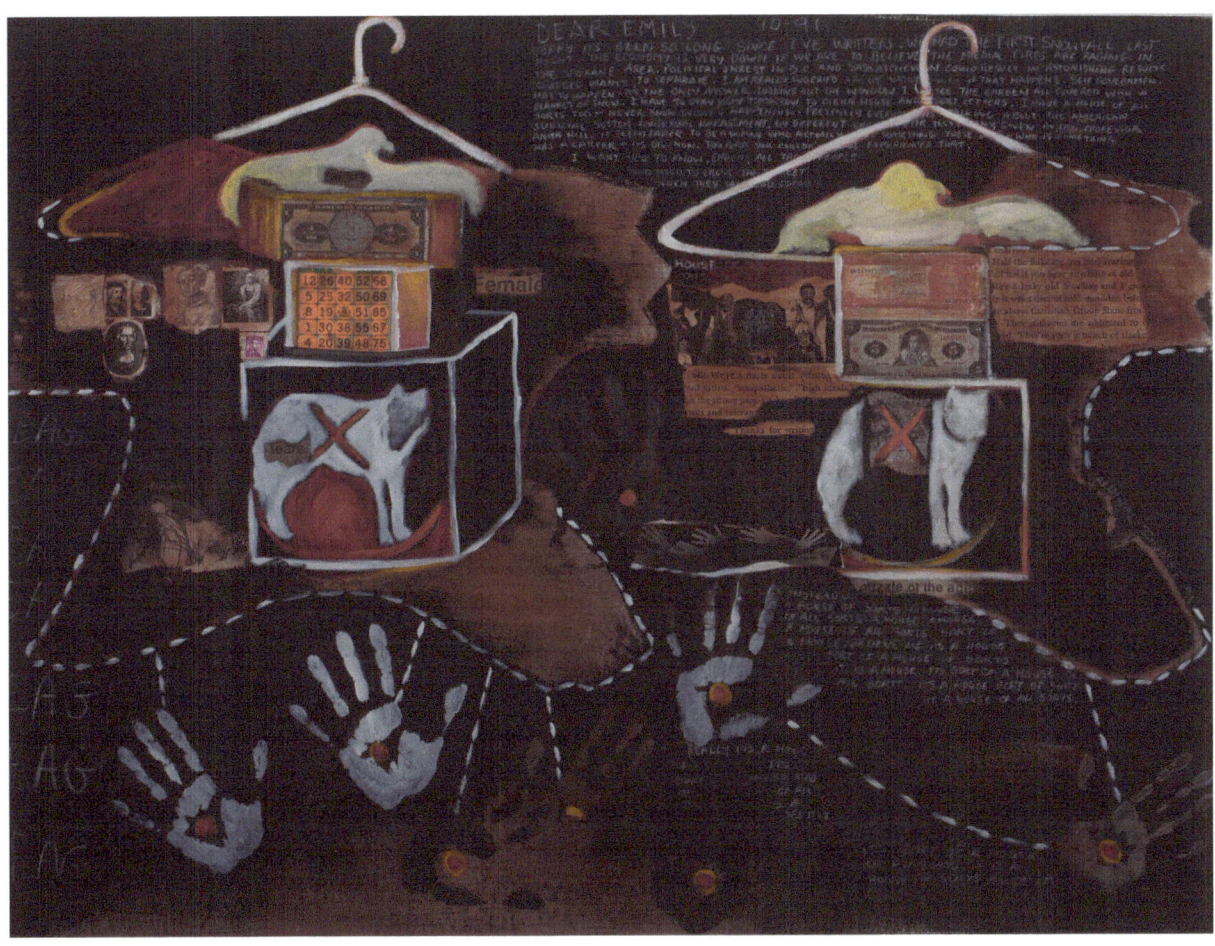

36. *Birch Bark Letters to Emily Carr: House of All Sorts*, 1991
101.6 x 127 cm
40" x 50"
Acrylic and collage on paper
Collection of the Kamloops Art Gallery

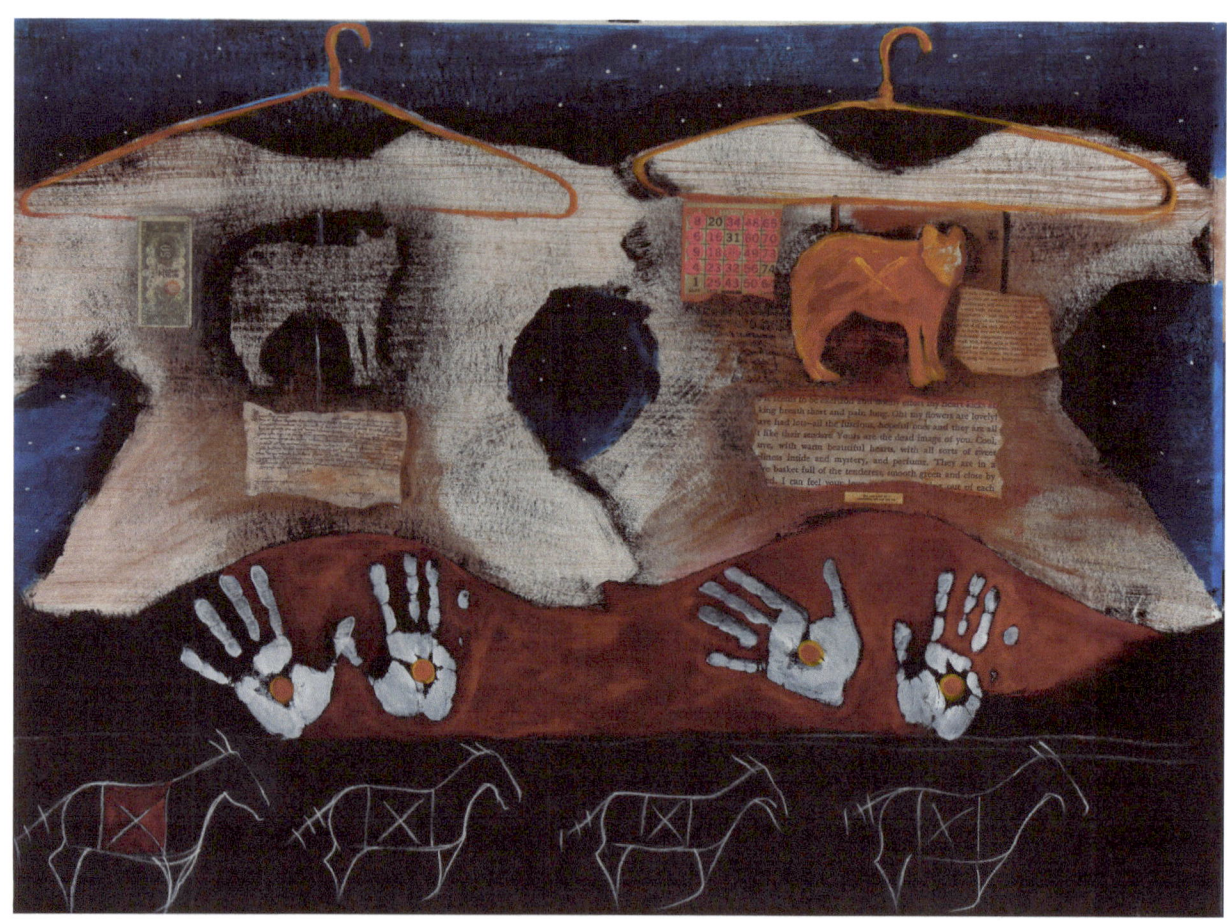

37. *Letters to Emily, Borrowed Power*, 1992
91.44 x 243.84 cm
36" x 96"
Collage on rag paper
Collection of the Alberta Foundation for the Arts

This work addresses cultural appropriation and, like many of Cardinal-Schubert's works, is a conversation between the artist and her imagined pen pal, confidant, and friend Emily Carr.

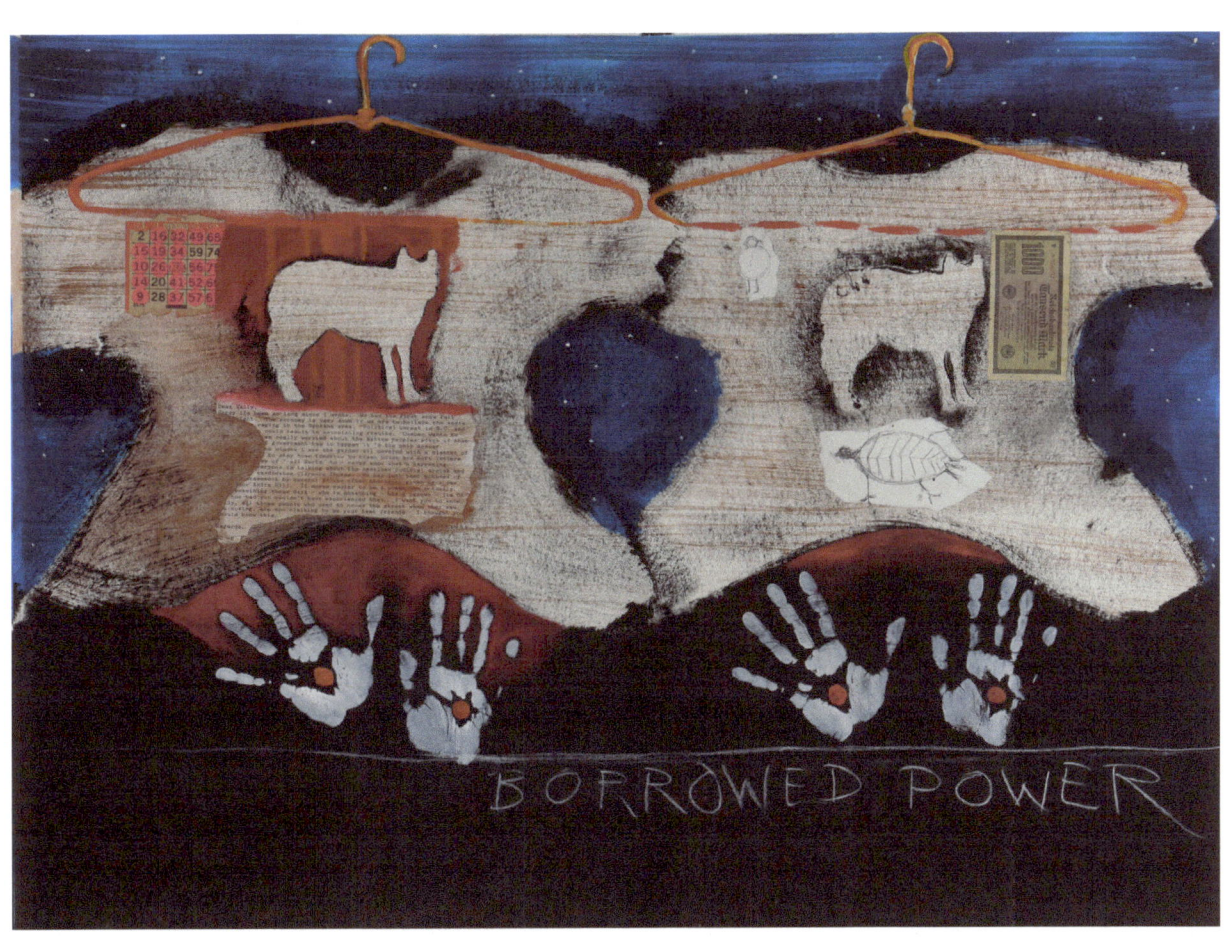

"Terribly Beautiful" 81

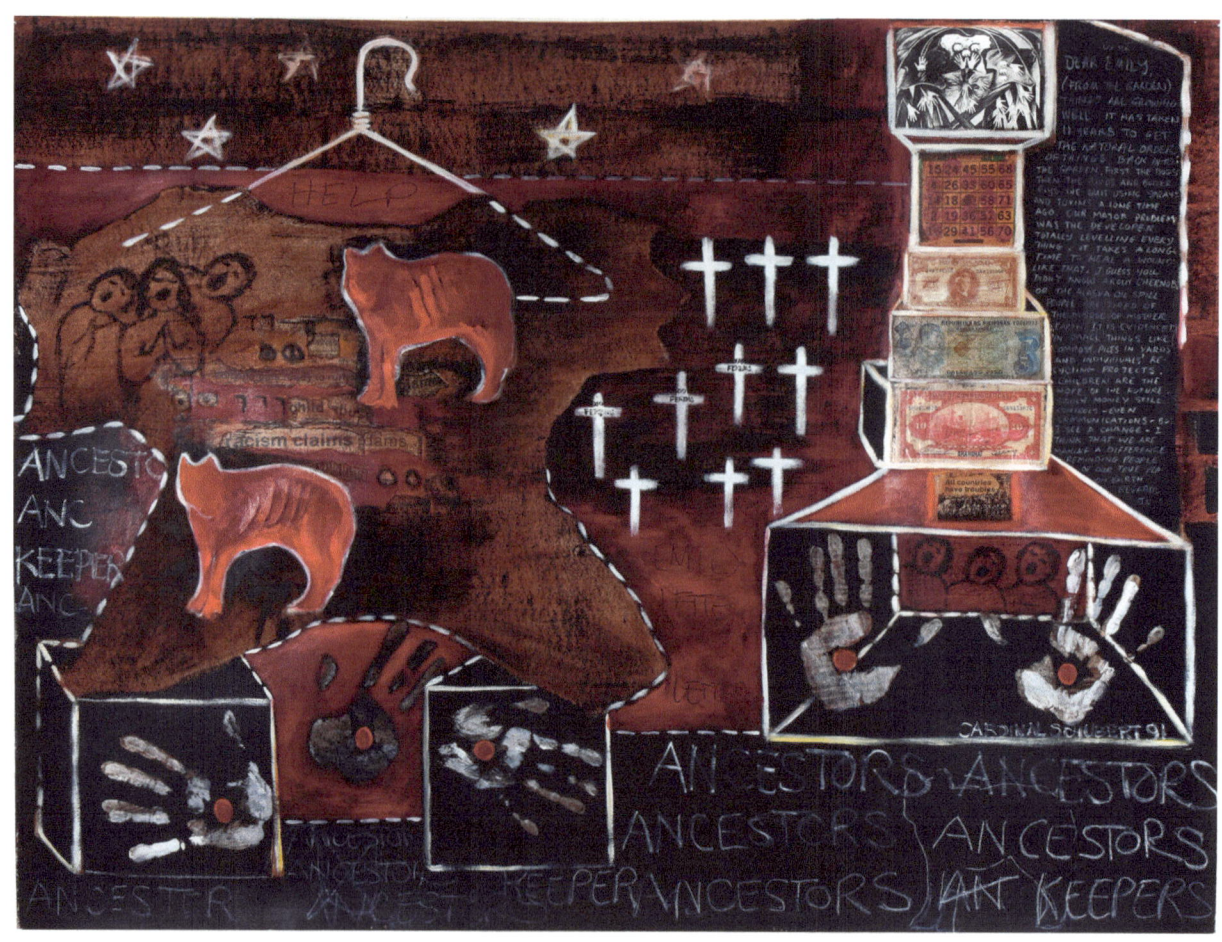

38. *Ancestors (Keepers)*, 1992
91.44 x 122 cm
36" x 48"
Collage on rag paper
Collection of the Alberta Foundation for the Arts

82 BY DAVID GARNEAU

39. *Ancient Voices beneath the Ground, Stonehenge*, 1983
81.3 x 121.8 cm
32" x 48"
Oil and graphite on rag paper
Collection of the Thunder Bay Art Gallery, Thunder Bay Art Gallery Art Plus Acquisition, 1985

On a trip to Stonehenge the artist was confronted with the celebration of and reverence for historical knowledge held there – even if that knowledge is not fully understood. This highlighted, for the artist, Canada's inability or unwillingness to embrace and celebrate that country's own wisdom held both by contemporary Indigenous people and found at sacred sites like Writing-on-Stone.

40. *Ancient Chant beneath the Ground*, 1982
61 x 81.4 cm
24" x 32"
Oil pastel, conté, and pastel on paper
Collection of the Alberta Foundation for the Arts

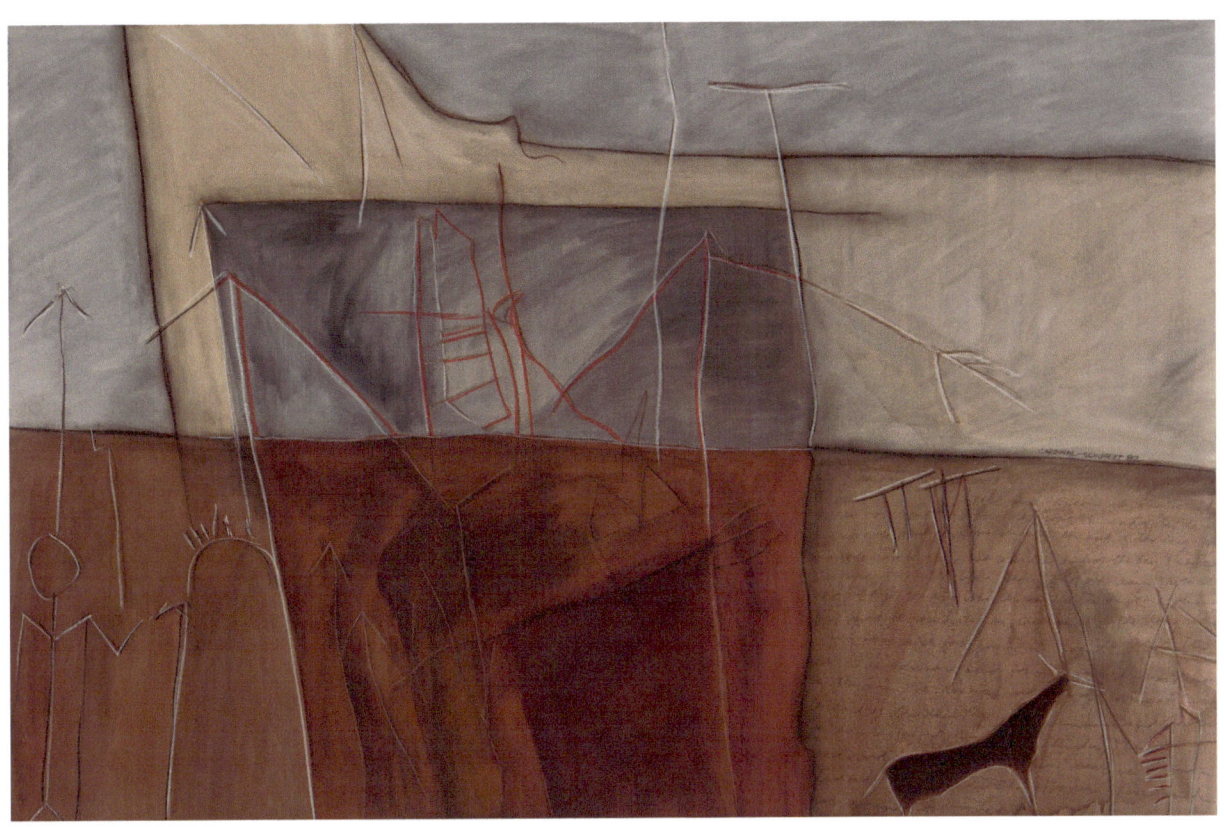

41. *The Sun Rose But for Some It Was the End*, 1982
81 x 121 cm
32" x 48"
Oil and pencil on rap paper
Collection of the Thunder Bay Art Gallery, gift of the Government of Alberta, 1983

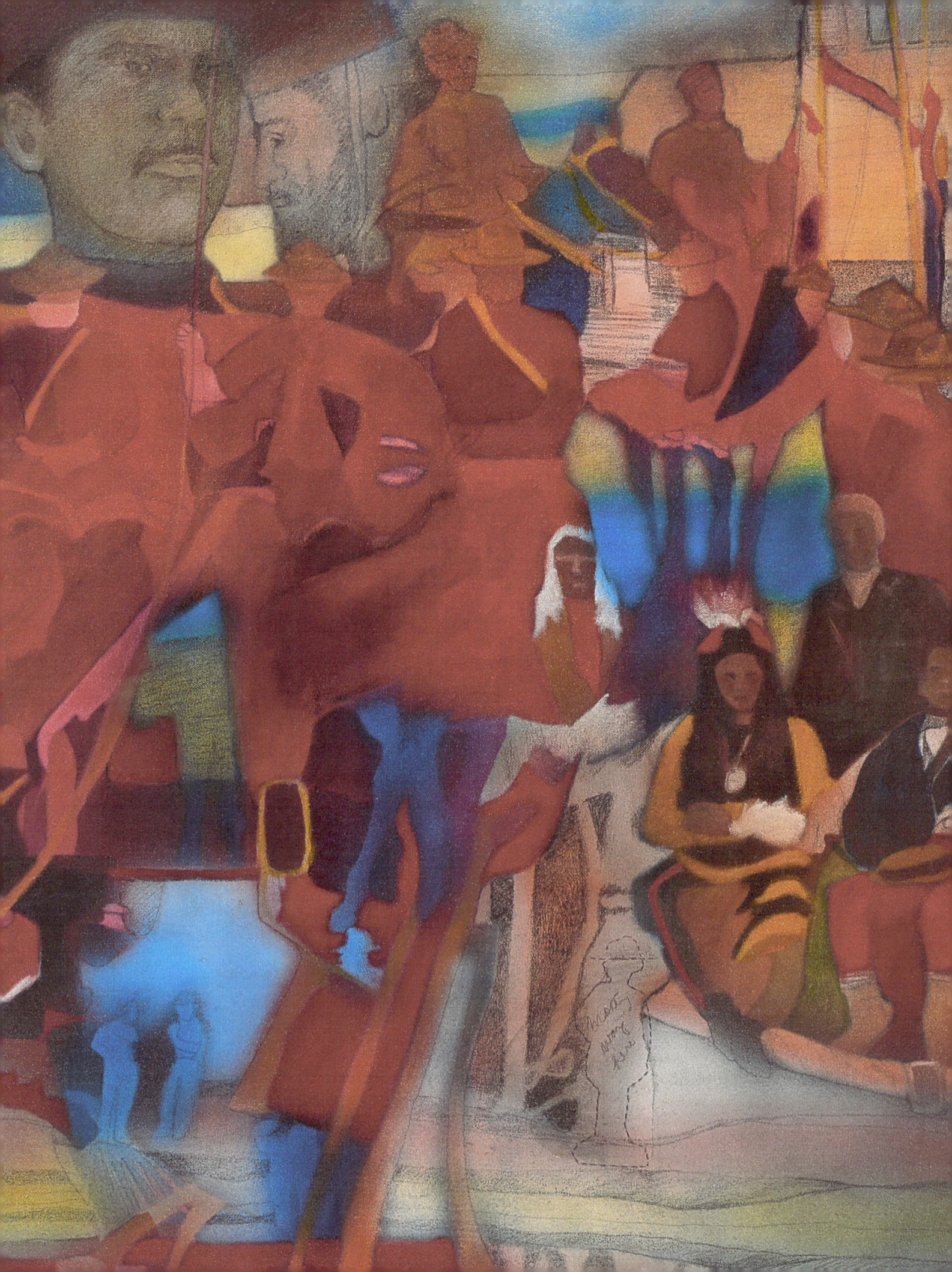

STILL SEEING RED

BY ALISDAIR MACRAE

"When did the artifact become art, and the art become artifact?"

– LOUISE PROFEIT-LEBLANC,
DOG RIB SYMPOSIUM, 2007

In the fall of 2007, the Dog Rib Symposium at Carleton University brought together renowned figures in the Indigenous art world. During one of the panels, Gerald McMaster spoke of his experiences curating moccasins at the Smithsonian Institute in Washington, DC. In a similar vein, Louise Profeit-Leblanc discussed the opposing forces between preserving material culture through a Western method of collecting, cataloguing, and occasional exhibitions, and leaving it accessible to be touched, held, and used.

Joane Cardinal-Schubert shared similar concerns almost twenty years earlier when speaking with Michael Bell during an interview for *Seeing Red*, an exhibition held in the spring of 1990 at the Agnes Etherington Art Centre. She noted her appreciation of the flexibility granted to the artists while mounting their work within the space, and how that compared to installing exhibitions at other galleries. However, she expressed a general discomfort with the preciousness bestowed on objects once they were installed in any

given exhibition space. Cardinal-Schubert described the act of removing objects from their regular use as very gross, and a miserly task.[1] She alluded to how Native culture tends to get used or imposed upon in such a context, and how it is typical of museums to not return anything.[2]

One of the more widely known criticisms of Western culture's treatment of Indigenous people is how it tries to keep Indigeneity "locked in the past." This damaging notion has been widely circulated by portrayals in museums, but also through cultural appropriations and popular mediums such as movies, television, and art. Stereotypes of stoic, shirtless warriors and Indian princesses are not only inaccurate, but also disavow an existence in the present – as though Native people were extinct. That fantasy, sadly, has real parallels in Canada for many who were denied their culture, opportunity to vote, recognition for military service, or identity due to their gender or ancestry.[3] Such hegemonic cultural practices were first established through assimilation under the residential school system in the late nineteenth century.

Although recognized widely for her accomplishments in the arts, Cardinal-Schubert's conflict with the colonial preservation of Indigenous culture involves much larger issues than gallery and museum collection and exhibition practices. Her struggle was central to who she was as a person, not just as an artist. Throughout her life, she fought for the recognition of Indigenous people as contemporary beings. Whether working as an artist, curator, writer, advocate, or mother with a family, Cardinal-Schubert's art, politics, activism, and personal life offer testimony to those efforts.

As a young person, Cardinal-Schubert did not directly set out to become an artist. She had also trained as a nurse and worked as a curator before turning to art full-time. The artistic opportunity to incorporate a wide variety of mediums while addressing her many interests certainly had its appeal, while her sensibilities could range from playful or humorous, to contemplative, or caustic. But it was with her art that she fought for the recognition of Indigenous people as contemporary beings: by working against colonial cultural distinctions, through her approach to art making, and with her choice of subjects.

In Loretta Todd's film *Hands of History*, Doreen Jensen relates how Native people had no word for art, as their lives were "replete with it."[4] She goes on to describe

how work by Indigenous women artists was dismissed, under imposed colonial notions of anthropological artifact, as women's work or craft.[5] Similarly, colonialism introduced the sense of traditional Native art and culture in opposition to what is seen as contemporary, with the former carrying a greater sense of authenticity. Cardinal-Schubert struggled against these classifications through her creative endeavours.

As with her artist peers also working in the 1980s, including James Luna, Edward Poitras, and Gerald McMaster, Cardinal-Schubert criticized the classification and display systems of Western museums, particularly their associations with anthropology. She deployed these systems against themselves through the subversive use of didactic text, labels, and exhibition methods. Drawing on her experience as a curator, she deliberately used non-precious materials, not only to contravene the expectations of viewers, but also to stymie conservators.[6]

During the late 1970s and early 1980s, when Cardinal-Schubert's artistic career began in earnest, the cultural voice of Indigenous people within mainstream North America was not well established. In spite of the supposed plurality introduced by postmodern art during that same time, it is naïve to think that merely associating Native culture with anthropology or craft misleads Western audiences. As with many woman artists, a lack of accessibility to contemporary art networks meant that Western audiences simply would not understand contemporary Aboriginal art, or be exposed to it.

Cardinal-Schubert rallied against the classifications of art and craft through her atypical use of mediums and materials. Similar to artists such as Jane Ash Poitras and Jim Logan, Cardinal-Schubert dismissed Western conventions of representation and fine art. As with Ron Noganosh, she blended what was seen as traditional Indigenous art with contemporary methods of art making, and intentionally incorporated craft and kitsch materials to confound, shock, and delight her viewers. Cardinal-Schubert could render subjects in a realistic, Western manner of representation. However, her avoidance of illusionistic methods of portrayal left room for jarring and expressive statements about her own circumstances as a contemporary Aboriginal person. By distorting scale, using strong, saturated colours, or incorporating stencils, the artist could communicate aspects of her experience more directly.

As a child, Cardinal-Schubert's family offered a supportive environment in which she could express herself. However, her experience with art school was less accommodating. She admitted she knew nothing about making art when she enrolled at the Alberta College of Art and Design, yet completed her studies at the University of Alberta and the University of Calgary in spite of starting at a later age than most students, and having a family to care for. As many would see, the artist had a particular approach to art, and used it to fight for the recognition of Indigenous people as contemporary beings.

Cardinal-Schubert seemed aware of a sense of responsibility she had as an artist. As she put it, she was not going to "take this lightly," and aspired to do more than make "pretty pictures."[7] The artist was humbly aware of those that had come before her, comparing the process of making a curvilinear line through printmaking to making one carved in stone. She recognized issues that she wanted to address through her art. Hence, her work includes references to residential schools, mental and physical health, substance abuse, environmental degradation, education, power, and racism. Her choice of subject matter may seem difficult or challenging to some audiences. Calling herself a non-elitist in an elitist profession, she made the most of her seemingly contradictory position.[8]

The artist always sought, with her work, to communicate or establish a dialogue,[9] and did not shrink away from communicating as directly as possible with her audience. She believed that those writing about art did not pay enough attention to the artist's process, and was incensed that some people did not think artists should speak about their work.[10] Accordingly, the artist produced her own text panel for the installation piece, *Art Tribe*,[11] eliminating any chance for misinterpretation. Through her understanding of colonialism, and the power that words could have over groups of people, it is no surprise that she became adept in their use. She also wrote essays (including those for artist catalogues), poems, and was an avid public speaker.

Although she worked as a curator both independently and at various institutions, Cardinal-Schubert grappled with the practice of conserving art objects. As mentioned previously, she enjoyed challenging those who curated her work into exhibitions, deliberately making some of her sculptural installations from non-precious

and ephemeral materials. At the same time, she used very permanent materials to create protective forms, such as a plaster warshirt, and plaster medicine bundles. The ultimate goal did not lie in creating a polished object that could be preserved in museum or gallery storage. Some of her first works were of a very large scale, simply because of her own creative ambitious, and not because she was receiving any sort of commissions.[12] For Cardinal-Schubert, the act of making an image or object was paramount, with everything else that followed being secondary.

Cardinal-Schubert approached art not only as a means of communication and self-expression, but also as a means to freedom. Although she had access to other career options she enjoyed the creative process, as it enabled her to cross boundaries.[13] And as she explained to young children, art allows us to imagine ourselves in many different roles that might not otherwise be immediately available – such as becoming an astronaut.[14] Her approach to work was neither linear nor straightforward. She appreciated the opportunity to work in a continuum, with other continuums emerging outwards from the initial activity.[15] In that way, she was always busy, whether it was with a painting, installation, drawing, poem, or sculpture.

Recognizing the challenges facing Indigenous people and women, Cardinal-Schubert learned early in her career to be very strategic as an artist. Either because she was a woman, or Indigenous, or both, the artist's work was often seen as political. She disliked that label, seeing it as dismissive, and responded by saying she was doing what any other artists were doing, merely responding to what was happening in their lives.[16] It so happened that because of the person that Cardinal-Schubert was, she cared deeply about those affected by racism, colonialism, or those who were otherwise marginalized. Inevitably, her engagement with these issues surfaced in her work as a reflection of her reality, and the realities of others. But she did not want the impact of her artwork to be relegated to mere political statements.

The content of Cardinal-Schubert's art can be hard to confront at times. The audience may be unsettled, particularly by her black painted sculptures and installations that enter into the physical space of the viewer. Through such works, and the audience's engagement with the art, Cardinal-Schubert sought to change how people

thought – no matter how challenging that might be for either party. Nonetheless, her creations can just as often be visually appealing as they are ominous, and continue to be sought out through commercial galleries. In either case, the goal seems to be the same, as she considered the work she sold to private collections a means to sneak into people's homes, and take over their minds.[17] Through her art Cardinal-Schubert covered a broad range of subjects, all of which sought recognition for Native people as contemporary beings.

Starting in the early 1980s, Cardinal-Schubert developed an interest in warshirts. A distinctive aspect of Plains Native culture, these objects typically recount histories through illustration and adornment on buffalo hides. Often a person's entire history, and hence their identity, could be recognized from a single warshirt. Cardinal-Schubert's interest in warshirts was also traumatic at times, for example when she viewed them within the collection of the Canadian Museum of History, which was then the Canadian Museum of Civilization. The objects were isolated from their original context, severing the historical lineage that they carried. She found their packaging within plastic and handling by staff very disrespectful as well.[18] Her work with the warshirts illustrates her effort to make the past part of the present.

Cardinal-Schubert made her own contemporary warshirts to protest the collection, storage, and treatment of these objects by museums. She used readily available materials, not only to disavow their archival quality, but also to underscore the fact that these objects were owned by people who had made them for their very own particular use. She incorporated personal mementos, such as a pair of scissors from her grandmother, attempting to have viewers understand what it would mean to have deeply personal items removed from their own lives and kept elsewhere, in a museum collection. Cardinal-Schubert also flaunted the conflation of tradition and modern life, with creations such as *Urban Warshirt – Metro Techno* (fig. 42), which blends analogue and digital technologies. *Self Portrait, Warshirt: The Americas Canopy* features a pink lacrosse mask and tambourine situated beyond the picture frame. Many of her warshirts were portrayed hanging on coat hangers, once again underscoring their contemporary nature, and the fact that these items belonged to someone, and were actively used.

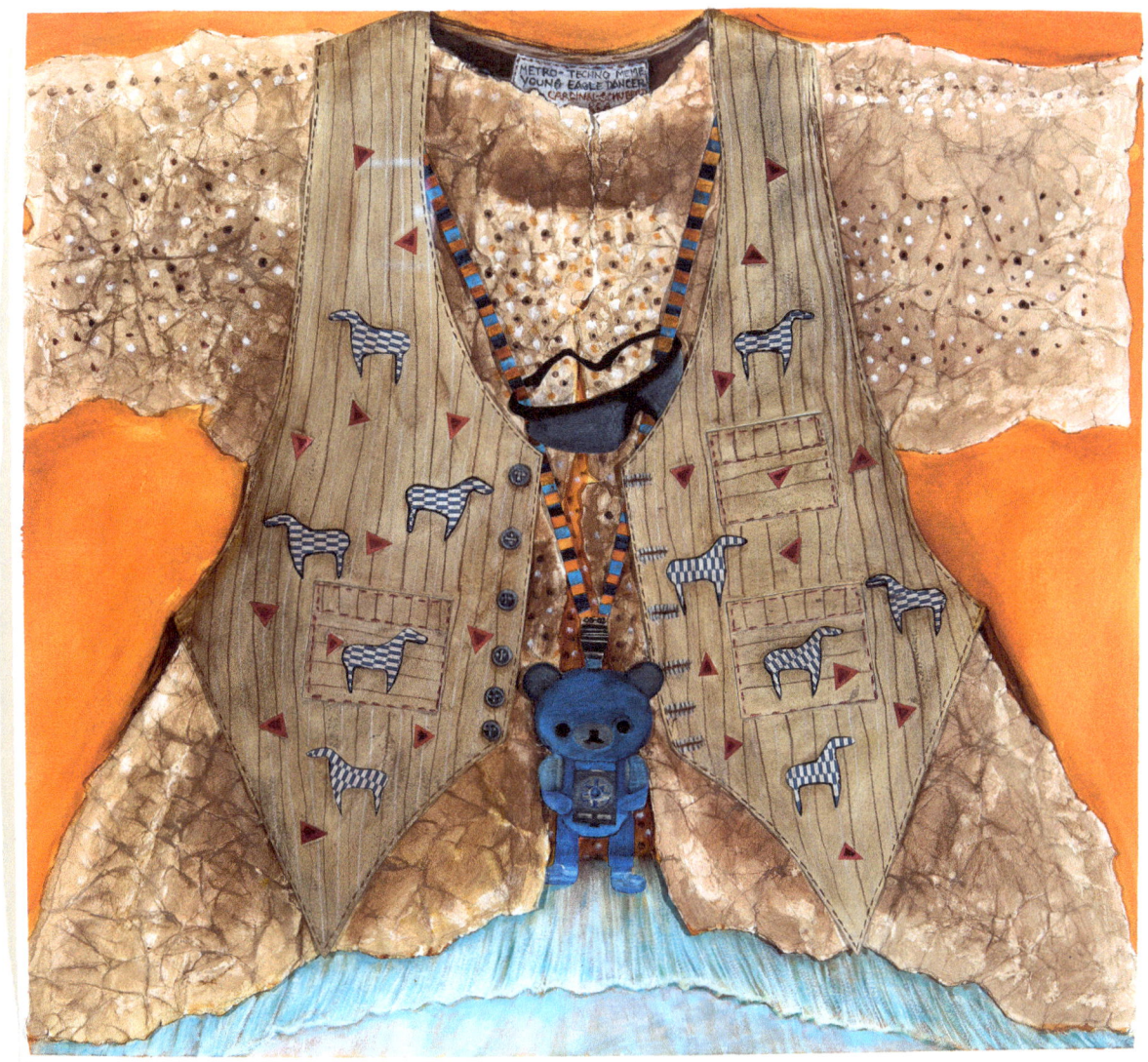

42. *Urban Warshirt, Metro – Techno*, 2007
83.82 x 78.74 cm
33" x 31"
Mixed media collage on paper
From the Estate of Joane Cardinal-Schubert

Cardinal-Schubert created several "modern" warshirts. Many are humorous but also reflect the protective covering everyone must don to face their everyday life. Warshirts, in Cardinal-Schubert's culture, are signifiers of prestige and power worn traditionally only by men. Many of Cardinal-Schubert's works are warshirts she creates and bestows upon herself.

Still Seeing Red 93

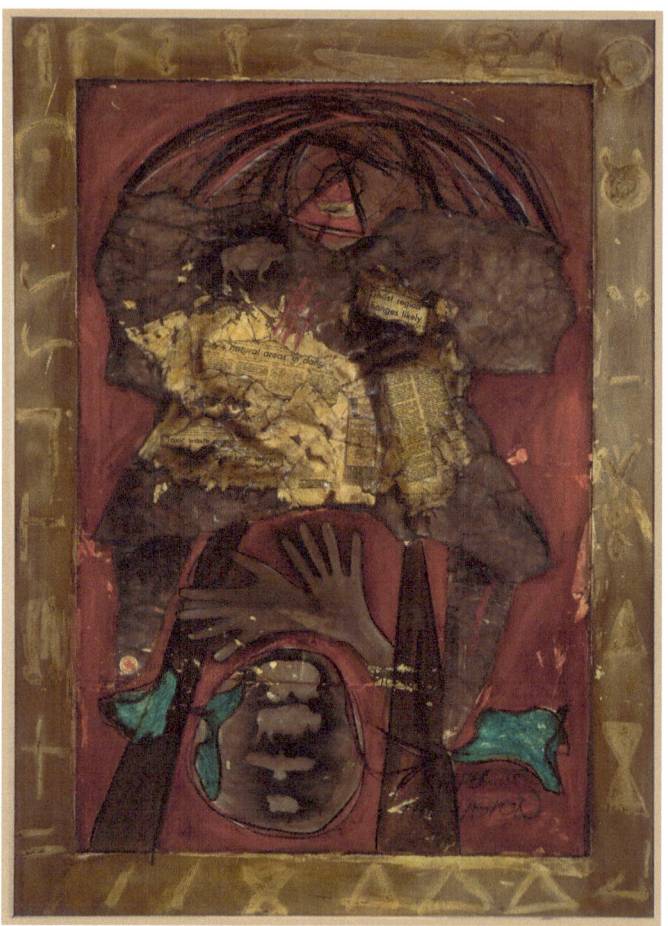 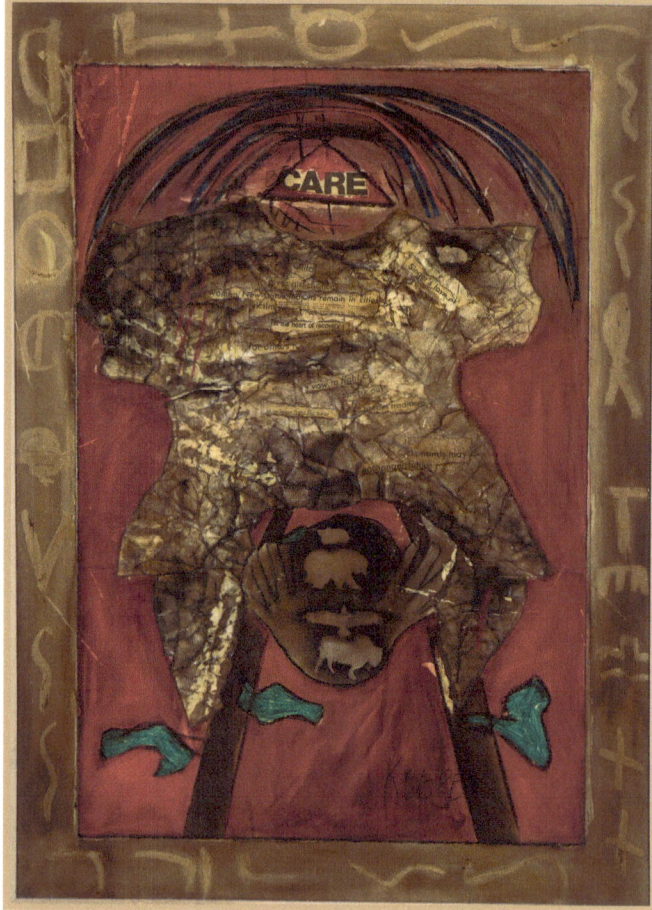

43. *Four Directions – Keepers of the Vision – Warshirts: This is the Spirit of the West, This is the Spirit of the East, This is the Spirit of the North, This is the Spirit of the South*, 1986
121.9 x 91.4 cm (each panel)
48" x 36" (each panel)
Oil, oil pastel, chalk, graphite, and collage on rag paper
From the Estate of Joane Cardinal-Schubert

Cardinal-Schubert created several Four Direction quadratychs and other works following Chernobyl. They encourage a coming together through disaster and references our collective responsibility to protect the earth.

A poem related to this work can be found on page 117.

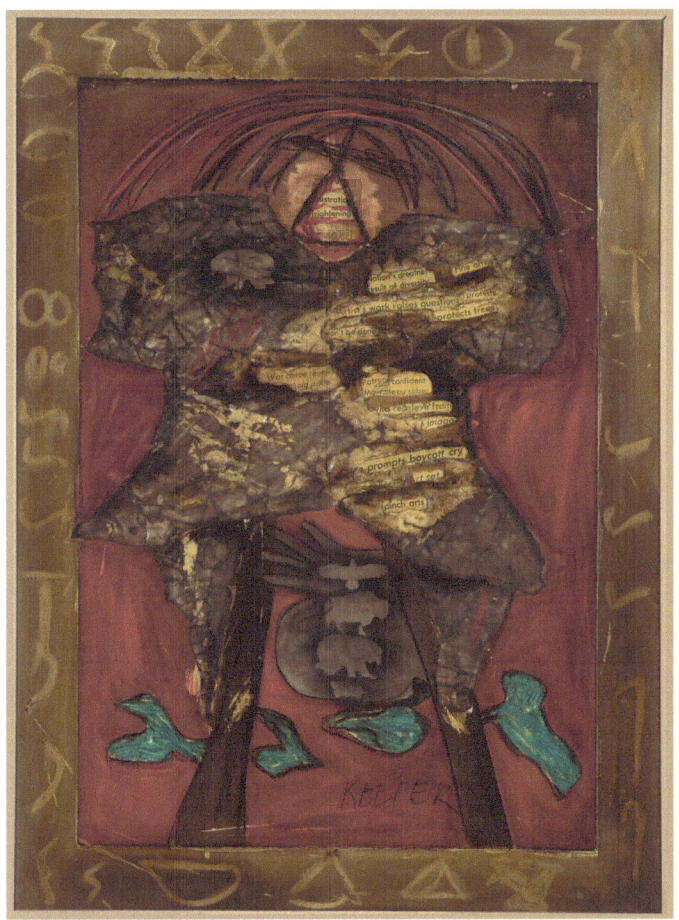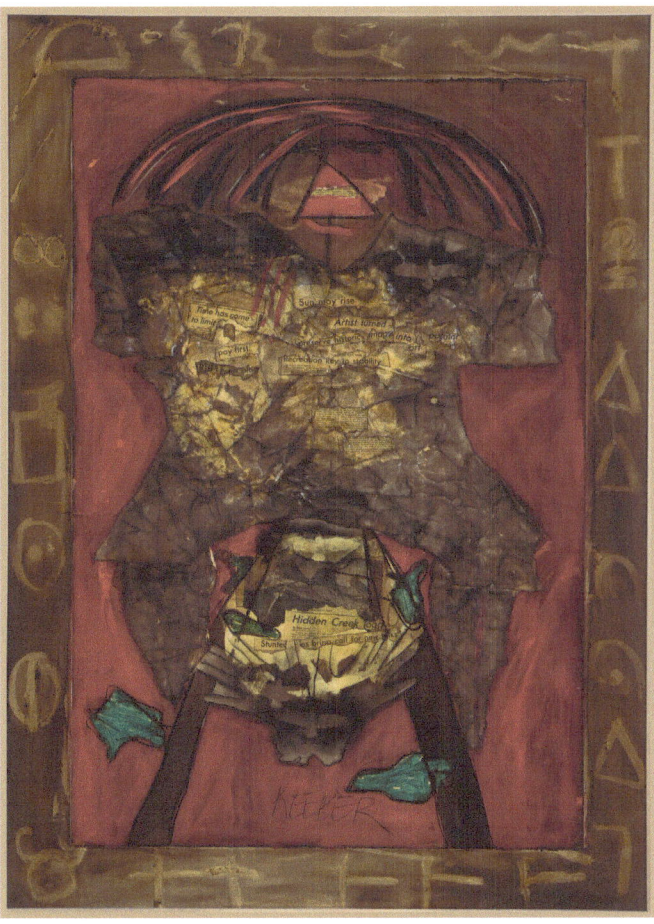

Medicine bundles typically store sacred items related to the health and well-being of those that carry them. Seeing these objects in museum collections, taken apart and tagged for classification, made Cardinal-Schubert equally distraught as when seeing the warshirts.[19] The bundles carried a tremendous significance for her, and by keeping them stored in museums, the culture of Native people had once again been taken away and denied its use, heritage, and contemporary existence. Again the artist reacted by creating her own bundles, with titles such as *Contemporary Artifact – Medicine Bundles: The Spirits Are Forever Within*, introducing modern materials, motifs, and themes. She wryly made these objects out of plaster, making it impossible for them to be taken apart and examined. However, their glossy exterior surfaces still entice the viewer. The colourful imagery includes a silhouette of a handprint, which can be seen as a symbol of protection. Her interest in the provenance of both the warshirts and the medicine bundles emerged at a time when repatriation was gathering momentum as a contentious issue in Canada, with her concerns culminating perhaps during the Winter Olympics in Calgary with "The Spirit Sings," an exhibition at the Glenbow Museum of Indigenous culture sponsored by an oil company.[20]

Cardinal-Schubert made other aspects of traditional Indigenous culture a part of the contemporary realm by incorporating them into her work. Images found carved into stone by Native people in southern Alberta had been documented, but not widely understood. The artist knew these motifs as pictographs, a combination of petroglyphs, or images cut into the rock, and pictographs, whereby images are painted on the surface of rock.[21] Drawing attention to their presence could raise awareness around their protection and broader understanding, especially for the history of Native people in that area. The artist took the same approach with the sweatlodge, incorporating it as a symbol into her works on paper. Like many aspects of Indigenous culture in Canada, ceremonies such as the sweatlodge and sundance had been outlawed during the twentieth century.[22] Cardinal-Schubert's use of the domed lodge motif not only draws attention to the oppression of Native people, but also revives its circulation in the present day.

Cardinal-Schubert also drew attention to Indigenous people as contemporary beings through her early representational

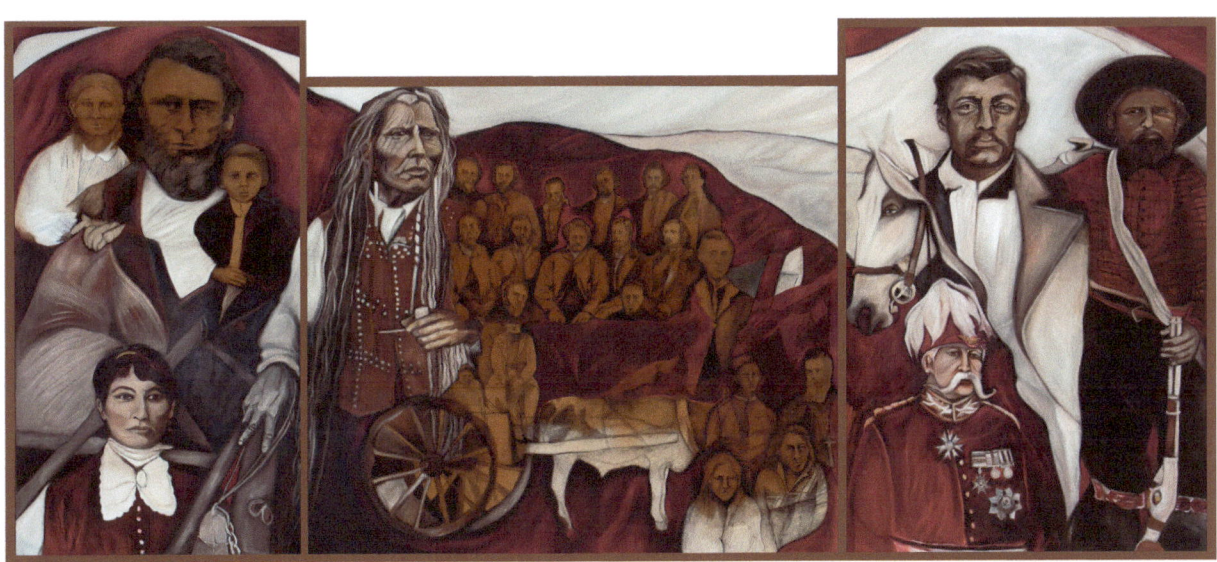

44. *Great Canadian Dream – Pray for Me, Louis Riel*, 1978
169 x 373 cm
66" x 146.75"
Oil on canvas, triptych
Collection of Carleton University Art Gallery, Ottawa:
Gift of Alan Lumsden, 1995.

Many of the works of Cardinal-Schubert commemorate historical individuals. They offer homage to those the artist felt were unrepresented or underrepresented in the accepted mainstream narratives of Canadian history.

The left panel of this work depicts the family of Louis Riel: his wife, Marguerite Monet; mother, Julie Lagimodière; son, John-Louis Riel, and father Louis Riel Sr. In the centre panel is Chief Poundmaker (Pîhtokahanapiwiyin), Louis Riel overseen by 12 members of the Conditional Council, a Métis couple in a Red River cart, and Big Bear (Mistahimaskwa) in the bottom right. The right panel features Michel Dumas, Gabriel Dumont, and Frederick Dobson Middleton.

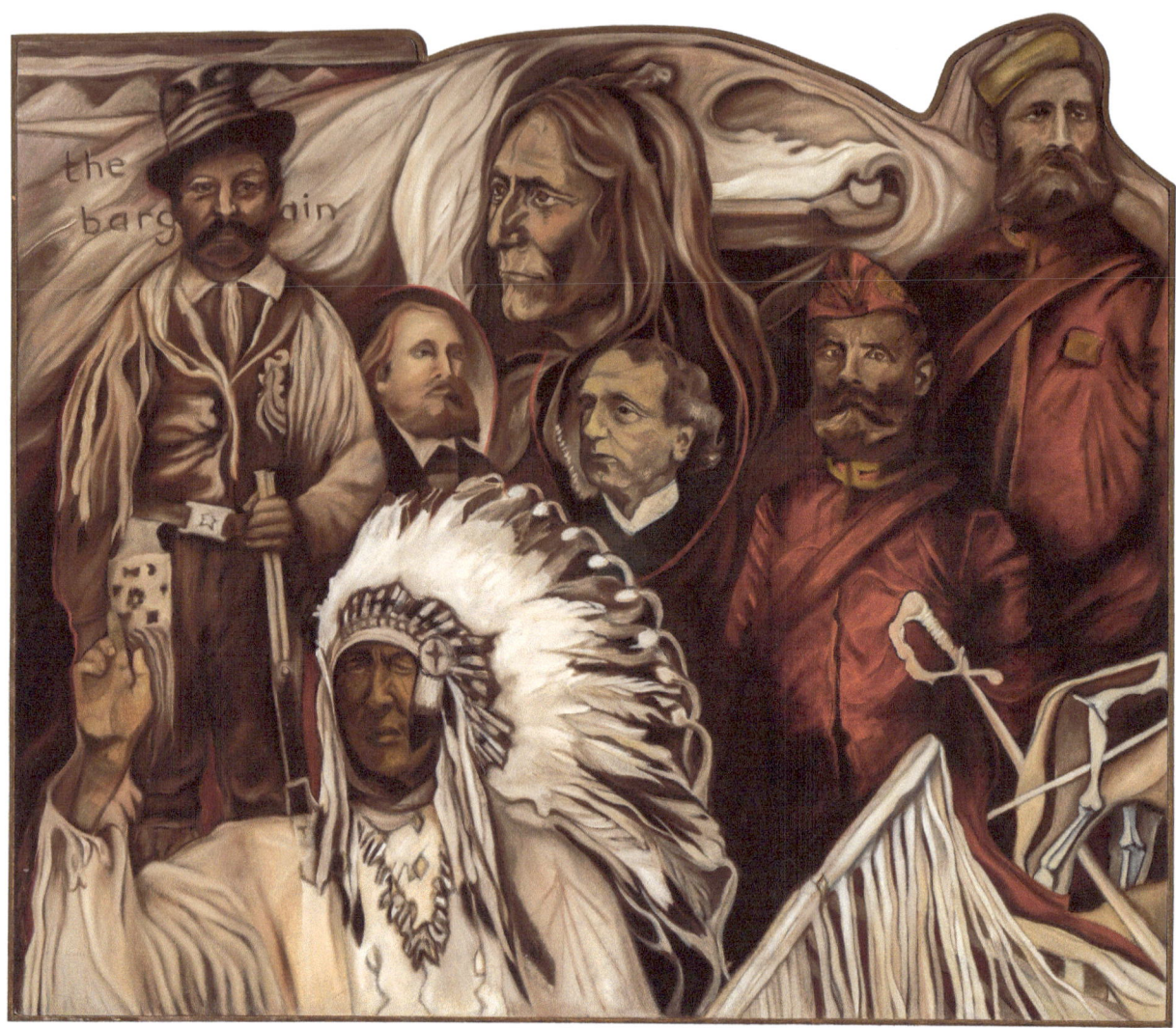

45. *Great Canadian Dream – Treaty No. 7*, 1978
152.5 x 305 cm
60" x 120"
Oil on canvas
Collection of the Red Deer Museum and Art Gallery

The subject of this work is the signing of Treaty 7, where Indigenous people of Southern Alberta gave up their hunting rights in return for food, reserve lands, and treaty money. In researching the treaty Cardinal-Schubert discovered that within one year of signing Treaty No. 7, people were reduced to killing their horses for food and eating gophers. On the top left edge of the left panel is Jerry Potts, Métis interpreter and guide, the large profile of Crowfoot (Isapo-Muxika) overshadows Sir John A. MacDonald below him and Colonel James MacLeod and Major Acheson Irvine are on the right. The foreground is dominated by a figure in full headdress holding a peace lance who the artist calls the "foreteller of the future."

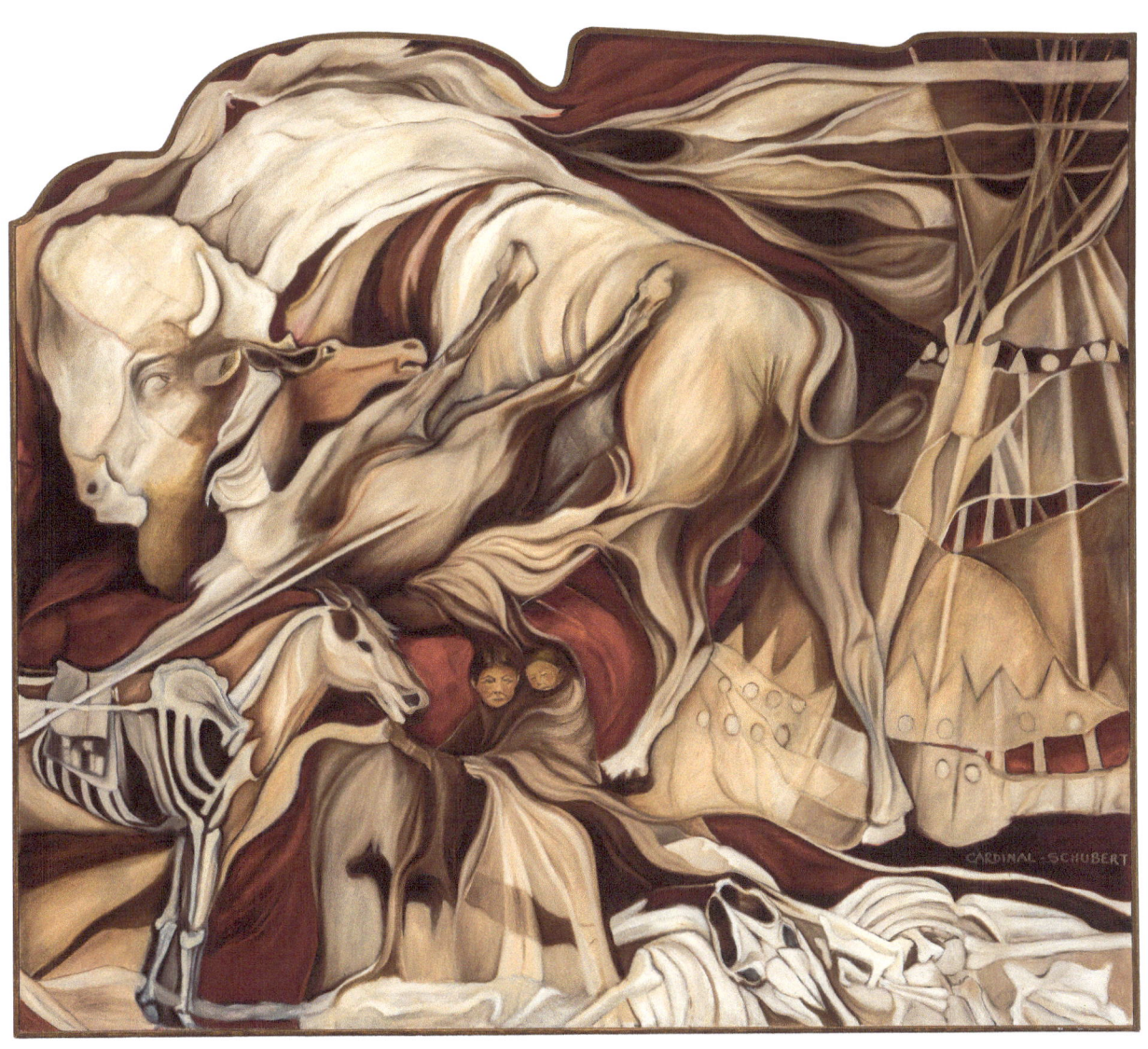

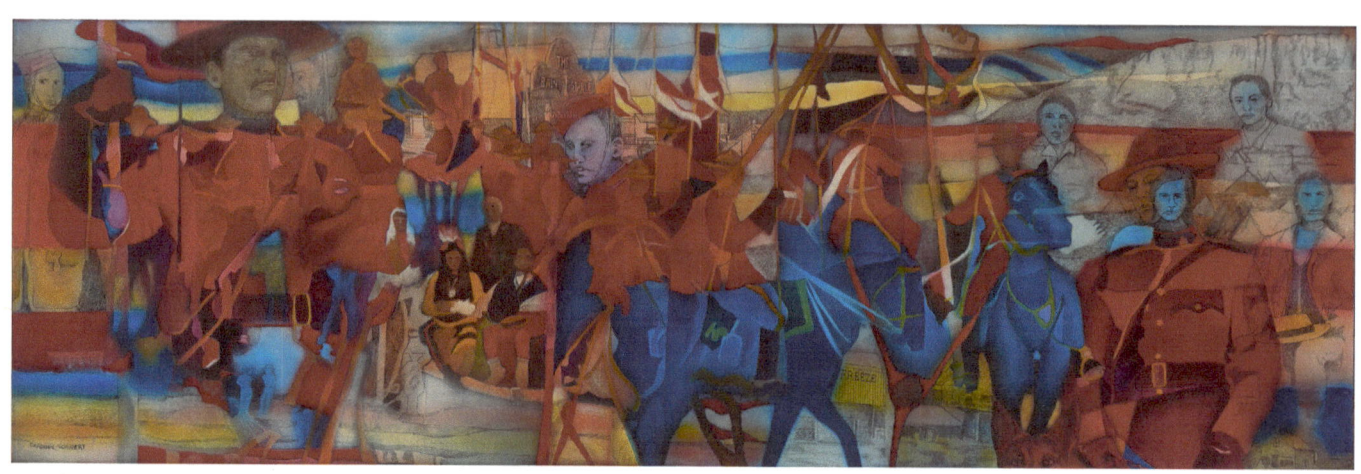

46. *Great Canadian Dream, No. 4, "Mountie Piece,"* 1978
81.3 x 243.8 cm
32" x 96"
Oil on canvas

Collection of Fort Calgary

works. *Great Canadian Dream – Pray for Me, Louis Riel* (fig. 44) is a large triptych that Cardinal-Schubert completed in the late 1970s, following a time of celebrations marking the 100th anniversary of Canada as a nation. It addresses the legacy of Louis Riel, the Métis people, and their conflict with the government of Canada. By depicting the historic events of Riel and his people, she brought them back into focus in the present. With the acknowledgement of that history comes the recognition that the Métis people are still largely unrecognized within Canada. *Great Canadian Dream – Treaty No. 7* (fig. 45) portrays some of the historical players involved in the treaty process, and the all too common legacy of broken promises, despair, and death that followed. As I write these words from unceded Algonquin Territory in the 150th anniversary year of Canada, the painting of the past serves as a metaphor for the present.

As part of preparations for Canada's sesquicentennial, 12,000 people participated in a poll between December 2013 and May 2014 to identify the top ten Canadian heroes. The resulting list included no women, and no Indigenous people.[23] In a similar fashion to her representational works, Cardinal-Schubert made art about figures that she considered unrecognized Canadian heroes. These portraits included Emily Carr, Big Bear, Crowfoot, Poundmaker, and Red Crow. *Homage to Smallboy* is a portrait that addresses the contemporary plight of Native people in two ways. The subject of the painting, Robert Smallboy, was a chief who sought to return to traditional lifestyles in the 1960s. He was widely regarded for his efforts, even earning the Order of Canada.[24] The portrait also denies the visual culture of Western portraiture by rendering Smallboy in an unromanticized manner. Cardinal-Schubert's related poem *There Is No Hercules (Homage to Robert Smallboy)* goes further to lament the loss of a leader, and condemn those that ignored him. Recognizing the frailty of the human condition in the moment in which Cardinal-Schubert depicted Smallboy, one is left with only the stark sense of contemporary existence.

There is No Hercules
(Homage to Robert Smallboy)

You
with your face of wisdom
your
comforting hands
your older age should
Demand
Respect

Yet
no one let you in
In Banff.

It was a cold night
you froze both legs
then,
they took you in
to the hospital
they took everything
away from you
including your legs.

They gave you
New things.

You could not burn
Sweetgrass
or have
Your food.

*You went home
to die.
Finally.
Painfully.
Two years later.*

*Wasn't it you
Who had
special
audience
with the Pope.*

*Didn't you save
Your people
by example
on the Plains.*

*Didn't you receive
the Order of Canada.*

*Too bad
There is no Hercules*

*In Banff
For an Old Indian
Out of Ceremonial Dress*

– JOANE CARDINAL-SCHUBERT, 1987

47. *Homage to Smallboy: Where Were You In July Hercules*, 1985
192.4 x 163.83 cm
76" x 64.5"
Oil and acrylic on canvas
From the University of Lethbridge Art Collection; purchased 1988 with funds from the Alberta Advanced Education Endowment and Incentive Fund as a result of a gift by the Crosby family, Banff

Chief of the Ermineskin Band and recipient of the Order of Canada, Robert Smallboy rejected reserve life, which he saw as the cause of drug abuse, alcoholism, violence, and suicide in his community and established the Mountain Cree Camp (Smallboy Camp) east of Jasper on the Kootenay Plains where his people could start a new way of life free from what he saw as civilization's evils. On a visit to Banff he was refused a room at several hotels, which forced him to spend the night on the street. He suffered frostbite in his feet that night, which eventually led to gangrene, a lengthy hospital stay, and contributed to Smallboy's death on July 8, 1984.

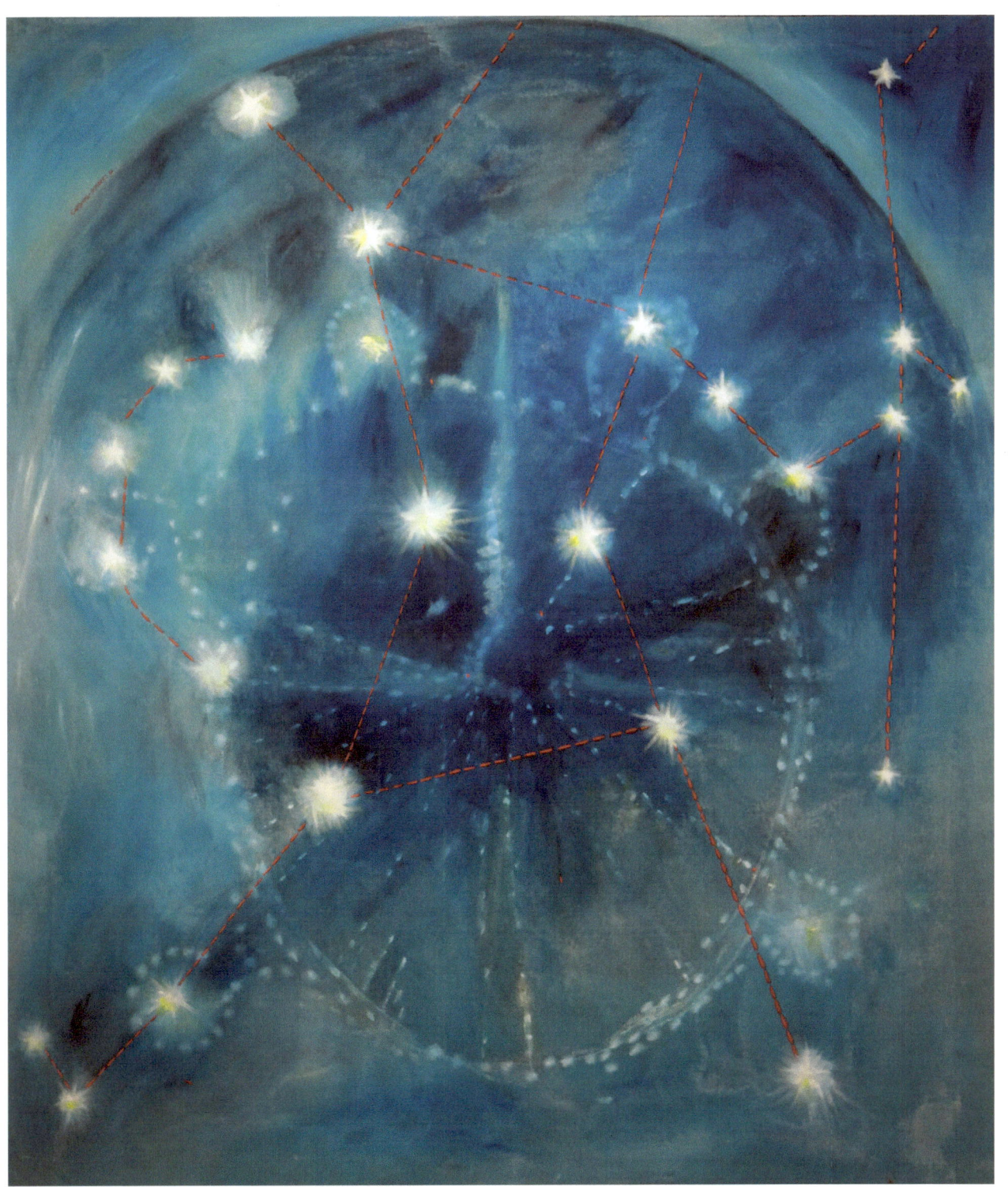

Still Seeing Red *105*

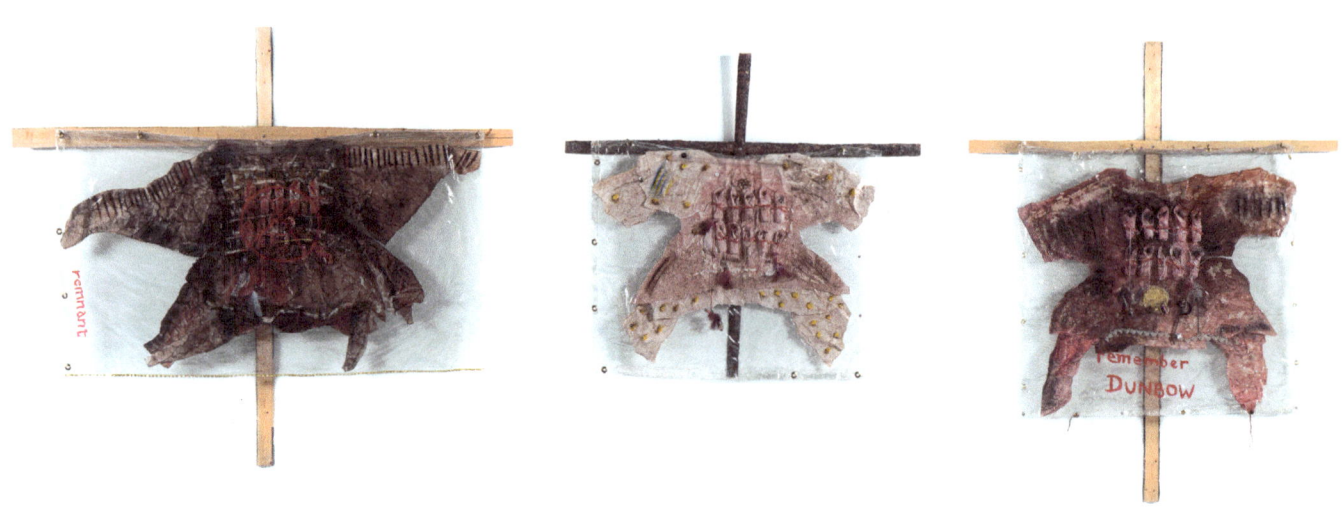

48. *Remnant Birthright; Museum II; Remember Dunbow; Is This My Grandmothers';
Remnant; Then There Were None*, 1988
102 x 91 cm each
40" x 36" each
Oil, conté, charcoal on rag paper, found objects, clear vinyl, wood
For installation: Preservation of a Species: Deep Freeze, 1989
From the Estate of Joane Cardinal-Schubert

Plastic wrappings in many of the artist's works reference Cardinal-Schubert's experience of seeing sacred objects with ceremonial significance catalogued, tagged, wrapped in plastic, and stored improperly within museum collections. These works became a part of a larger installation titled *Preservation of a Species: Deep Freeze*, referencing frozen stereotypes while alluding partly to cold storage areas in museums for human remains that are almost always Indigenous.

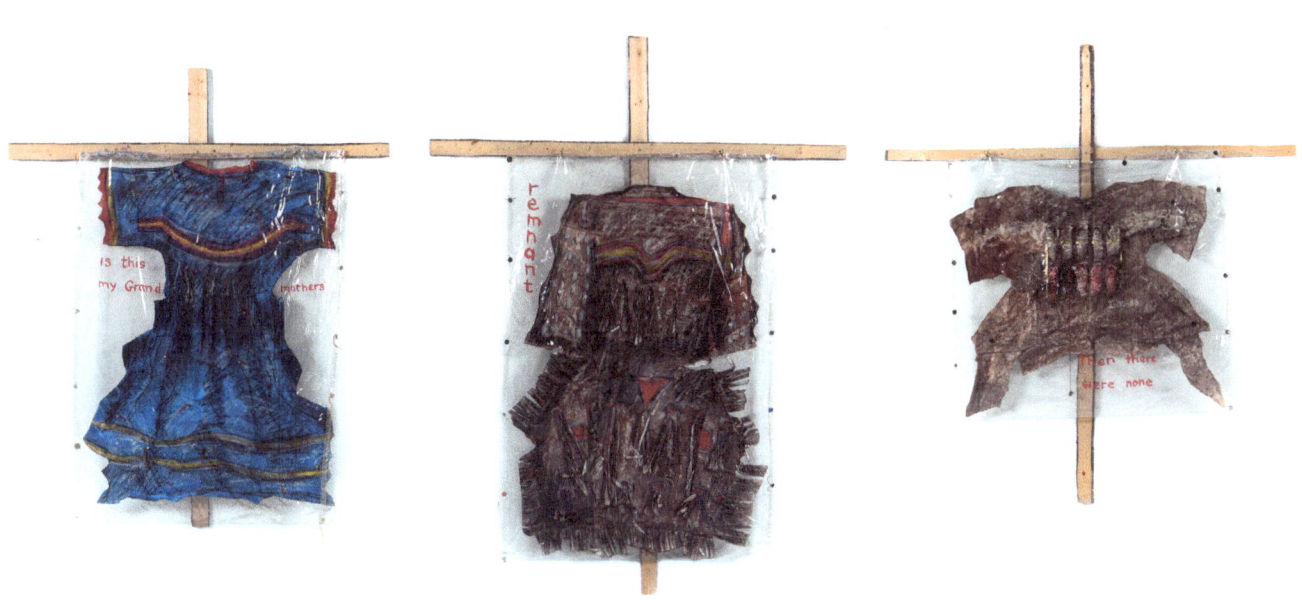

Through a broad range of works that incorporated recurring motifs in a variety of formats, Cardinal-Schubert addressed the recognition of Indigenous people as contemporary beings. *Preservation of the Species: Deep Freeze* is an installation consisting of several smaller works. It considers the history of Indigenous people within Canada, from the introduction of residential schools up to the present, using information drawn from news headlines and detritus from modern life. The title makes reference to not only the preservation of culture, but also the greater challenge of survival – in spite of stereotypes that can leave one frozen, and prevent one from participating in daily life.[25]

Preservation of a Species: DECONSTRUCTIVISTS (This Is the House That Joe Built) is an installation that engages the viewer on several levels. Referencing Cardinal-Schubert's father, Joseph Cardinal, it forces viewers to consider different mental and physical states than what they are used to. Vast areas of the space are painted black, displaying Cardinal-Schubert's characteristic chalkboard writing. Viewing windows are set into constructed walls, some of which are tinted red. The experience of looking through the red tinted window alludes to the contemporary existence of Native people. At the same time, the windows are deliberately placed at heights that are uncomfortable to look through.

This Is My History is a title for both an exhibition and a single artwork. Through both, the artist draws attention to omissions and dark chapters within Canada's imposed historical narrative. In the artwork, which is similar to figures 6, 7, 8, and others related to pictographs and Writing-on-Stone in the artist's oeuvre, she takes ownership over what she recognizes as her narrative, incorporating pictographic figures using oil paints and canvas. The exhibition offered an important body of work, firmly established in the present and continuing to unfold. Appropriately, the notion of history's authorship, and how that can influence both the present and the future, does not seem lost on Cardinal-Schubert.[26]

Lastly, two of her works that recognize Indigenous people as contemporary beings include *The Lesson* and *Drum Dancer: The Messenger AKA Prairie Pony*, a public artwork at the Calgary International Airport. *The Lesson* (fig. 23) recreates the power dynamics of a contemporary classroom setting while exposing the experience of residential schools. The artist transformed the walls

of the space into large black chalkboards, using their implicit authority to write histories from an Indigenous perspective. The use of classroom desks provides objects that viewers can relate to their own experience of educational institutions, while situating themselves in relation to Cardinal-Schubert's wall text. In the same way, Cardinal-Schubert uses the shared public space of the Calgary International Airport to banish thoughts of Indigenous people as belonging in the past. *Drum Dancer* uses bright colours and the playfully balanced figure of a horse to draw people towards it. The sculpture also incorporates Indigenous motifs, such as the four directions, and is positioned in relation to the pictographs at Writing-on-Stone.[27] Serving as a reminder of the Native presence in that area, the piece situates Indigenous culture outside of the museum and in the public space of contemporary, international travel.

Cardinal-Schubert's artwork cannot be separated from other aspects of her life. Indeed, it was integral in helping establish an identity for herself, communicating ideas, and reaching a broad audience. However, it was not the only means for working through and drawing attention to what she cared about most deeply. While certainly no less important than her art, the following section will briefly discuss how her politics, activism, and personal life relate to gaining recognition for Native people as contemporary beings.

Cardinal-Schubert fought for the recognition of Indigenous people as contemporary beings through her political stances. Many of her concerns manifest themselves in her artwork, as is the case with the work entitled *Rider* (fig. 1). Including the text "C-31" in the work references amendments to the Indian Act under Bill C-31 that would allow for gender equality and greater self-government by Aboriginal people.[28] Given the disjunctive and fractured nature of the composition, Cardinal-Schubert's feelings about the amendments may be seen as ambiguous, in that they were still metered out by the federal government. However, the work points to two other important political aspects of her life.

Cardinal-Schubert did not attempt to reclaim her Native status following the introduction of Bill C-31. She did not agree with the government definition of Métis, and so maintained her affiliations with the Kainai people.[29] Moreover, although she believed in the rights of women, she did not identify as a feminist, as she believed

her circumstances were largely determined by her race.[30] These two aspects of her life illustrate the importance of self-determination, not just for her, but for all Indigenous people who have experienced subjugation of any form by colonialism.

Cardinal-Schubert recognized how both racial and gender inequality diminished the contemporary experience of Native people. She fought against racism, participating in exhibitions such as *Racism in Canada*, and espoused the acceptance of others in spite of differences. She drew attention to her plight as an Indigenous woman artist by establishing a fictitious dialogue with Emily Carr. The resulting works took the form of both text and mixed media on paper, drawing attention to race and gender inequity. Becoming involved in theatre, in 2003 Cardinal-Schubert participated in bringing a production of *The Vagina Monologues* to Calgary.

Cardinal-Schubert's work as an activist also contributed to the recognition of Indigenous people as contemporary beings. As an advocate for Native culture, she participated in conferences on Aboriginal art, and was an active member of the Society for Canadian Artists of Native Ancestry (SCANA)[31] and the Calgary Aboriginal Arts Awareness Society (CAAAS).[32] Besides offering a mentorship role to other artists through these organizations, and an Indigenous art exhibition space through her work with CAAAS, she was also part of initial efforts to establish Indigenous arts programming at the Banff Centre for the Arts.[33]

Cardinal-Schubert's concern for the environment was also part of her struggle for the recognition of Indigenous people as contemporary beings. Her father's career as a game warden likely helped to establish the importance of the natural world in her mind. Later, she would cite her own connections to the land (territory that had been stolen through colonialism), stating that it was in her DNA.[34] Many of her artworks draw attention to poor environmental conditions affecting health, including tuberculosis and substance abuse, while her use of black recalls pollution and oil spills. A work entitled *Dead River Scrolls* laments the damming of the Oldman River in Alberta. The installation incorporates empty water and liquor bottles as a visual metaphor for the dam, these disposable items often littering fresh water systems after they have been consumed. Her environmentalism can also be linked to her concern for

the pictograms,[35] innately connected to the land on which they were created.

Cardinal-Schubert's personal life reflects a struggle to be recognized as a contemporary being. She went back to school well into adulthood to follow her passion for art. She was not accustomed to formal art education, and did not feel at ease with the various mediums and materials she was exposed to.[36] Regardless, she began to create work prolifically soon after graduating. Cardinal-Schubert was also aware of how she was seen by others, and took ownership of her identity. From an early experience in art school, one of her classmates attempted to belittle and label her by asking what tribe she belonged to. Sensing that she was being challenged, she quickly responded, "Blood."[37] Prior to that experience, racism had caused her to often hide her identity.[38] However, upon leaving school, and participating in several exhibitions, she had no fear of letting people know who she was.

As the Indigenous curatorial field continues to develop, so too does the collection and exhibition of Native art. The repatriation of objects from museums and private collections remains unresolved, although the profile of contemporary Indigenous art has increased. Cardinal-Schubert's conflict with the collection and exhibition of Indigenous culture is central to who she was as a person, not just an artist. Given her career in the arts, many other issues can be traced back to that conflict. She fought throughout her life for the recognition of Indigenous people as contemporary beings. That struggle is firmly rooted in her art, politics, activism, and personal life.

However, Cardinal-Schubert's struggle is not limited to seeking a space for Indigenous culture outside of the museum where it may be observed frozen in time, as part of the past. It is also for those that are unrecognized or forgotten, limited to reservations, fighting for control over land and resources they are entitled to, who make up a larger percent of the prison population and who go missing or are murdered on a more frequent basis than others. In recognizing Cardinal-Schubert's struggles and achievements, there is an opportunity to finish her important work.

NOTES

1. *Seeing Red: Interview*, Michael Bell (Kingston, ON: Agnes Etherington Art Centre, 1990), VHS.
2. Ibid.
3. Traditional cultural practice was reinstated by an amendment to the Indian Act in 1954, but Canadian citizenship and the vote were granted to status Aboriginal people only in 1960. Lee-Ann Martin, "Contemporary First Nations Art Since 1970: Individual Practices and Collective Activism," in *The Visual Arts in Canada: The Twentieth Century*, eds. Anne Whitelaw et al. (Don Mills, ON: Oxford University Press, 2010), 371.
4. *Hands of History*, directed by Loretta Todd (Montreal, QC: National Film Board of Canada, 1994), VHS.
5. Ibid.
6. Allan J. Ryan, *The Trickster Shift: Humour and Irony In Contemporary Native Art* (Vancouver: UBC Press, 1999), 143.
7. *Hands of History*.
8. *Seeing Red*.
9. Northwest Profiles Interview.
10. Allan J. Ryan, *The Trickster Shift: Humour and Irony in Contemporary Native Art* (Vancouver: UBC Press, 1999), xv.
11. Ibid., xv.
12. *Seeing Red*.
13. *Hands of History*.
14. Ibid.
15. Ibid.
16. *Seeing Red*.
17. Allan J. Ryan, *Second Annual New Sun Symposium* (Ottawa, ON: Carleton University, 2003), VHS.
18. *Hands of History*.
19. Joane Cardinal-Schubert, Kathryn Burns, and Gerald McMaster, *Joane Cardinal-Schubert: Two Decades* (Calgary: Muttart Public Art Gallery, 1997), 41.
20. "Aboriginal Artifacts Repatriating the Past." *CBC News*, Mar. 16, 2006, http://www.cbc.ca/news2/background/aboriginals/aboriginal_artifacts.html.
21. Deborah Godin, "Joane Cardinal-Schubert: This Is My History," in *Joane Cardinal-Schubert: This Is My History*, eds. Tom Preston et al. (Thunder Bay: Thunder Bay National Exhibition Centre and Centre for Indian Art, 1985), 5.
22. Michael Bell, "Seeing Red," in *Agnes Etherington Art Centre, Exhibitions: 1989–1990*, ed. Steve Anderson (Kingston, ON: Agnes Etherington Art Centre, 1992), 79.
23. "Top 10 Canadian Heroes List Includes Pierre Trudeau, Jack Layton." *CBC* News, June 15, 2014, http://www.cbc.ca/news/canada/top-10-canadian-heroes-list-includes-pierre-trudeau-jack-layton-1.2676398.
24. "The Governor General of Canada > Find A Recipient." *The Governor General of Canada*. Accessed Feb. 13, 2016. http://www.gg.ca/honour.aspx?id=2292&t=12&ln=Smallboy.
25. Deborah Godin, "Joane Cardinal-Schubert: This Is My History," in *Joane Cardinal-Schubert: This Is My History*, eds. Tom Preston et al. (Thunder Bay, ON: Thunder Bay National Exhibition Centre and Centre for Indian Art, 1985), 40.
26. As described by George Orwell in the novel *1984*, those who control the present control the past, and those who control the past control the future.
27. "About Dr. Joane Cardinal-Schubert LL.D. (Hon.), R.C.A.," in *An Evening with Dr. Joane Cardinal-Schubert R.C.A.* (Calgary, AB: Masters Gallery Ltd, 2008).
28. "Bill C-31." *The University of British Columbia*. Accessed Feb. 15, 2016. http://indigenousfoundations.arts.ubc.ca/home/government-policy/the-indian-act/bill-c-31.html
29. Eckehart Schubert and Justin Cardinal-Schubert, interview by Alisdair MacRae, Feb. 24, 2012, interview 4, transcript.
30. Ibid.
31. "Society of Canadian Artists of Native Ancestry, Board Meeting, Nov. 18, 1994," minutes, Ramada Renaissance Hotel, Regina, 1994; "Society for Canadian Artists of Native Ancestry, Committee Developing Programs and Planning Structure for IAC, conference call, May 7, 1996," transcript, University of Lethbridge, 1996.
32. Clint Buehler, "Dr. Joane Cardinal-Schubert to receive National Aboriginal Achievement Award for Arts," *First Nations Drum*, last modified Feb. 2007, http://firstnationsdrum.com/2007/02/dr-joane-cardinal-schubert-to-receive-national-aboriginal-achievement-award-for-arts/.
33. Ibid.
34. Deborah Godin, "Joane Cardinal-Schubert: This Is My History," in *Joane Cardinal-Schubert: This Is My History*, eds. Tom Preston et al. (Thunder Bay, ON: Thunder Bay National Exhibition Centre and Centre for Indian Art, 1985), 30.
35. Joane Cardinal-Schubert, Kathryn Burns, and Gerald McMaster, *Joane Cardinal-Schubert: Two Decades* (Calgary: Muttart Public Art Gallery, 1997), 27.
36. *Hands of History*.
37. Ibid.
38. Godin, "Joane Cardinal-Schubert: This Is My History," 23.

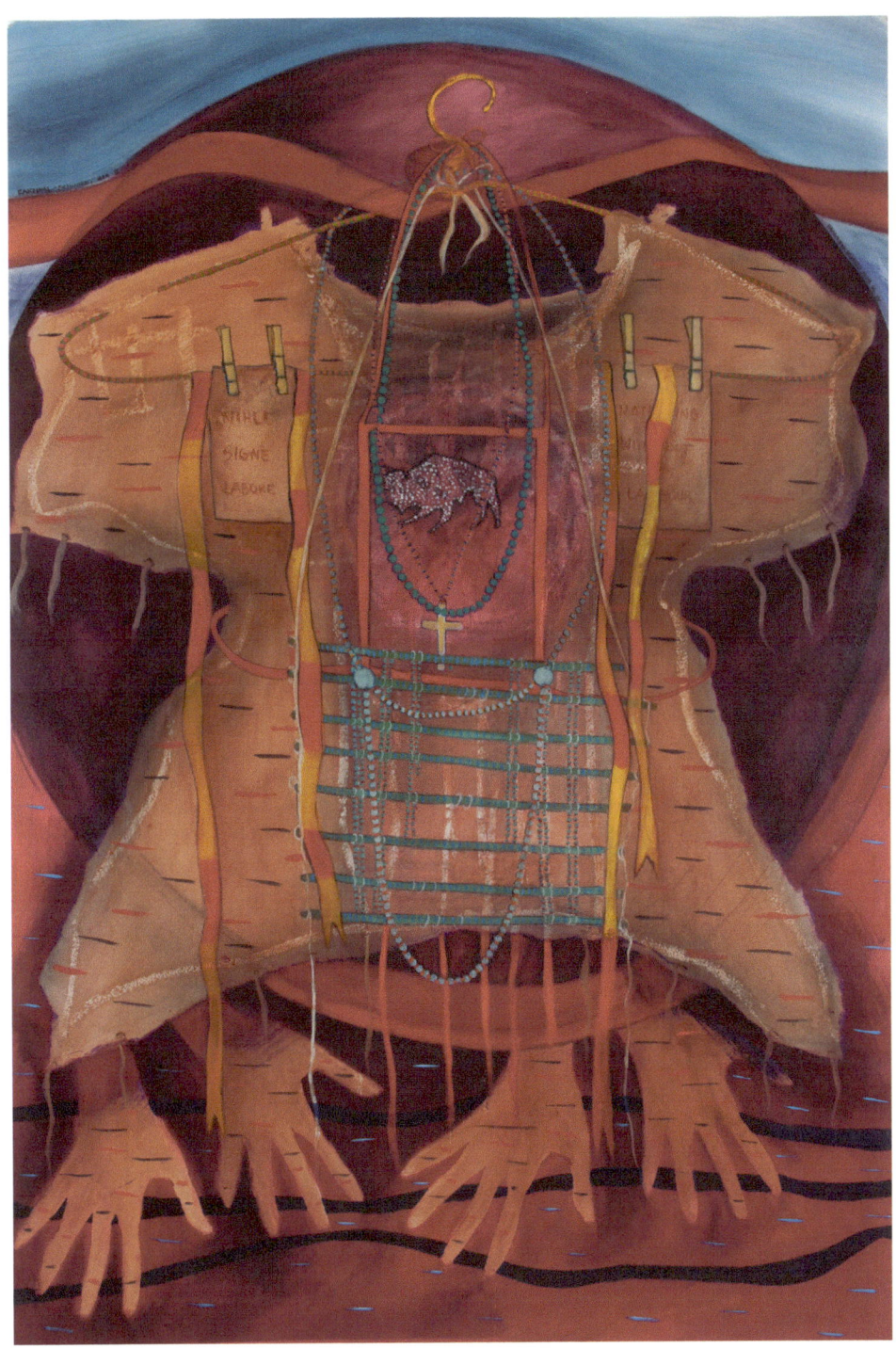

49. *Nihle Signe L'Arbore*, 1994
120.5 x 80 cm
47.5" x 31.5"
Mixed media on rag paper
Collection of the Alberta Foundation for the Arts

50. *Looking for the Silver Bullet*, 1995
152.3 x 122 cm
60" x 48"
Acrylic on canvas
Collection of the Alberta Foundation for the Arts

BY ALISDAIR MACRAE

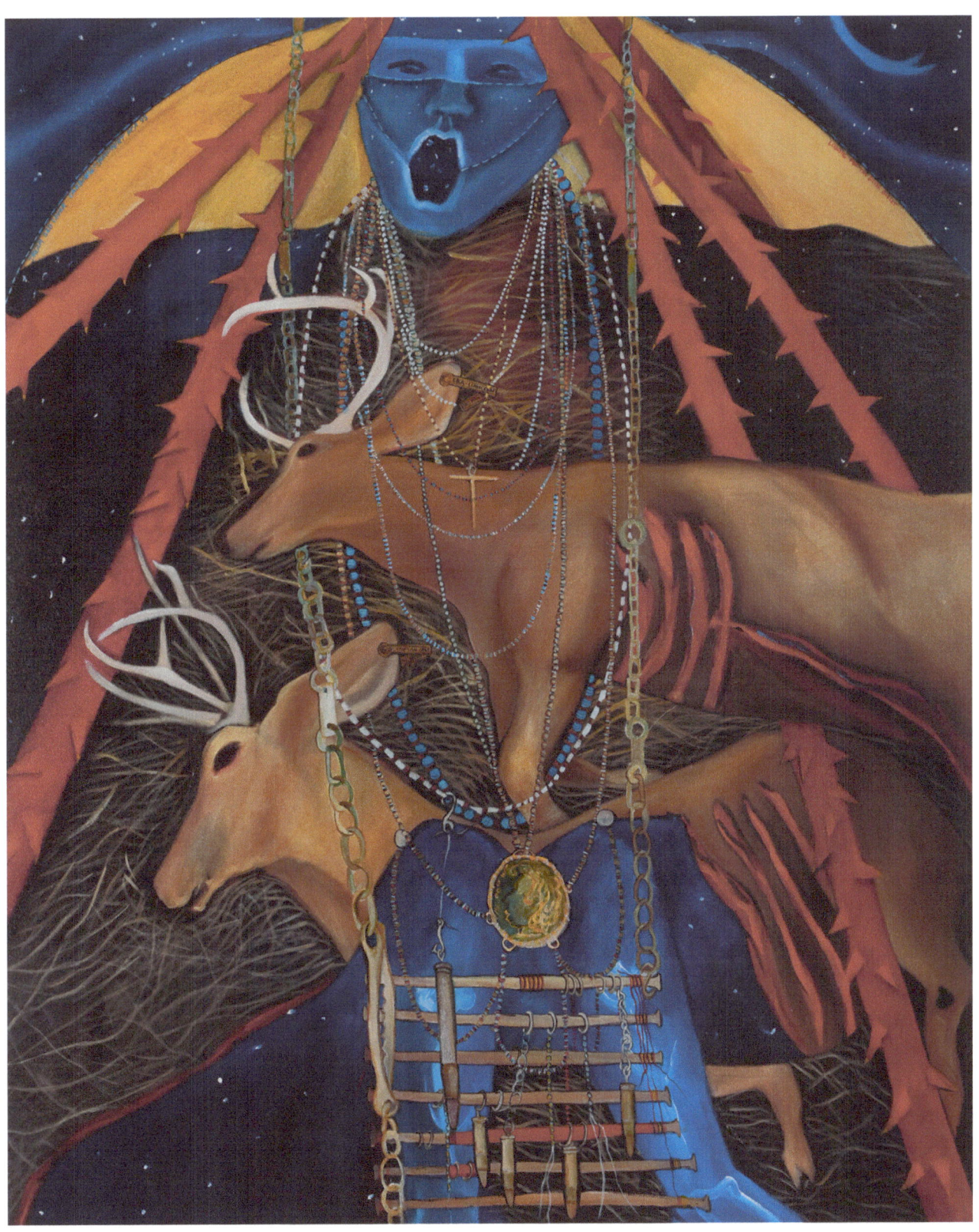

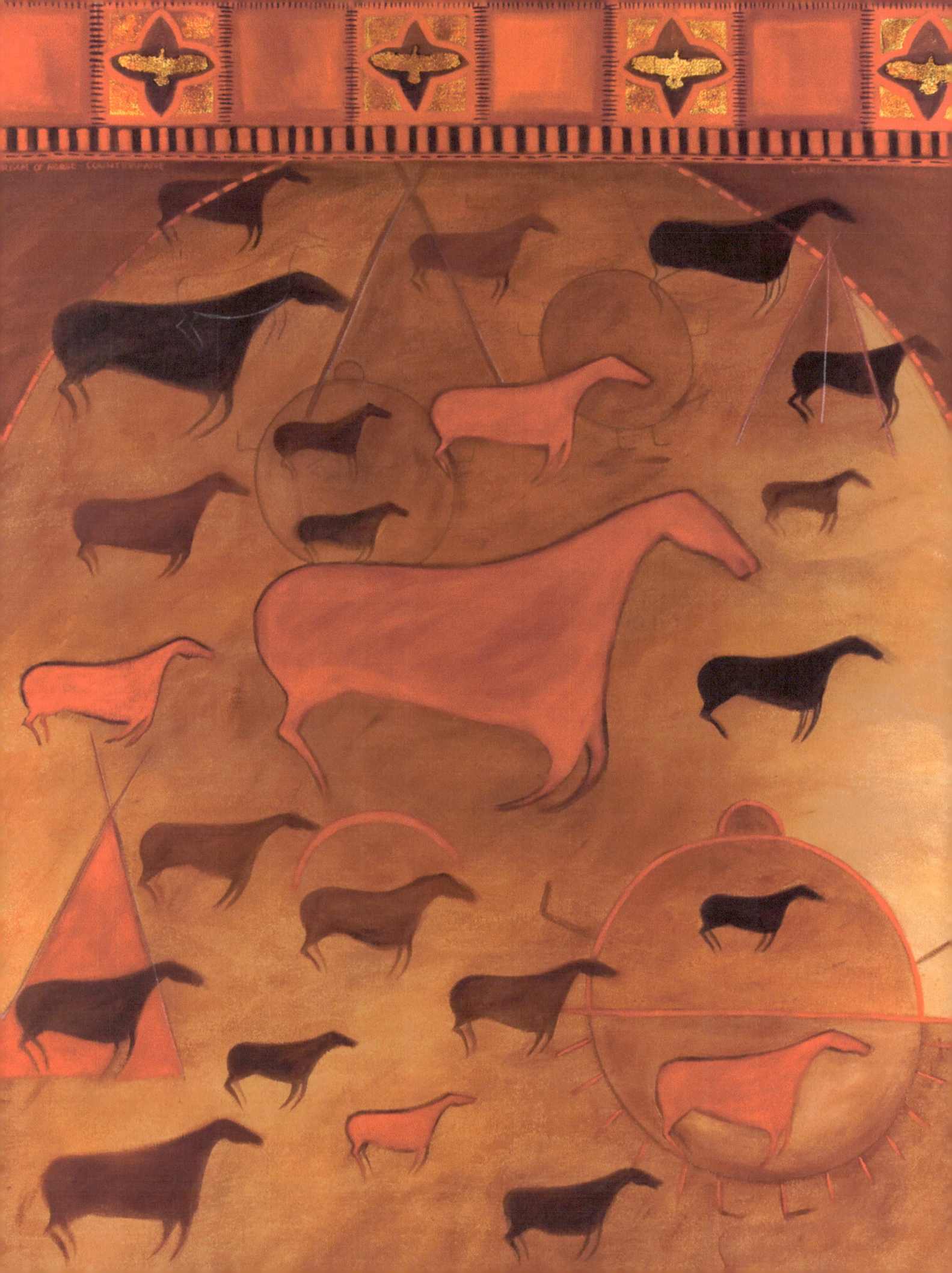

RECOLLECTIONS

by Tanya Harnett

Keeper

Keeper of the Vision
Spirit of the Four Directions
Your Heads

Thrusting

Screaming Out

Keeper! Keeper!
Scream for
All Creatures
on the Earth.

Your Warshirts
Marked with the White – Hot
Brands
of Words
of the
Lost Generation.

You bring forth
Your Animal Spirits
resting on their
barren stumps —

Grave markers.

Let the next
Generation
be born
with the knowledge
of what has passed

— Joane Cardinal-Schubert[1]

Our proximity to each other reveals unperceivable forces that create unique experiences. Our narratives intertwine. When someone passes on to the next world the mysterious forces at work can seem even more intangible. In that place where our stories and memories are suspended and are so very real and true. It makes it all that more important for us to keep our stories sincere, close to our hearts, and with respect. Keeping, retelling, sharing, and passing those stories on to the future generations is a responsibility to be exercised with great honour and care. In celebration of Joane Cardinal-Schubert's life and work, it seems only fitting for us to participate in this spirit by sharing some of our own collection of Joane stories.

The English language is a poor fit for describing Plains Indian cultural practices and belief systems. English is the mainstream language in Canada. It's accessed by the majority, but a multitude of other languages enrich and expand thought with different ways of knowing that result in a much richer and greater whole. Diversity is important. In a traditional First Nations construct, it is largely understood that the spirit of those have who have passed before us remain with us, but in the English language or Western European thought, the deceased are more often referred to in the past tense. This contradicts Plains Indian belief systems so we run into a colonial wall. It is a stumbling writer's block. I will tend to write about Joane in the present tense

thus acknowledging her continued presence as ancestor. Not surprisingly, I imagine a crossed-armed Joane Cardinal-Schubert reminding us that her spirit is still here and that she is not a woman to be ignored.

At the Banff International Curatorial Institute Symposium *Making A Noise!: Aboriginal Perspectives on Art, Art History, Critical Writing and Community*, Joane delivered a paper entitled "Flying with Louis."[2] It was a fun and humorous metaphorical story of an Aboriginal Art Community flying on an Aboriginal Concorde. In Joane's story, she included a full cast of Aboriginal characters with references to Bill Reid, Jane Ash Poitras, Doreen Jensen, Daphne Odjig, Jackson Beardy, Eddy Cobiness, Norval Morrisseau, Everett Soop, Gerald Tailfeathers, Herbert Schwartz, Harold Cardinal, Robert Houle, Leo Bushman, Morgan Wood, Skawennati Tricia Fragnito, Terrance Houle, Teresa Marshall, and Alex Janvier – with the Aboriginal Concorde piloted by Louis Riel and co-piloted by Pauline Johnson. It is a story well worth the read. Joane's poetic skit is an Aboriginal art history sampler that teases her audience. Although it is tongue-in-cheek, she calls for serious attention to the field of Aboriginal art history. It is a direct call made to the future generations to maintain our stories about Aboriginal Art – she made a fun little trail for us to follow.

In a recent keynote address in the *New Maternalisms Redux* colloquium hosted by the University of Alberta, the visual art theorist and cultural analyst Griselda Pollock answered a question from the audience.[3] In her reply, she described a kinship model for art praxis that was not held to a fixed place, but rather in relationships connected through generations, with each of those generations demarcated by the intersections of socio-political events. It may have been revolutionary to some, but for First Nations people it is a normative understanding. That kinship model describes how the Aboriginal contemporary art community relate to each other. We tend to identify with each other in familial relationships – cousin, aunt, uncle, grandparent. In the *Making A Noise!* symposium, Joane identified herself as being positioned in a "second wave" of Aboriginal contemporary artists, and she credited Alex Janvier for coining the term. Following this kinship model, Joane would be my art auntie and I, along with

many cousins, may be considered to be in a "third wave." Of course, following my generation is a "fourth wave" that are busy at work in the circle that will go around and around again.

Being an Aboriginal professor at the University of Alberta, teaching Contemporary Native Art history and studio art practice, I feel a greater responsibility to make sure that our history is passed down, shared, and to remind people that the stories we carry need to be passed down. During my tenure of teaching at the University of Lethbridge, in Blackfoot country, we established the first BFA Native American Art (Art History and Museum Studies) degree. What does it mean to be an Aboriginal art historian? What is the skill set needed to navigate in this field of research? What is this field of research? How will these stories be gathered and disseminated? How does ethics factor into Indigenous research? What are the responsibilities? Will field research mean going home? What is home? I am curious to know how these questions will be answered. But for now, I will simply put up a sign for Joane – "Historians Needed" or better yet, posted in big red neon pulsing letters, "Keepers of the Vision Needed."

With curiosity, I have wondered about my auntie's stories, her escapades, her encounters, her exchanges with people, and her adventures. I wondered what stories could be gathered, shared, and celebrated. I am sure that there would be many. Joane has always left an impression on people. With the absence of Joane in the physical world, her spirit has become more available for us to (re)call upon. Our stories about Joane are sometimes shared orally – perhaps sitting with friends in laughter and lament – or in a knowing exchange between people, where the pace of time slows. With Joane in her place with the ancestors, our conversations may feel a little bit more one-sided, but the work and the ideas she left for us have given us a way to move forward.

As an Urban Indian artist, writer, educator, poet, activist, theorist, and provocateur – Joane has challenged the walled city, the ivory tower, and the houses of government. She infiltrated them. She has navigated the terrain of Western European thought to suit her needs and to the best of her advantage. It was always clear that her intention was to translate, transform, deconstruct, to shake, and to dismantle the colonial thought process. She stated, "I picked art because I could be involved

in that physical expression of making imagery. But also because it was the only alternative for me in other ways too. It was a discipline that crossed boundaries and there were clearly boundaries for Native people when I was going to school."4 It was those unjust boundaries or limitations that called Joane into action. She used her weapons of physical expression to confront and defy those boundaries. Joane gave a wide and timeless call for all Aboriginal artists to pick up their arms and join in the fight. She believed that, "as artists, our only weapon is this battle for survival, because battle it is. It is our knowledge, responsibility and a commitment to share our world view with others. Even if we reach only one person and change their mind, it is a conquest."5 From her peers, and for good reason, Joane Cardinal-Schubert has warmly, earned the title *Joane of Art*.

Joane was no backyard warrior. She positioned herself on a national and international stage. She opposed the colonial framework by entrenching herself amongst the Indigenous art community writ large and positions herself on the frontlines. She worked in grand gestures that can be seen in several bodies of her visual art practice, such as in her series of *Warshirts* and in the profound work on residential schools with *The Lesson*. A fine example of Joane at work can be seen in her art piece entitled, *Preservation of a Species: DECONSTRUCTIVISTS (This is the House That Joe Built)* (1990). The work was included the 1992 seminal exhibition *Indigena: Contemporary Native Perspectives in Canadian Art*. This all Aboriginal art production was curated by Lee-Ann Martin and Gerald McMaster. The exhibition celebrated the works of nineteen artists; Kenny and Rebecca Baird, Carl Beam, Lance Belanger, Bob Boyer, Joane Cardinal-Schubert, Domingo Cisneros, Joe David, Jim Logan, George Longfish, Mike MacDonald, Lawrence Paul, Edward Poitras, Jane Ash Poitras, Rick Rivet, Eric Robertson, Luke Simon, Lucy Tasseor, and Nick Sikkuark. The accompanying catalogue includes six essays by the Indigenous writers Gloria Cranmer Webster, Alootook Ipellie, Georges E. Sioui Wendayete, Loretta Todd, Alfred Youngman, and Lenore Keeshig-Tobias.

The exhibition *Indigena* marked the 500 years after Christopher Columbus' "discovery" of the "New World." Of course, the climate surrounding the show was politically charged and the exhibition itself challenged the normative Western institutional

museological approaches in exhibiting an Aboriginal art show. It was an Indigenous juggernaut brilliant in its design. Simply by hosting a completely Indigenous exhibition it changed everything. *Indigena* is a creation story. After *Indigena* Aboriginal artists, curators, writers, and academics gained freedom, multiplied in numbers, and held some authority. It is a momentum that continues to spread out into diverse territories and to ones yet to be imagined. Joane is one of our decorated veterans that returned home from *Indigena* in honour and she will always be known as a warrior who participated in that crest of change.

In 1984, this "second wave" of artists brought about a new organization called the Society of Canadian Artists of Native Ancestry (SCANA). It was a national body aimed at the advancement of Aboriginal artists that continued the call for inclusion into the galleries, collections, cultural centres, and in the institutions of higher learning. Joane played an active role in this organization. At the 1987 Society of Canadian Artists of Native Ancestry "Networking Conference" in Lethbridge, Carl Beam and Joane sat on a panel. In a humorous moment, the two revealed difference philosophical approaches to their way of life and their art practice. David General was the moderator of the panel and he addressed Joane:

> David General: Do we need that mainstream? Do you think we should be cautious and stay away from it, Joane?
>
> Joane Cardinal-Schubert (JCS): Well, it's there. I mean, we don't drive our cars on dirt paths anymore. You know we …
>
> (Carl Beam interjects.)
>
> Carl Beam (CB): Sure. I do.
>
> JCS: Did you drive down here or did you fly?
>
> CB: I drove. I drove a lot of dirt roads.
>
> JCS: Okay. That's fine. That's your choice. It's about choices right?[6]

These two strong-minded heavy hitters kept very different lifestyles. In this moment, Joane held a position and she advocated for urban spaces for Aboriginal artists. Not only did she make space for herself,

she defended the urban territory for future generations of Aboriginal artists producing artwork in the city.

As an active community member in the City of Calgary, Joane served on the Calgary Aboriginal Arts Awareness Society (CAAAS) from 1988 until 2005. Israel Lachovshy recalled Joane working very hard to curate the annual CAAAS art shows. He stated that it was always a successful endeavour. She reached out to younger Aboriginal artists, to support and to make way for them. She was very generous in making pathways for others and I was fortunate enough to be a witness, and recipient, of that generosity.

While an undergraduate student, I was asked to contribute artwork to a CAAAS exhibition entitled *White Buffalo's All* (1995). The artwork was collected by a fellow First Nations art student, Kimowan Metchewais, and he in turn delivered the work to Joane as she would not step into the University of Alberta's Fine Arts Building due to racism she had previously experienced there.[7] I was scared to go to the opening. I had no idea how my work would be received in the CAAAS exhibition. I was making contemporary art and I had this ridiculous notion that my artwork would not be deemed as Indian enough, so I didn't attend the opening reception. Two days later, when I was brave enough to sneak into the Triangle Gallery and I visited the exhibition. I was shocked to see my prints run up the full length of the wall and directly opposite to a wall of Alex Janvier's paintings. It was as if my work was having a conversation with Alex's. I could see things in my work that I hadn't before. More importantly, I found place. As tears welled up, I had to leave the building. It was just such a profound moment for me. Her efforts to outreach to younger Aboriginal artists changed the way I think, look, and see.

Joane kept a special space for the colour red. It is the predominate colour in her palette. Joane and Kimowan Metchewais share a special something and when Kim made a small red painting on paper, he humorously entitled it *A Guide to Doing Contemporary Indian Art* (fig. 51). Joane recognized the humour and she purchased it. The piece suggested a line drawing in a one-point

perspective system that took up much of the surface area of the work, then with dashed foreshortening lines that seem to deny that notion. A penciled- free hand written text detailed the instructions: place images below, old photographs, some modern stuff for contrast, syllabics, the occasional taboo, some rock drawings, buffalo(s), nifty titles, a few tipis, and some shocking words. It was cheeky play with a mentor and she loved it.

The personal stories from those of us in the "third wave," and who might have had some on the ground or face-to-face associations with Joane, may connect with her as "auntie." She treated us as an auntie would. She was in her "kitchen of art" making sure that we all were fed. The Blackfoot dancer and choreographer and my friend, Troy Emery Twigg describes Joane as a close adopted auntie, a mentor, camp fire keeper, and as one of his best friends. Troy spent a good deal of time with Joane and he stated that one of the most important teachings he received was when Joane said: "Listen Troy. Don't ever think that you are better than anyone else and don't let anyone think they are better than you." She was fast with good advice.

Delia Crosschild, a contemporary Blackfoot painter and contemporary of Joane's, spoke fondly of her fellow artist. She recalled a playful moment when the two Blackfoot artists were lying down on the floor of the Glenbow Museum looking up at a painting of Delia's entitled *Trickster's Shift* (2001). It was mounted on the ceiling. They spent a good deal of time there talking about the colour, the movement, discussing Napi stories and, of course, laughing. Delia has taught art at the Kainai High School since 1997 and every year she shows the 1994 Loretta Todd film *The Hands of History*, where Joane makes a feature appearance. As a result, hundreds of proud Blackfoot students have been exposed to the work of Joane Cardinal-Schubert. Delia's daughter Joel Crosschild received the first BFA in Native American Studio Art, at the University of Lethbridge. Art goes down a family line in their house. Joel remembers being a very young girl when her mother took her to a performance of *The Lesson* (1990). It's hard to imagine how big and monumental that piece may have appeared in the eyes of a young child. It was shocking to adults. Delia continues to celebrate Joane's work with the young people. She mentioned how she loves the part in *The Hands of History* when Joane says with a grin "I'm Joane Cardinal-Schubert – and I play a lot."

51. Kimowan Metchewais
A Guide to Doing Contemporary Indian Art, 1989
28.6 x 19.1 cm
11.25" x 7.5"
Oil on paper
From the Estate of Joane Cardinal-Schubert

Joane was an iconoclast. Some people found her intimidating, and she could be. Joane was often positioned on the frontline of many Indigenous political events, but she repeatedly insisted that she was not political. "I started on this road to paint about my personal ... but because I am Aboriginal, my work is considered political. I don't think about it as political ... I think of it as personal."[8] Still, the major works *Preservation of a Species: DECONSTRUCTIVISTS (This Is the House That Joe Built)* and *The Lesson* are definitely political.[9] Her work is packed full of political narrative. This can be seen in Joane's installation *Preservation of a Species: DECONSTRUCTIVISTS (This Is the House That Joe Built)*. In a quite negative review entitled "Whose Nation? Two Recent Exhibitions at the National Gallery of Canada and the Canadian Museum of Civilization Raised Disturbing Questions about the Positioning of First Nations Art in the White Mainstream" by Scott Watson in the 1993 spring edition of *Canadian Art*, Watson goes on to describe Joane's installation:

The title [of the installation] refers to the death-bed of the artist's father, Joe Cardinal: 'If I had made a stand – you wouldn't have to. You've got to stand up to them.' In this installation, Cardinal-Schubert has painted the walls black and covered them with writing in chalk, invoking the memory of a school room, a site highly charged with memories of brutality for many First Nations people. Mixing memory, polemic and history, the artist has written accounts of oppression and defiance. As a non-status Indian, she protests, "What does part Indian mean? (which part?) You don't get 50% or 25% or 16% treatment when you experience racism – it is always 100%" One had to peer into a small room to see her statement. It felt like one was intruding.[10]

Scott Watson's very dismissive review begrudgingly gives weight to Joane's artwork by acknowledging its impact.

It was impossible to quibble with the force of Cardinal-Schubert's work as activist statement. It stared you down without blinking and was fiercely honest. But as an artist, Cardinal-Schubert deployed strategies that worked against the message she wished to convey. There was a sense that much was executed in haste, that the installation was provisional. While this created a feeling of urgency and readiness for action, it also undercut the seriousness and deliberation of what she had to say. It's the difference between scattershot and a well-aimed bullet.[11]

Buckshot was exactly what Joane wanted to convey, after all her work was just across the river from the nation's capital and Joane would not want go to Ottawa without leaving her mark. She had a lot of ground to cover.

Dick Averns gave account of Joane's unwavering iconoclastic character. While seated in the audience at the 2006 Alberta College of Art and Design (ACAD) convocation, Dick witnessed the delivery of an alumnus award to Joane Cardinal-Schubert. Averns provided context to the event as he described the ACAD institutional climate as a place with waning morale and high staff turnover.

It's almost as if Joane could sense that in the manner in which the award was bestowed. [The award] was as much about the President/College seeking to benefit by claiming Joane as one of their own … as much as it was about Joane being honoured … and what struck me was the way in which Joane had delivered her comments. It was not quite with derision, but certainly with a clip and tone that drew the breath and humour of the audience … as if to say, you don't need a piece of paper to succeed. It certainly didn't strike me as condescending to the grads in the audience, but a form of veiled warning about not succumbing to the pandering of institutions … It could be that Joane was hamming it up, calling bluff or performing a whiff

of nonchalance. Either way, her message was one of self-reliance, conveying the value of speaking truth to power, and that one can make art of value by engaging deeply with your belief regardless of status.[12]

Joane held the wise voice of experience. Higher institutions of learning did not put out the welcome mat for Indigenous people and many people looked away as the doors were closed on Aboriginal artists. It was rare to see those in the "second wave" in teaching positions. Things have shifted a bit, but not as much as one might think. It is still a coup, or a major battle, to claim entrance into the ivory tower. In the past decade, more tenure and tenure-track academic positions have opened up for Aboriginal people. Joane would have made a fantastic academic studio teacher and positioned in a different time she would have been, but she was solidly mentoring a "third wave" of artists anyway, and she positioned herself right at the front door of the art institutions.

Joane held the position of curator at the University of Calgary's Nickle Arts Museum from 1977 until 1985. She spent many waking hours dedicated to the museum and she worked there for eight years. Joane is largely recognized as an artist working in a wide range of media, but not as many people are aware of her extensive arts administration and her experienced curatorial skill set. In this environment, Joane was just as much of a mentor to the people working in the art gallery world. Gallery work is a profession where training is gained through mentorship and, if you're lucky, under strong tutelage. Many people credit Joane for teaching them the craft. Her standards were high and she expected good work.

Now retired, Lesia Davis, a former City of Red Deer Culture Superintendent and the former Executive Director of the Campbell River Museum, has had thirty-five years of experience working in the arts. She started her career as an unemployed walk-in, with no formal training, no resume, and without a job posting. Joane saw something in her person and hired her immediately. Within a week she was tagged with the position as curatorial assistant. "I was mentored in all aspects of art and art curating through the mind and eyes and heart of Joane. Only in retrospective did I realize what a generous gift that was."[13] Galleries keep stories. There is institutional memory and for sure, the Nickle Arts Museum is

imprinted with Joane Cardinal-Schubert's spirit. It seems very fitting that the first full retrospective of Joane Cardinal-Schubert's work be held within those walls and I can only imagine the weight felt by the curator Lindsey V. Sharman to "get it right." I also imagine Joane's spirit in the gallery, advising, and giving direction to her own retrospective. She has passed on to the other side but she is still with us.

Kristy Trinier, Director of Visual, Digital and Media Arts at the Banff Centre for the Arts and former curator at the Art Gallery of Alberta recalled working on the installation of Joane's mid-career exhibition at the Art Gallery of the South Okanagan in Penticton, BC, in the summer of 1998. It was her first time working in an art gallery. She described Joane as open and generous as they installed Joane's iconic work *The Lesson* (fig. 24).

> Watching her install *The Lesson* was a powerful experience I will not forget: the sound of the chalk and the time she took in writing each word. Sourcing the apples, she held each one in her palms before setting it on the chair: 'the apples must be red on the outside and white on the inside, the way they wanted us to be.' Exhausted at the end of the installation, I remember we walked outside the gallery to the edge of Okanagan Lake and she looked for a long time over the water.[14]

The silent contemplation was just as profound as the work itself. The work on the subject of residential schools is heavy.

Perhaps, Joane Cardinal-Schubert's most important curatorial contribution was to the Narrative Quest project with the Alberta Foundation for the Arts (AFA). The AFA recognized a weak representation of Indigenous artwork in the collection holdings and intended to do something about the matter. In a forward thinking gesture of affirmative action, the AFA contracted Joane to compile recommendations for Aboriginal artworks to be considered for the AFA's curatorial acquisition committee. Joane took this responsibility very seriously. In a rather intimate telephone conversation I had with Joane, in 2008, we exchanged stories about our shared experience in facing cancer. We discussed at length the responsibility she felt in her effort to include as many artists as she

could balanced by a strong representation of artwork from contemporary Aboriginal artists. She mentioned her concerns about knowing that she could not include every First Nations artist who resided in the invisible boundaries of Alberta, but she did a wonderful job. The AFA targeted initiative added an astonishing seventy-three pieces of artwork by senior, mid-career, and emerging Aboriginal artists giving a more accurate representation of the presence of Aboriginal artists in Alberta and the final result added much more colour to the AFA collection.

To celebrate these new additions to the collection, Gail Lint, an AFA art collection consultant, curated the *Narrative Quest* exhibition. Not surprisingly, Gail recognized that the Indigenous additions to the collection had a prevalent theme based on storytelling. The *Narrative Quest* exhibition was displayed across Alberta. Initially exhibited at the AFA Arts Branch in 2009 and then shortly followed by exhibitions at the Royal Alberta Museum, the Art Gallery of Grande Prairie, with edited versions on display at MOCA and the Red Deer Museum and Art Gallery. In 2015, an edited version of *Narrative Quest* was exhibited in Tokyo, Japan at the Embassy of Canada in the Prince Takamado Gallery. The work is now folded into the main collection.

Each artist that Joane approached regarding the AFA initiative had one-on-one conversations with her not long before she passed. These artists hold stories of their last conversations with Joane in close regard. It was as if the spirit world opened pathways that gave the way for Joane to visit and to touch the hearts and minds of her Aboriginal art family before she moved on to the next world. Joane's last physical studio act was to submit the teepee poles for her own work *Medicine Wheel (There is No Hercules)* (1985) (fig. 52) for *Narrative Quest*. When the folks from the AFA came to her home in Calgary to pick up the teepee poles for the piece she was too ill to be able to make it to her door. Her husband Mike and her son Justin brought the teepee poles outside on her behalf. She never made it to see the *Narrative Quest* exhibition.

In Joane's poem she calls out to us, the keepers of the vision, the guardians of our stories, to hold on to our responsibility to protect our stories. There are old stories going back thousands of centuries and there are our new stories that fold into the continuum. She asks us to be true to our stories, to retell them again and again and to keep

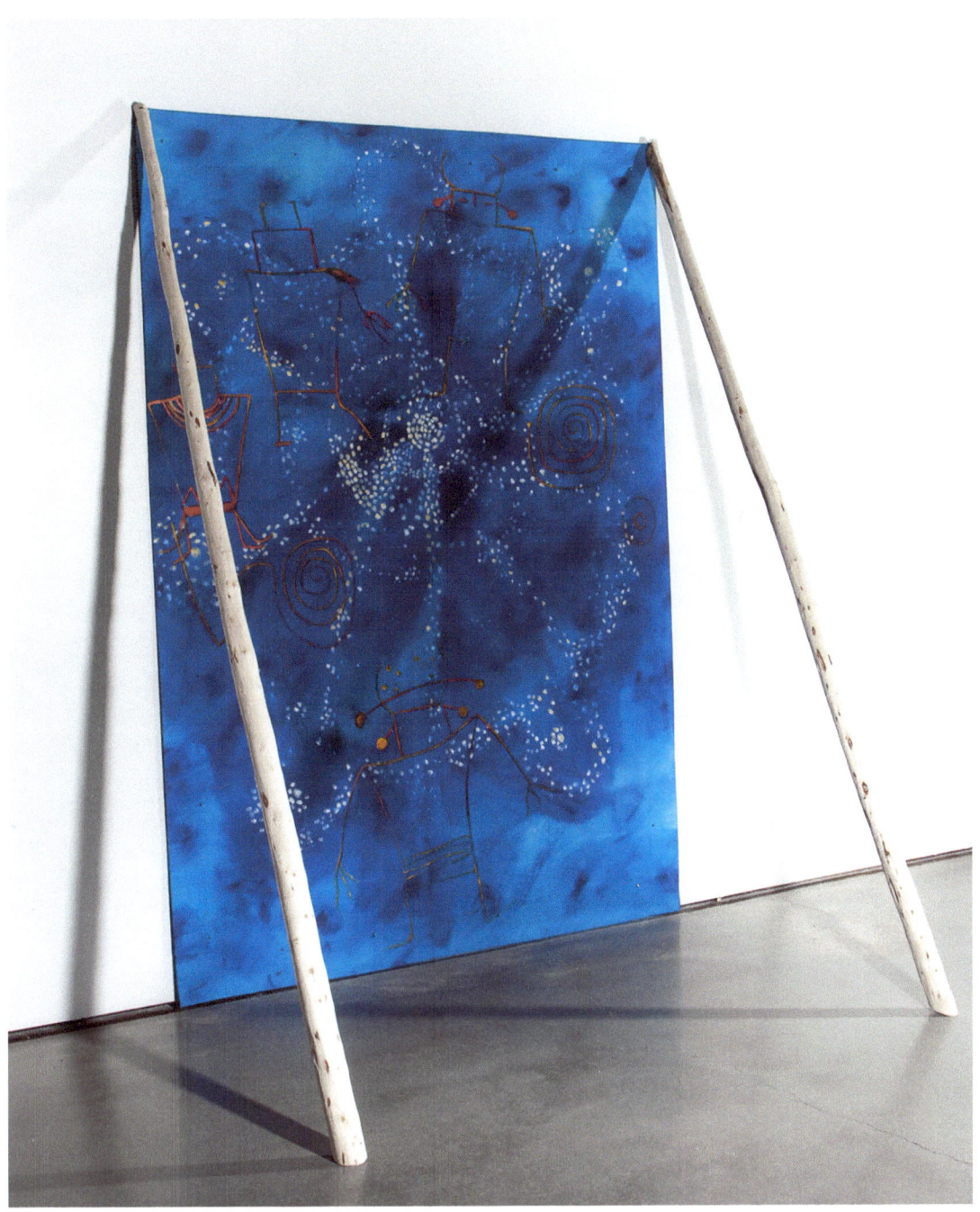

52. *Medicine Wheel (No Hercules)*, 1985
233 x 172.1 x 111.1 cm
92" x 68" x 43.75"
Acrylic on canvas and lodge pole pine
Collection of the Alberta Foundation for the Arts

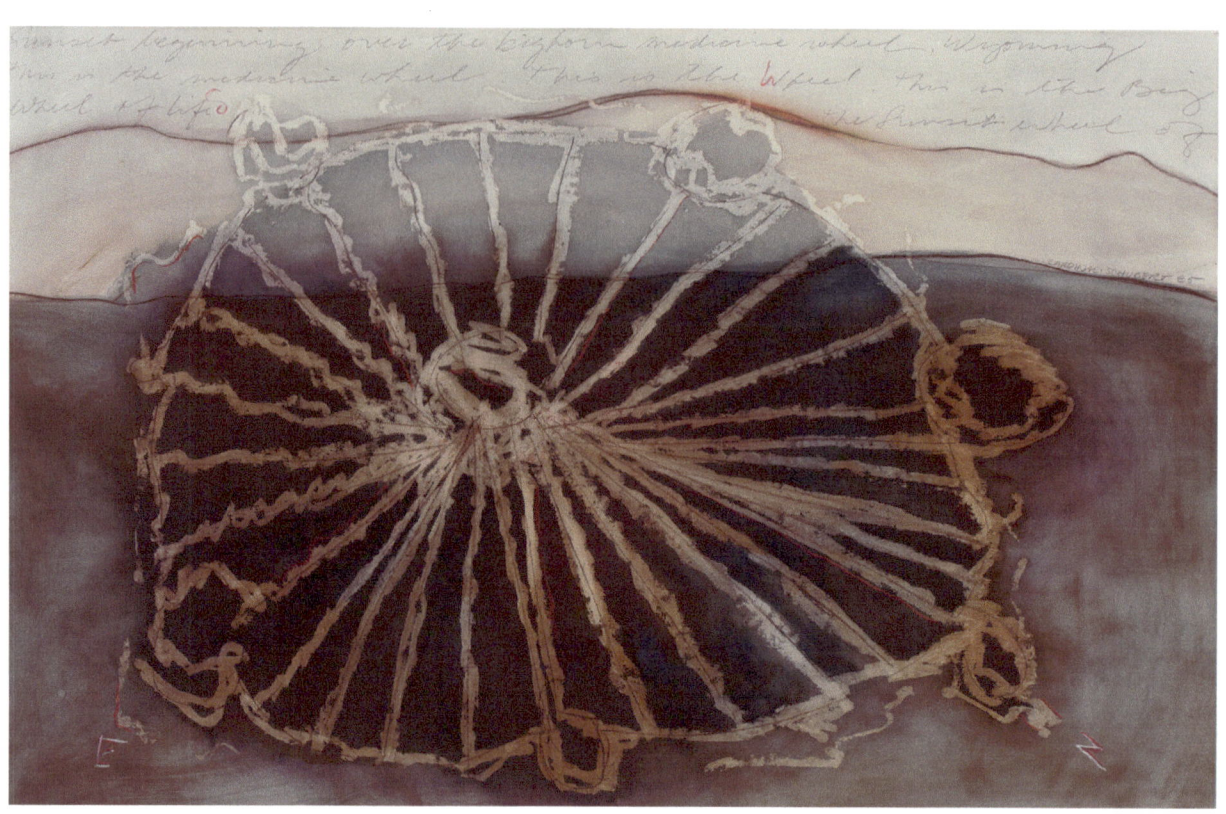

53. *Sunset Beginning*, 1985
66.5 x 101.8 cm
26" x 40"
Oil and coloured pencil on paper
Collection of the Alberta Foundation for the Arts

them in the circle. That was where Joane positioned herself. "I exist at the centre of a big circle. My 'stories' are circular, the end and the beginning linked ... referenced ... and I can cross over the circle and spin off into little circles."[15] I wondered what other circles did she have. Who held more stories and would share them.

As Joane depicted so many people on her Aboriginal Concorde, I wondered where she saw herself in the story. Then it occurred me – she wouldn't be on the Concorde. She would be on the ground – in the control tower, directing traffic.

> Joane, our dear aunty, please save a slow waltz for us all in the sweet hereafter. I was told once by an elder that you'll never see two colours in heaven: red and black. But I am sure that you've advocated for your favourite red cowboy boots up there, and I'm sure you're wearing them now, laughing it up, celebrating, checking up on us all and seeing that all of your hard work, all your trailblazing has paid off. We enjoy so many things now because of your hard work and all you've inspired. Yes, save a slow waltz for your friends and family. There'll be a long line. And we'll visit in line to see you once again. I hear the bannock and jam up there is superb. And the tea? Handpicked by angels and ancestors all laughing together.
>
> You will always be a cherished soul to all who knew you, and I was very lucky to share time with you. Thank you for reminding us all what this life is about: to lighten the load for others, to make the world a better and brighter place for the future generations, to fight hard for common sense and what's right everywhere. Mahsi cho. Thank you so very much for the light you brought us all. A ho!
>
> – Richard Van Cap[16]

NOTES

1. The poem "Keeper" is from the back of a University of Alberta Fine Arts Building Gallery exhibition poster for the Joane Cardinal-Schubert *Passage to Origins I: Joane Cardinal-Schubert*. Edmonton, 1993.

2. Keynote address "Flying with Louis" by Joane Cardinal-Schubert. It was delivered as a part of the 2003 Walter Phillips Gallery and the Banff Centre's Aboriginal Arts Program *Making A Noise!: A Forum to Discuss Contemporary Art, Art History, Critical Writing, and Community from Aboriginal Perspectives* and the subsequent publication edited by Lee-Ann Martin.

3. Griselda Pollock delivered the lecture "Feminist Art Ethics and the Anthropocene," held in conjunction with the *New Maternalisms Redux* public colloquium hosted at the University of Alberta and organized by Natalie Loveless and Sheena Wilson.

4. The quote is from Loretta Todd's 1994 film *Hands of History*.

5. Quote from the University of Alberta Fine Arts Building Gallery exhibition poster for the Joane Cardinal-Schubert *Passage to Origins I: Joane Cardinal-Schubert*. Edmonton, 1993.

6. This exchange was recorded in the 1987 Society of Canadian Artists of Native Ancestry "Networking Conference" in Lethbridge. They are housed in my office at the University of Alberta. Art Historians wanted.

7. Macleod, Jennifer. "Joane Cardinal-Schubert: At the Centre of Her Circle." *Galleries West* (Spring 2003): 10–11.

8. Ibid.

9. Joane performed several versions of *The Lesson*.

10. Scott Watson, "Whose Nation? Two Recent Exhibitions at the National Gallery of Canada and the Canadian Museum of Civilization Raised Disturbing Questions about the Positioning of First Nations Art in the White Mainstream," *Canadian Art* (Spring 1993): 34–43.

11. Ibid.

12. In correspondence and telephone conversation with Dick Averns.

13. In correspondance with Lesia Davis.

14. In correspondence with Kristy Trinier.

15. Jennifer Macleod, "Joane Cardinal-Schubert: At the Centre of Her Circle," *Galleries West* (Spring 2003): 10–11.

16. Richard Van Camp's tribute to Joane Cardinal-Schubert. *Facebook*. Edmonton, 16 September 2009.

54. *My Mother's Vision VII*, 1983
80.3 x 192 cm
31.5" x 75.5"
Oil, pastel, and charcoal on paper
Collection of the Alberta Foundation for the Arts

55. *Moonlight Sonata: In the Beginning*, 1989
171.5 x 122.5 cm
67.5" x 48"
Oil on canvas
Collection of the Alberta Foundation for the Arts

"Was it the Robin's egg, I scrambled up the fence to view ... sometimes there sometimes not ... but then there ... was it the snail I squeezed between my fingers at 5 as I squatted at the edge of the creek ... or the succession of hawks, bears, muskrats, Canada geese ... deer and other birds and animals that we intimately gained knowledge of in our family ... or was it the setting sun on our lake with the deep blue black clouds arching over us while the bittern sounded gulong gulong ... and the loon whom I was sure was a person, laughed its loony laugh ... or was it the fact that the importance of these things were pointed out to me ... was I emerging ... emerging from what ... emerging as a single human being ... with specific interests ... hmmmm emerging ... "

– Joane Cardinal-Schubert, RCA
"Surface Tension" from the artist's personal documents

BY TANYA HARNETT

Recollections *137*

56. *Crowsnest Mountain and the Seven Sisters*, 1989
75.6 x 106.1 cm
30" x 42"
Oil on paper
Collection of the Alberta Foundation for the Arts

57. *This Is the Land*, c. 1988
150.5 x 242.5 cm
59.5" x 95.5"
Oil on Masonite
Collection of the Alberta Foundation for the Arts

58. *I Dream of Horse/Counterpane*, 2002
183.2 x 122.2 cm
72" x 48"
Acrylic and gold leaf on canvas
Collection of the Alberta Foundation for the Arts

BY TANYA HARNETT

59. *Yellow Plywood*, 2005
75.5 x 105.5 cm
30" x 41.5"
Mixed media on rag paper
Collection of the Alberta Foundation for the Arts

60. *Flutterby (Birchbark Letter)*, 1998
120 x 99.5 cm
47.5" x 39"
Mixed media on canvas
Collection of the Alberta Foundation for the Arts

[STILL] RESPONDING TO EVERYDAY LIFE

by Joane Cardinal-Schubert and Gerald McMaster

This interview was conducted by Gerald McMaster with Joane Cardinal-Schubert in 1997 for a retrospective exhibition called *Joane Cardinal-Schubert: Two Decades* organized by the Muttart Gallery in Calgary and curated by Kathryn (Kay) Burns. It was published in a catalogue produced for the exhibition that was "dedicated to the Kainaa People of Southern Alberta." Another two decades on, we look back again, but in this publication the interview is published in reverse order, which seems more fitting this go-round. This re-ordering plays with the artist's own rejection of linear narratives and allows one to retrace Cardinal-Schubert's footsteps and perhaps see new meaning in her words. This is also informed by the artist's assertion to look back to look forward. Dr. McMaster's closing comments and introduction to this interview are included successively to give Joane Cardinal-Schubert the final word. (Only if, of course, you read it front to back.) Here, in her own words, Cardinal-Schubert discusses her work and shares how viewers might take her "glancing back" to help walk forward through the themes she presents.

– Lindsey V. Sharman, 2017

Introduction and Closing

On the eve of Calgary-based artist Joane Cardinal-Schubert's retrospective at the Muttart, I felt this was the place to begin "glancing back," as she says, at her life and art. As we will discover in this retrospective Cardinal-Schubert has a close connection and tactile response to her media, as well as a profound connection to her childhood. If we are to believe some Adlerian psychoanalysis that we are conditioned by our "childhood logic," I would suggest that in Cardinal-Schubert's case, this logic forms the basis of her practice. Thus, in this retrospective we can begin to examine the complex and discrete approach to creativity.

– Gerald McMaster, 1997

In closing, understanding the idea of a retrospective is a traditional phenomenon in the visual arts [which] frames the life of an artist: it is a trace in their life. For the rest of us, these traces can be as banal as photographs and home movies, which are deeply personal and wrapped in much sentimentality. For the artist, their work operates on a similar level. The difference, however, is that they add thought, opinion, and physical expression. A retrospective allows us to look at their life, it opens the artist's work to various levels of interpretation which we, the viewers, then overlay with our own brand of logic. The foregoing conversation has merely gotten us to the threshold; the rest is up to us.

– GM

GM: Creativity is bringing two or more things together to come up with something interesting, that is why I asked about innovation. Regarding the technical innovations you've made and your experiences of using new materials, I want to ask: have you ever combined something that is very Indian with your knowledge of materials and art to create something that is a Cardinal-Schubert? Is there an aesthetic identity that is yours?

JC-S: I thought of how people used materials in the past and their respect for the natural world. If I look at my earlier work, I was interested in using earth tones. Or, sometimes my ideas come about because I realize how much people don't understand; sometimes it's about some obtuse thing happening, like the Lubicon situation where kids were dying. Earlier I mentioned the muskrats stretched across our wall, in the work *One Little, Two Little, Three Little, Preservation of a Species* (1987), that is how I placed the plaster babies. The combination of plaster and babies had a relationship to seeing the muskrat skins on the wall. In it you will see personal references.

Before I realized I was interested in a thing called art, I had been interested in making things. A certain amount of this came from watching my dad. He was always building things. When I look back at it now, I realize that not everyone lived that way. Later, when I started making art, I remembered how these ideas helped me creatively. I wasn't interested in doing something someone else had done, that is why I never understood art history or understood a lot about other artists' works, who seemed to be more interested in re-making something that had been done before. For me, if I wasn't doing something innovative or seeing something in a new way, I didn't want to do it! For me, the whole process is about the discovery and excitement of working. This is just to say that my everyday experiences have a lot to do with what I make.

GM: With your own experiences, do many of these ideas come naturally?

JC-S: I think it has a lot to do with the first six years of my life like remembering a lake with water lilies, the animal life, and my dad's trap lines around the lake.

He used to stretch muskrats across boards and tack them in long rectangles along the wall. As a kid, I was curious of how the hides had been scraped, their smell, colours, and fur. Those moments are still important for me.

GM: If it's the case that we don't know the outcome of a work, let me turn to the idea of innovation. Are there some things you've done that should be pointed out?

JC-S: I think the most interesting thing I found is that I have absolutely no adherence or any sort of respect for the traditional use of materials. I cross disciplines. I've tried all media. Sometimes when I can't quite express an idea, those cross disciplines become really important to me. My biggest innovation, I think, is getting a chance to work with students, of working, showing, and questioning them about creativity. By gathering various materials I've shown them how to create something that brings them to a point of emotion. I love the challenge of innovation, especially using materials differently.

For me, walking down the street and noticing something becomes a frozen moment and combines somewhat with what I'm doing or experiencing. The way I found this out one time, was walking through a park in early August and seeing green shimmering leaves. I took a photograph. Suddenly I realized what Impressionism was! Everything I was taught, all the Impressionists whose works I looked at, the things I saw in Japan [Impressionist works], in that sudden moment everything came together and made sense. Only sometime later did I develop the photo. Another moment was when I went to Waterton park, where I photographed a bear through a cracked window. Still another moment was when I was working on some pictographic drawings. In a presentation to some art students, I showed them a slide of a work I had done. It was a pictograph and bears. I noticed the park, Waterton Park, and the Milk River. I was then able to tell them how my work came from those experiences. They were able to understand how I work.

GM: It's like you're getting a clearer picture now?

JC-S: One keeps adding to the information and being informed. If I don't continue being informed, it I don't keep being interested, if I don't keep finding out about things, I wouldn't be doing it. I'm so interested in the process of making a work. For me that is the most wonderful part because I don't know anything when I start.

GM: So you can return to ideas over and over again?

JC-S: Yes, or I re-address ideas, because they simply come up in my life. For example, the same things I was concerned about when I was a kid still come up in my life now.

GM: That's what I mean by themes, so that, in opposition to linearity, you're dealing with ideas that jump around.

JC-S: I believe in chaos theory, chaos as the natural order of things, which I see in my work.

GM: Have you and the curator put some guidance into the selection for the viewer?

JC-S: Absolutely not. The idea of the retrospective and linear presentation wouldn't work with me as I found out from looking at my own work. I really work in this huge circle with many little spin-off circles.

GM: Certainly when you're creating, you're not creating for anybody but doing it for yourself; but, when the works are on display, you can't do anything about it. The viewer will look and decide for themselves what to interpret.

JC-S: I agree, that's what I want to happen.

GM: You talked about your work being a mirror, I might call it a looking glass, where the viewer looks into your work, whereas the mirror reflects ideas. In the twenty years of work, are there themes you and the curator selected you felt were important for the viewer?

JC-S: I'd like to address the idea of the looking-glass and mirror. The thing about a retrospective isn't the act of looking

(Still) Responding to Everyday Life *147*

back but a glancing back; because, it is just a quick glance, I don't need to look, because I'm already carrying all that stuff with me when I work. When we're talking about the looking-glass, it's like taking a really long look or a studied thing. It's not that way with me. I'm not trying to get that involved; I'm not trying to take over how people look at something; I'm putting in a small bit of how I feel about something. My work is coded, a coded visual vocabulary that satisfies me inside where no one can get to. It's important for me to have that kind of language in my paintings, so the viewer will not get it. All I want to do for the viewer is to create a glance. I don't want to interfere with their memories or how they feel about the situation. I only want to create the beginning so that they can escape to that mental video-tape that carries all the important information. I try not to overlap into their sensitivity or personal memory.

GM: A retrospective is a looking back with a perspective of today, seeing where you've come from, and seeing in the works what you were thinking at the time, you take the audience through a trip. How often does that happen?

JC-S: A retrospective is a Western European idea of what happens within an artist's lifetime. When I worked as a curator I had a problem with art being created for the under-thirty crowd. I never did fit in. I didn't go to university until I was thirty. I didn't start creating serious pieces until I was thirty, thirty-five. You know, some things I made as a little kid informed me more than my work now. A retrospective is something I do all the time as I work; I'm always looking back. The knowledge of when I was little and the way I look at the world is included in what I'm doing now. I don't feel that being a certain age is unconnected to an earlier age; I've set it aside because I'm too old. I'm the same person I was when I was two. I think that is why people look at me and think that I'm a lot younger than I am. I don't have a sense of what I should be; I just am!

In my work, I'm trying to create a mirror for people to look into, to make people feel the way I do, which is to be personally concerned with a lot of things. We live in a world where we understand it by language and by the things that are out there. What I try to do is take some

of those things and put them together in a visual context, to create a kind of reference to memory.

Gerald McMaster: What do you think about having this retrospective of your work?

Joane Cardinal-Schubert: I think it's interesting it originates in a city which, for the most part, has totally ignored me (laughs). It originates with the one public gallery that showed me in 1977 as one of its first artists and then went on to show my work in the context of eight other group shows over the past twenty years, I'll get to look at paintings I haven't seen for a long time, to see them juxtaposed against new works. It's really a good learning experience and valuable to see where I've been. It's not often we get that chance to recall a lot of work and to revisit concepts.

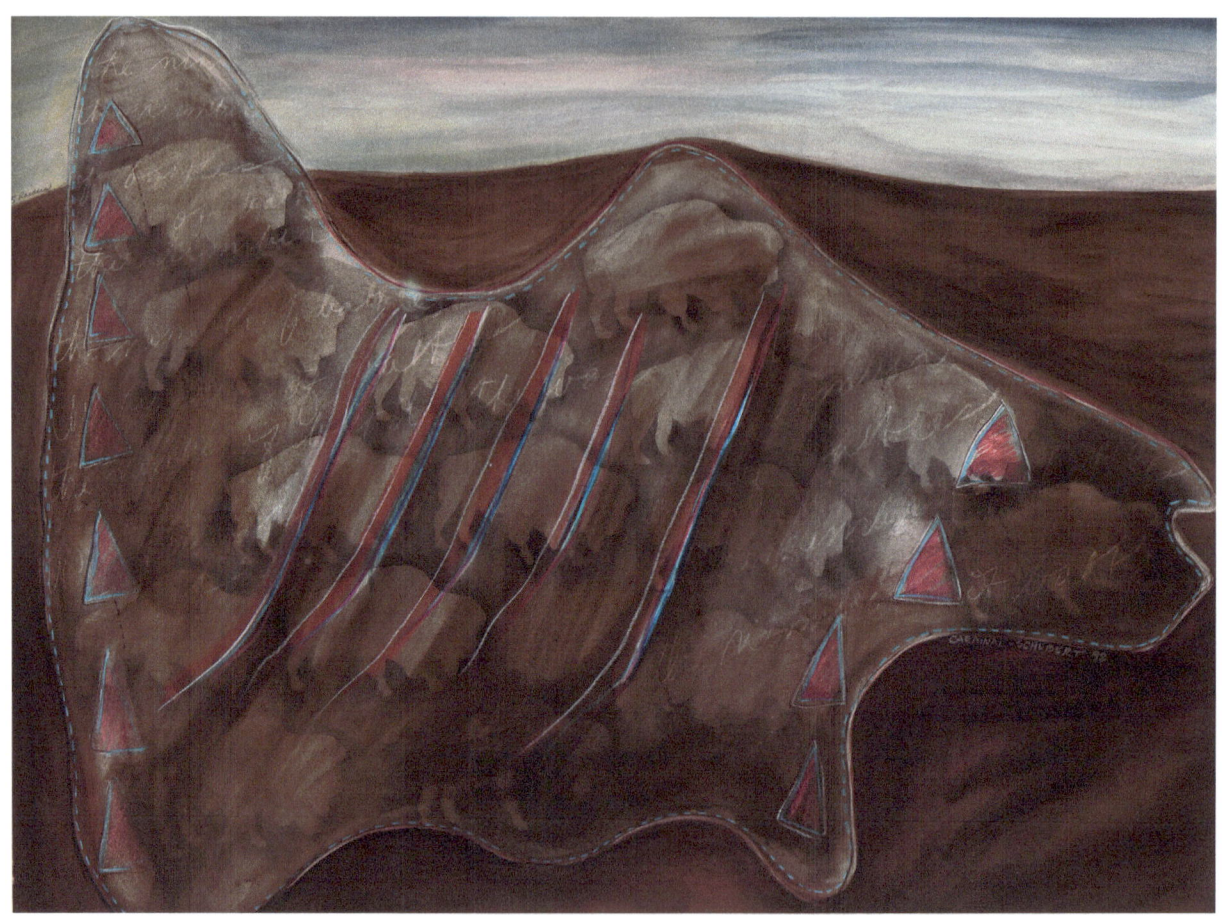

61. *5 Raiders*, 1982
58.42 x 78.74 cm
23" x 31"
Oil pastel on paper
Collection of the Juniper Hotel, Banff

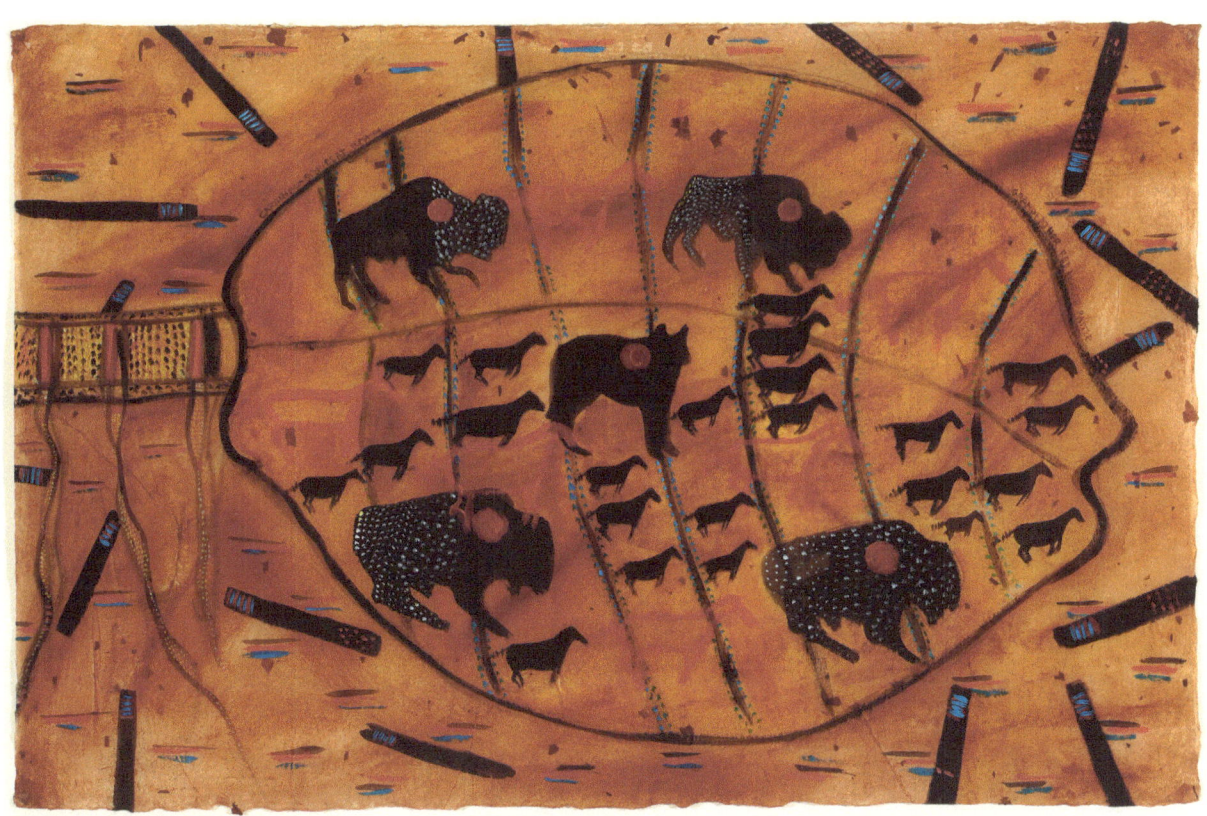

62. *Grandfather Red Horse Rattle*, 1994
59.9 x 91.2 cm
32.5" x 36"
Oil on canvas
Collection of the Robert McLaughlin Gallery; purchased with the support
from the Canada Council for the Arts, Acquisition Assistance Program, 1998

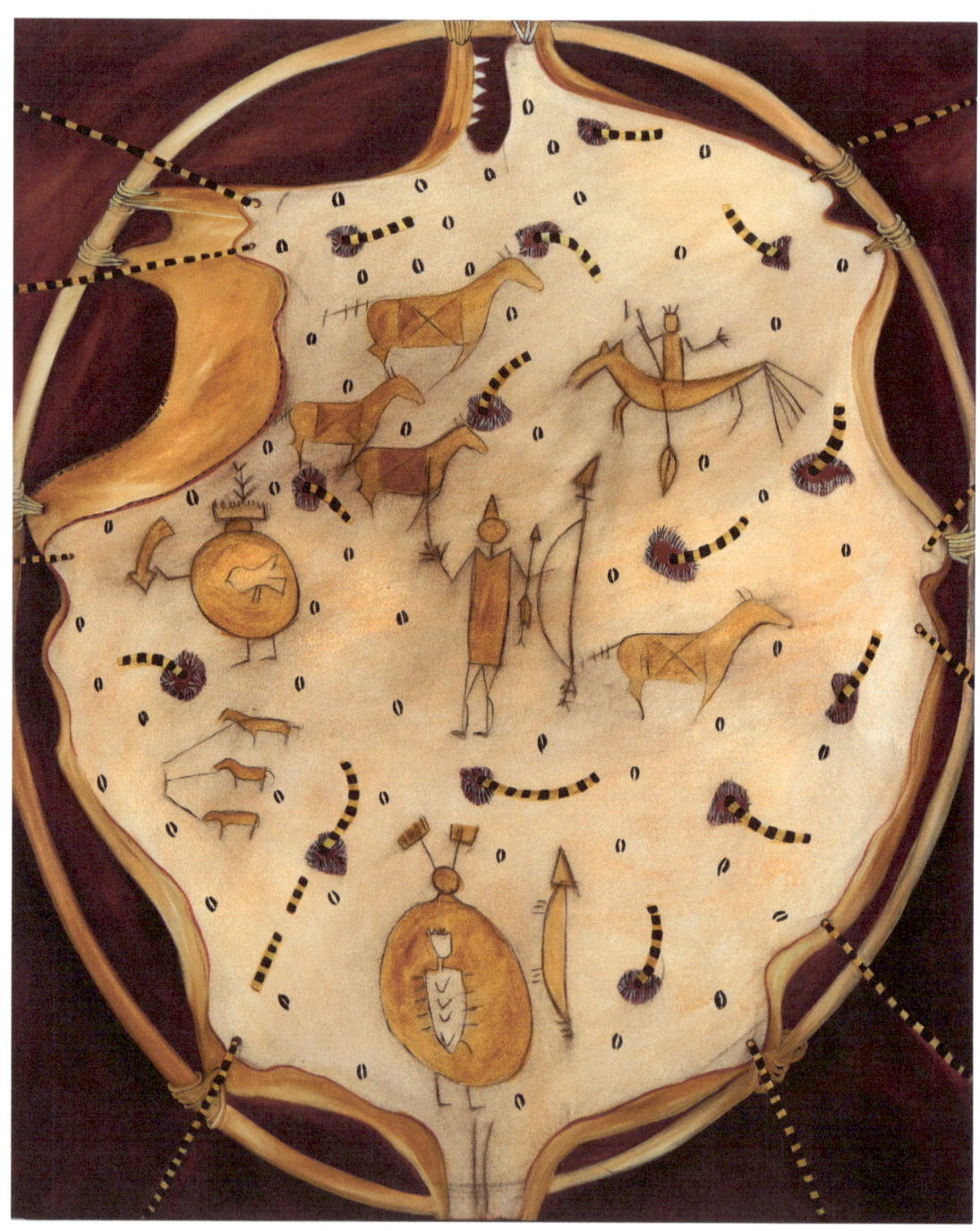

63. *Dreaming of Ghost Dance Shirts*, 1995
153 x 121.9 cm
60.25" x 48"
Acrylic on canvas
Fulton Family Collection

IMAGE LIST

All images reproduced with permission from the Estate of Joane Cardinal-Schubert. Photography by Dave Brown, LCR Photo Services, University of Calgary, unless otherwise noted.

1.
Rider, 1986
152 x 213 cm
60" x 84"
Oil and graphite on canvas
From the Estate of Joane
 Cardinal-Schubert

2.
Self Portrait Warshirt, n.d.
152.4 x 101.6 cm
60" x 40"
Mixed media on paper
From the Estate of Joane
 Cardinal-Schubert

3.
Warshirt for the Earth, 1980
59.7 x 80.7 cm
23.5" x 31.75"
Mixed media/Acrylic on paper
Collection of the Red Deer Museum and
 Art Gallery 2001.107.1
Photo: Red Deer Museum and
 Art Gallery

4.
Remembering My Dreambed, 1985
149.86 x 114.3 cm
59" x 45"
Acrylic on canvas
From the Estate of Joane
 Cardinal-Schubert

5.

Springtime in the Rockies, 1977

16.5 x 21.6 cm

9.75" x 11"

Hand coloured plexi etching on paper, artist's proof

Collection of Glenbow; gift of Shirley and Peter Savage, 1995

995.018.143

Photo: Glenbow

6.

Pictograph – Writing-On-Stone, 1980

54.4 x 73 cm

21.5" x 28.5"

Conté and oil on paper

Government House Foundation Collection: GHF81.001.001

Photo: Alberta Foundation for the Arts

7.

14 Raiders, 1981

49.53 x 72.39 cm

30" x 41"

Oil stick and conté on paper

Collection of Glenbow; anonymous donation, 2015

2015.006.002

Photo: Glenbow

8.

Grassi Lakes, 1983

81.28 x 121.92 cm

32" x 48"

Watercolour and oil crayon on paper

Collection of Glenbow; purchased with the support of the Canada Council for the Arts Acquisitions Assistance Program/oeuvre achetée avec l'aide du programme d'aide aux acquisitions du Conseil des Arts du Canada, and from the Glenbow Collections Endowment Fund, 2000

2000.002.003

Photo: Glenbow

9.

Girl on a Bicycle, 1973

121.9 x 182.9 cm

48" x 72"

Acrylic on canvas

From the Estate of Joane Cardinal-Schubert

10.

Carousel (Portrait of Christopher and Justin), 1977

121.9 x 182.9 cm

48" x 72"

Acrylic on canvas

From the Estate of Joane Cardinal-Schubert

11.
Sunday and the Gossips at Mountview Mennonite Church, 1975
91 x 93 cm
35.75" x 36.5"
Acrylic on canvas
From the Estate of Joane Cardinal-Schubert

12.
Sick Father, 1969
50.8 x 91.4 cm
20" x 36"
Acrylic on canvas
From the Estate of Joane Cardinal-Schubert

13.
Finally, I Am Witnessing the Death of John Wayne, 1979
59.7 x 90.2 cm
23.5" x 35.5"
Acrylic on paper
Collection of Greg Younging

14.
This Is My Mother's Vision, 1987
51 x 101 cm
20" x 39.75"
Oil and conté on paper
City of Calgary Civic Art Collection, gift of the Calgary Allied Arts Foundation, 1988
Photo: City of Calgary Civic Art Collection

15.
Ceremonial Mound, 1982
60.96 x 81.28 cm
24" x 32"
Acrylic and pastel on paper
Private collection, Calgary

16.
Creation of Life, n.d.
54.6 x 74.9 cm
21.5" x 29.5"
Chalk and mixed media on paper
Joan and David Taras Collection

17.
Walking My Dog, 1977
38.1 x 58.42 cm
15" x 23"
Intaglio, artist's proof
From the Estate of Joane Cardinal-Schubert

18.
After Neil, n.d.
40.6 x 44.45 cm
16" x 17.5"
Intaglio, artist's proof
From the Estate of Joane
 Cardinal-Schubert

19.
Alberta Landscape, n.d.
34.29 x 53.34 cm
13.5" x 21"
Intaglio, artist's proof
From the Estate of Joane
 Cardinal-Schubert

20.
Ghost Dance, 1987
40 x 49.53 cm
16" x 19.5"
Hand-tinted etching, 37/50
From the University of Lethbridge Art
 Collection; transferred from the
 Native American Studies Department,
 2004
Photo: University of Lethbridge Art
 Collection

21.
Self Portrait, n.d.
33.02 x 35.56 cm
13" x 14"
Intaglio and woodblock
From the Estate of Joane
 Cardinal-Schubert

22.
Kitchen Works: sstorsiinao'si, 1998
411.48 x 411.48 cm
162" x 162"
Mixed media installation around five
 54" x 54" panels arranged in the
 shape of a cross.
From the Estate of Joane
 Cardinal-Schubert

23.
Self Portrait as an Indian Warshirt, 1991
61.5 x 91 cm
36.75" x 47.5"
Mixed media on paper
Collection of Glenbow; purchased with
 the support of the Canada Council
 for the Arts Acquisitions Assistance
 Program/oeuvre achetée avec l'aide du
 programme d'aide aux acquisitions
 du Conseil des Arts du Canada and
 with funds from Glenbow Collections
 Endowment Fund, 2000
2000.002.004
Photo: Glenbow

24.
The Lesson, 1989
Installation, dimensions variable
chairs, whistles, books, apples, rope, mirror, chalk
Installation view, Witnesses: Art and Canada's Indian Residential Schools (September 6-December 1, 2013) From the Morris and Helen Belkin Art Gallery, UBC.
Photo: Michael R. Barrick

25.
Detail of *Where the Truth is Written – Usually*, 1991
76.2 x 152.4 cm
30" x 60"
Oil on canvas flag with lodgepole pine flag pole
From the Estate of Joane Cardinal-Schubert

26.
Modern Dancer – Grandmother's Thimble Dress Dream, 2006
119.38 x 81.28 cm
47" x 32"
Oil and acrylic on canvas
Private Collection

27.
When We Saw Our Grandmother's Dress, 2007
48" x 31.5"
121.9 x 80 cm
Acrylic on paper
Fulton Family Collection

28.
Phoenix Rising, c. 1999
50.8 x 40.6 cm.
16" x 20"
Oil on canvas
Collection of Glenbow; gift of Tamar Zenith, 2008
2008.006.002.
Photo: Glenbow

29.
Dawn Quilt, 1999
124.5 x 125 cm
49" x 49.5"
Acrylic, oil pastel, gold foil on canvas
Collection of Glenbow; purchased with the support of the Canada Council for the Arts Acquisitions Assistance Program/oeuvre achetée avec l'aide du programme d'aide aux acquisitions du Conseil des Arts du Canada, and from the Glenbow Collections Endowment Fund, 2000
2000.002.002
Photo: Glenbow

30.
Dream Bed Lover – Tipi Flap, 1999
220.9 x 161.3 cm
87" x 63.5"
Acrylic on canvas
Collection of Glenbow; purchased with funds from the Suncor Energy Foundation, 2008
2008.065. 001
Photo: Glenbow

31.
Song Of My Dreambed Dance, 1995
152 x 122 cm
60" x 48"
Acrylic on canvas
Collection of the National Gallery Of Canada: 41762; gift of the Alberta Foundation of the Arts, Edmonton
Photo: National Gallery of Canada

32.
Warshirt for Clayoquot Sound, 1994
125 x 97 cm
49" x 38"
Acrylic and mixed media collage on paper
Collection of the Thunder Bay Art Gallery, purchased with the support of the Canada Council for the Arts Acquisition Assistance Program/ oeuvre achetée avec l'aide du programme d'aide aux acquisitions du Conseil des arts du Canada, 1997
Photo: Thunder Bay Art Gallery

33.
I Hear the Call of the Loon from My Dream Bed, 1995
121.92 x 81.28 cm
48" x 32"
Mixed media
Collection of Ranchmen's Club, Calgary

34.
Once I Held a Rabbit (Mary), 1974
91.4 x 50.8 cm
36" x 20"
Acrylic on canvas
From the Estate of Joane Cardinal-Schubert

35.
In the Garden, 1986
111.76 x 111.76 cm
44" x 44"
Acrylic on canvas
Fulton Family Collection

36.
Birch Bark Letters to Emily Carr: House of All Sorts, 1991
101.6 x 127 cm
40" x 50"
Acrylic and collage on paper
Collection of the Kamloops Art Gallery
Photo: Kamloops Art Gallery

37.
Letters to Emily, Borrowed Power, 1992
91.44 x 243.84 cm
36" x 96"
Collage on rag paper
Collection of the Alberta Foundation for the Arts: 2017.003.002AB
Photo: Alberta Foundation for the Arts

38.
Ancestors (Keepers), 1992
91.44 x 122cm
63" x 48"
Collage on rag paper
Collection of the Alberta Foundation for the Arts: 2017.003.001
Photo: Alberta Foundation for the Arts

39.
Ancient Voices beneath the Ground, Stonehenge, 1983
81.3 x 121.8 cm
32" x 48"
Oil and graphite on rag paper
Collection of the Thunder Bay Art Gallery, Thunder Bay Art Gallery Art Plus Acquisition, 1985
Photo: Thunder Bay Art Gallery

40.
Ancient Chant beneath the Ground, 1982
61 x 81.4 cm
24" x 32"
Oil pastel, conté, and pastel on paper
Collection of the Alberta Foundation for the Arts, 1982.080.001
Photo: Alberta Foundation for the Arts

41.

The Sun Rose But for Some It Was the End, 1982

81 x 121 cm

32" x 48"

Oil and pencil on rap paper

Collection of the Thunder Bay Art Gallery, gift of the Government of Alberta, 1983

Photo: Thunder Bay Art Gallery

42.

Urban Warshirt, Metro – Techno, 2007

83.82 x 78.74 cm

33" x 31"

Mixed media collage on paper

From the Estate of Joane Cardinal-Schubert

43.

Four Directions – Keepers of the Vision – Warshirts: This is the Spirit of the West, This is the Spirit of the East, This is the Spirit of the North, This is the Spirit of the South, 1986

152.4 x 114.3 cm (each panel)

48" x 36" (each panel)

Oil, oil pastel, chalk, graphite, and collage on rag paper

From the Estate of Joane Cardinal-Schubert

44.

Great Canadian Dream – Pray for Me, Louis Riel, 1978

169 x 373 cm

66" x 146.75"

Oil on canvas, triptych

Collection of Carleton University Art Gallery, Ottawa: Gift of Alan Lumsden, 1995.

45.

Great Canadian Dream – Treaty No. 7, 1978

152.5 x 305 cm

60" x 120"

Oil on canvas

Collection of the Red Deer Museum and Art Gallery

46.

Great Canadian Dream No. 4, "Mountie Piece," 1978

81.3 x 243.8 cm

32" x 96"

Collection of Fort Calgary

Photo: Fort Calgary

47.

Homage to Smallboy: Where Were You In July Hercules, 1985

192.4 x 163.83 cm

76" x 64.5"

Oil and acrylic on canvas

From the University of Lethbridge Art Collection; purchased 1988 with funds from the Alberta Advanced Education Endowment and Incentive Fund as a result of a gift by the Crosby family, Banff

Photo: University of Lethbridge Art Collection

48.

Remnant Birthright; Museum II; Remember Dunbow; Is This My Grandmothers'; Remnant; Then There Were None, 1988

102 x 91 cm (each)

40" x 36" (each)

Oil, conté, charcoal on rag paper, found objects, clear vinyl, wood

From the installation *Preservation of a Species: Deep Freeze, 1989*

From the Estate of Joane Cardinal-Schubert

49.

Nihle Signe L'Arbore, 1994

120.5 x 80 cm

47.5" x 31.5"

Mixed media on rag paper

Collection of the Alberta Foundation for the Arts: 2008.106.002

Photo: Alberta Foundation for the Arts

50.

Looking for the Silver Bullet, 1995

152.3 x 122 x 2 cm

60" x 48"

Acrylic on canvas

Collection of the Alberta Foundation for the Arts: 1997.170.001

Photo: Alberta Foundation for the Arts

51.

Kimowan Metchewais

A Guide to Doing Contemporary Indian Art, 1989

28.6 x 19.05 cm

11.25" x 7.5"

Oil on paper

From the Estate of Joane Cardinal-Schubert

52.

Medicine Wheel (There Is No Hercules), 1985

233 x 172.1 x 111.1 cm

92" x 68" x 43.75"

Acrylic on canvas and lodge pole pine

Collection of the Alberta Foundation for the Arts: 2008.106.003.ABC

Photo: Alberta Foundation for the Arts

53.

Sunset Beginning, 1985

66.5 x 101.8 cm

26" x 40"

Oil and coloured pencil on paper

Collection of the Alberta Foundation for the Arts: 1986.010.002

Photo: Alberta Foundation for the Arts

54.

My Mother's Vision VII, 1983

80.3 x 192 cm

31.5" x 75.5"

Oil, pastel, and charcoal on paper

Collection of the Alberta Foundation for the Arts: 1985.069.001.AB

Photo: Alberta Foundation for the Arts

55.

Moonlight Sonata: In the Beginning, 1989

171.5 x 122.5 cm

67.5" x 48"

Oil on canvas

Collection of the Alberta Foundation for the Arts: 1989.025.001

Photo: Alberta Foundation for the Arts

56.

Crowsnest Mountain and the Seven Sisters, 1989

75.6 x 106.1 cm

30" x 42"

Oil on paper

Collection of the Alberta Foundation for the Arts: 1991.002.001

Photo: Alberta Foundation for the Arts

57.

This Is the Land, c. 1988

150.5 x 242.5 cm

59.5" x 95.5"

Oil on Masonite

Collection of the Alberta Foundation for the Arts: 2016.004.001

Photo: Alberta Foundation for the Arts

58.
I Dream Of Horse/Counterpane, 2002
183.2 x 122.2 cm
72" x 48"
Acrylic and gold leaf on canvas
Collection of the Alberta Foundation for the Arts: 2002.002.001
Photo: Alberta Foundation for the Arts

59.
Yellow Plywood, 2005
75.5 x 105.5 cm
30" x 41.5"
Mixed media on rag paper
Collection of the Alberta Foundation for the Arts: 2008.106.001
Photo: Alberta Foundation for the Arts

60.
Flutterby (Birchbark Letter), 1998
120 x 99.5 cm
47.5" x 39"
Mixed media on canvas
Collection of the Alberta Foundation for the Arts. 2008.106.004
Photo: Alberta Foundation for the Arts

61.
5 Raiders, 1982
58.42 x 78.74
23" x 31"
Oil pastel on paper
Collection of the Juniper Hotel, Banff

62.
Grandfather Red Horse Rattle, 1994
59.9 x 91.2 cm
32.5" x 36"
Oil on canvas
Collection of the Robert McLaughlin Gallery; purchased with the support from the Canada Council for the Arts, Acquisition Assistance Program, 1998
Photo: Robert McLaughlin Gallery

63.
Dreaming of Ghost Dance Shirts, 1995
153 x 121.9 cm
60.25" x 48"
Acrylic on canvas
Fulton Family Collection

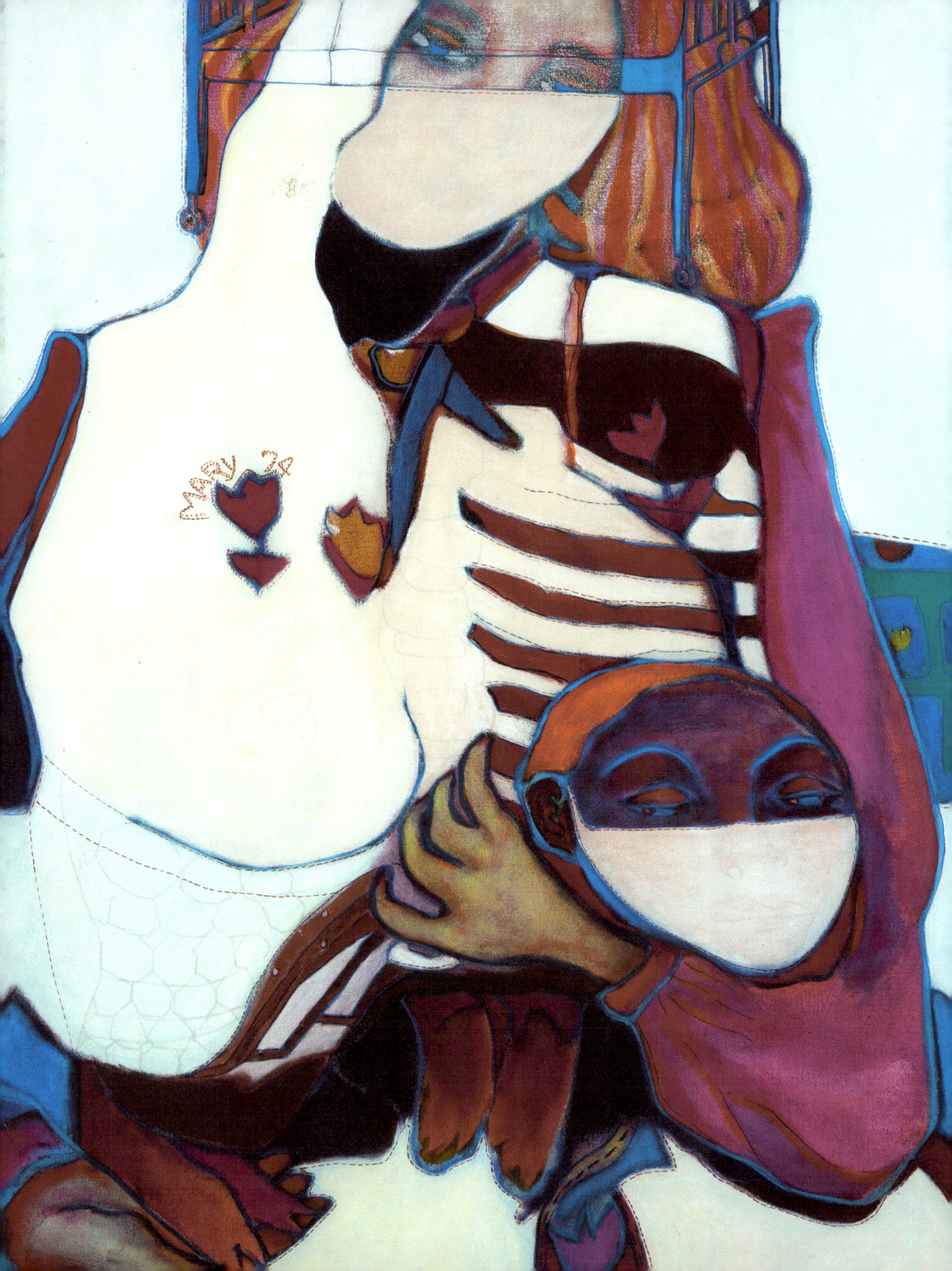

CURRICULUM VITAE

Dr. Joane Cardinal-Schubert, RCA

b. Red Deer, Alberta, Canada, 1942

d. Calgary, Alberta, Canada, 2009

Education

1983	Certificate, Cultural Resource Management Development for Arts Administrators, Banff Centre, Alberta
1977	BFA, major in printmaking and painting, University of Calgary, Alberta
1962–64; 1966–68	Certificate, major in printmaking and painting, Alberta College of Art, Calgary, Alberta

Professional Experience

2000–03	Volunteer President, Calgary Aboriginal Arts Awareness Society, (Founded the F'N (First Nations) Gallery in 2001)
1988–2000	Arts Committee; Volunteer, Calgary Aboriginal Arts Awareness Society
1988–95	Triangle Gallery Board
1979–85	Assistant Curator, Nickle Arts Museum, University of Calgary, Calgary, Alberta
1977–79	Curatorial Assistant, University of Calgary Art Gallery, Calgary, Alberta

Selected Solo Exhibitions

2015	*Works of Joane Cardinal-Schubert*, Masters Gallery Ltd, Calgary, Alberta
2013–14	*Joane Cardinal-Schubert*, Alberta Society of Artists and Alberta Foundation For the Arts travelling exhibition (TREX)
2009	*Works of Joane Cardinal-Schubert*, Masters Calgary Ltd, Calgary, Alberta
2003	*Works of Joane Cardinal-Schubert*, Masters Gallery Ltd, Calgary, Alberta
2002	*Spring Thaw*, BearClaw Gallery, Edmonton, Alberta
2000	*Billboard of Dreams*, Masters Gallery Ltd, Calgary
1999	*Mother Earth Has Had a Hysterectomy*, Surrey Art Gallery, site specific: commissioned installation
1999	*A Journey*, Masters Gallery Ltd, Calgary
1999	*Joane Cardinal-Schubert*, Toronto International Pow Wow, Sky Dome, Toronto
1998	*Letters to Emily*, Women's Art Resource Centre Gallery, Toronto, Ontario
1998	*Flutterby/Chaos Counterpane*, Bugera/Kmet Galleries, Edmonton, Alberta
1997–2000	*Joane Cardinal-Schubert: Two Decades*; Muttart Gallery, Calgary; Thunder Bay Art Gallery, Thunder Bay, Ontario; Yukon Art Gallery and Museum, Whitehorse, Yukon; Art Gallery of Greater Victoria; Surrey Art Gallery; South Okanagan Art Gallery, Kelowna; Woodland Cultural Centre, Brantford; Robert McLaughlin Gallery, Oshawa
1996	*Dream Beds*, Derek Simpkins Gallery, Vancouver; Masters Gallery, Calgary
1995	*The Lesson*, Central Michigan University, Mt. Pleasant
1994	*Joane Cardinal-Schubert RCA*, Imperial Oil Gallery, Museum of the Regiments, Calgary, Alberta
1994	*Joane Cardinal-Schubert*, The Forum, Steele, Germany
1993	*Passage to Origins*, FAB Art Gallery, University of Alberta, Edmonton, Alberta

1993	*The Lesson* (performance) En'okiwin Centre, Penticton, British Columbia
1993	*The Lesson* (performance and lecture) Merrit, British Columbia
1992	*Looking and Seeing*, Derek Simpkins Tribal Arts, Vancouver, British Columbia
1991	Intermedia Arts Gallery, Minneapolis, Minnesota
1990	*Preservation of a Species: Cultural Currency, The Lesson*, Articule Gallery, Montreal, Quebec
1990	*Preservation of a Species: Deconstructivist*, Ottawa School of Art Gallery, Ottawa, Ontario
1990	Women's Bookworks (Street Installation), London, Ontario.
1985	*Joane Cardinal-Schubert: This Is My History*, Thunder Bay Art Gallery, Thunder Bay, Ontario
1982	White Village Fine Art, Edmonton, Alberta

Selected Group Exhibitions

2014–16	*Path Makers*, Alberta Foundation for the Arts Travelling Exhibition (TREX)
2014	*Night at the Museum*, University of Lethbridge Art Gallery, Lethbridge, Alberta
2014	*Indigenous Ingenuity*, Whyte Museum of the Canadian Rockies, Banff, Alberta
2013	*Made in Calgary*, Glenbow, Calgary, Alberta
2013	*Witnesses: Art and Canada's Residential Schools*, Helen and Morris Belkin Art Gallery, Vancouver, British Columbia
2009–15	*Narrative Quest*, Organized by the Alberta Foundation for the Arts, curated by Gail Lint, curatorial assessment and recommendation by Joane Cardinal-Schubert. Capital Arts Building, Edmonton; Royal Alberta Museum, Edmonton; Red Deer Museum and Art Gallery; Museum of Contemporary Art, Calgary; Art Gallery of Grande Prairie; Embassy of Canada, Prince Takamado Gallery, Tokyo, Japan
2008	*Honouring Tradition: Reframing Native Art*, Glenbow, Calgary, Alberta

2007	*Overstepped Boundaries: Powerful Statements by Aboriginal Artists in the Permanent Collection*, Kamloops Art Gallery, Kamloops, British Columbia
2004	*Contested Landscape*, Kelowna Art Gallery, Kelowna, British Columbia
2002	*Five Degrees*, Art Gallery of Calgary, Calgary, Alberta
2002	*Album, ACAD 75*, Alberta College of Art and Design, Calgary, Alberta
2001–02	*Nitsitapiisinni: Our Way of Life, (Blackfoot People – Then and Now)*, Glenbow Museum, Calgary, Alberta
2001	*Benefit: Artrageous*, Alberta College of Art and Design, Calgary, Alberta
2001	*Ten Little Indians*, St. Norbert Art Centre, Manitoba
2000	*Mother Earth Has Had a Hysterectomy*, Uptown Gallery, Winnipeg, Manitoba
2000	*The Powwow: An Art History*, Mackenzie Art Gallery, Regina, Saskatchewan
1999	*Fusion, Tradition & Discovery: A Celebration of Shared and Cross-Cultural Experiences*, Spirit Wrestler Gallery, Vancouver, British Columbia
1999	*Guerrilla Tactics, A Diary*, Southern Alberta Art Gallery, Lethbridge, Alberta
1998–99	*Inhere/Out There: An Exhibition of Contemporary Alberta Art*, Alberta Biennial, Glenbow Museum, Calgary; Edmonton Art Gallery, Edmonton, Alberta
1996	*Captain Vancouver, 1939 by Charles Comfort: Four Native Perspectives*, Confederation Centre Art Gallery in Museum, Charlottetown. Prince Edward Island
1994	*With Emily Carr – Letters to Emily*, Art Gallery of Greater Victoria, Victoria, British Columbia
1992–93	*First Ladies*, Pitt Gallery, Vancouver, British Columbia; A Space Gallery, Toronto, Ontario
1993	*Canadian Art*, Palais Gallery, Prague, Czechoslovakia
1992–95	*INDIGENA: Contemporary Native Perspectives*, Canadian Museum of Civilization, Hull, Quebec

1992	*New Territories: 350/500 Years After: An Exhibition of Contemporary Aboriginal Art of Canada,* Les Maisons de la Culture de Montréal, Montreal, Quebec
1992	*Changers: A Spiritual Renaissance,* Dalhousie Art Gallery, Nova Scotia
1992	*Contemporary First Nations Art,* Ufundi Gallery, Ottawa, Ontario
1991	*New Alberta Art – Diversities,* Glenbow Museum, Calgary, Alberta
1991	*Solidarity: Art After OKA,* SAW Gallery, Ottawa Ontario
1991	*Visions of Power,* Earth Spirit Festival, Harbour Front, Toronto, Ontario
1991	*An (Other) Voice,* Russell Gallery, Lindsay, Ontario
1991	*Strengthening the Spirit: Works by Native Artists,* National Gallery of Canada, Ottawa, Ontario
1991	*Our Words Are One,* Triangle Gallery, Calgary, Alberta
1991	*Art for All,* Edmonton Art Gallery, Edmonton, Alberta
1991	*Okanata,* A Space Gallery, Toronto, Ontario
1990	*Indian Summer: An Exhibition of Works by Joane Cardinal-Schubert, Irvin, Eula & Daryl Chrisjohn, Robert Fréchette, Florence Ryder,* Embassy Cultural House, London, Ontario
1990	*Carl Boam – Joane Cardinal-Schubert,* Ufundi Gallery, Ottawa, Ontario
1990	*Seeing Red,* Agnes Etherington Art Centre, Queens University, Kingston, Ontario
1990	*Fear of Others: Art Against Racism,* New Gallery, Calgary, Alberta
1989	*Beyond History,* Vancouver Art Gallery, Vancouver, British Columbia
1989	Augusta Savage Memorial Gallery, University of Massachusetts, Amherst
1988	*Revisions,* Walter Phillips Gallery, Banff, Alberta
1988	*Women in the University of Lethbridge Collection,* University of Lethbridge, Lethbridge, Alberta
1988	*In the Shadow of the Sun,* West Germany and Canadian Museum of Civilization, Hull, Quebec

1986–87	*Stardusters: New Works by Jane Ash Poitras, Pierre Sioui, Joane Cardinal-Schubert, Edward Poitras,* Thunder Bay Art Gallery, Thunder Bay, Ontario; Mackenzie Art Gallery, Regina, Saskatchewan; Burnaby Art Gallery, Burnaby B.C.; Southern Alberta Art Gallery, Lethbridge, Alberta; SAW Gallery, Ottawa, Ontario; Musée du Bas-Stain-Laurent, Rivière-du-Loup, Quebec; Galerie d'Art du Centre culturel de l'Université de Sherbrook, Quebec
1986	*Four Woman Group Show*, Brignell Gallery, Toronto, Ontario
1984	*Sharing Visions*, Alberta Society of Artists, various locations in Korea and Japan
1983	Canada House, Alberta Room, London, Eng.
1983	International Art Exposition, Solina, Sweden
1976	*Images of Light*, Dandelion Gallery, Calgary, Alberta
1975	*Royal Horses Mouthpiece*, Dandelion Gallery, Calgary, Alberta
1975	BFA Exhibition, University of Calgary Art Gallery, Calgary, Alberta
1974	Contemporary Artists, Festival Calgary, Calgary, Alberta
1969	SUB Art Gallery, University of Alberta, Edmonton, Alberta
1969	Fort Malden Art Guild, Amherstburg, Ontario
1967	Student Exhibition, Alberta College of Art, Calgary, Alberta

Selected Invited Lectures

2003	Keynote Address, "Flying with Louis," Aboriginal Curatorial Symposium, the Banff Centre
2003	Plenary Speaker, New Sun Chair Symposium, Carleton University, Ottawa, Ontario
2002	CMA Panel Relevance and Elitism, CMA Conference, Calgary, Alberta
2002	Seattle Arts Museum, Salmon Festival, Speaker, Seattle, Washington

2001	Plenary, *Atanarjuat: The Fast Runner*. World Premier, Uptown Theatre, Calgary
2001	Native Awareness Week, Guest Speaker, Native Students Centre, University of Calgary, Calgary, Alberta
2000	Gatherings, Art Gallery of Nova Scotia, Plenary, Speaker
2000	Aboriginal Arts Café, Gallery of Nova Scotia, Halifax, Nova Scotia
1998	Keynote Address, British Columbia Festival of the Arts, Victoria, British Columbia
1995	HERLAND, Glenbow: Address for the Film and Video Festival
1994	Panellist, Mined Culture, Open Space, Victoria, British Columbia
1994	Plenary, University of Calgary, Department of Communications, International Management Academics.
1994	Lecture, "This is My History," Concordia University, Department of Fine Art, Montreal, Quebec
1993	Lecture, Kelowna Art Gallery, Kelowna, British Columbia
1993	Lecture, Camousin College, Victoria, British Columbia
1993	Presenter, "Master Native Artists of North America" with Allen Hauser and Bob Hazous, Smithsonian, Washington, DC,
1993	Arts Nominee, Women of Distinction, YMCA, Calgary, Alberta
1993	Plenary Speaker, Panellist, *The Waking Dreamer Ends the Silence*, International Conference of Aboriginal Peoples of the World, Museum of Civilization, Hull, Quebec
1993	Workshop, Performance, *The Lesson*, Merrit, British Columbia
1991	Lecture, Camousin Art College, Victoria, British Columbia
1991	Mount Allison University, Owens Art Gallery, Sackville, New Brunswick
1991	Keynote, Panellist, "INterventing the Text," University of Calgary, National Conference of Educators
1990	Lecture, Panellist, Gettysburg College, Gettysburg, Pennsylvania

1990	Lecture, Studio Visits, Workshops, MAWA, Winnipeg, Man.
1990	Guest Speaker, Panel Moderator, National Symposium of Aboriginal Women, New College, University of Toronto
1990	Lecture, SAW Gallery, Ottawa
1990	Lecture, Articule Gallery, Montreal, Quebec
1990	Lecture, Western Canadian Art Association Conference, Saskatoon, Saskatchewan
1990	Guest Speaker, CARFAC, National Conference, Regina, Saskatchewan
1990	Lecture, *Three Women in Canada*, Lecture Series, Ontario College of Art, Toronto
1990	Lecture, Fanshawe College, London, Ontario
1990	Guest Speaker, Panellist, Agnes Etherington Art Centre, Queen's University, Kingston, Ontario
1989	Art Editor, Consultant, Oxford Companion to Native Studies, University of Victoria
1989	Artist in Residence, Art Department, University of Western Ontario, London, Ontario
1989	Lecturer, Guest Speaker, Department of Native Studies, University of Alberta, Edmonton
1989	Guest Speaker, Panellist, Ontario Indian Arts and Craft Conference, Ontario College of Art, Toronto
1989	Workshops, Studio Visits, and Guest Lecture, WOMAD, Winnipeg Manitoba, Plug In Gallery
1989	Paper Presentation, "In the Red," Meridian Nights Series, San Francisco Art Institute
1989	Guest Speaker, Panellist, National Native Women's Symposium, University of Lethbridge, Lethbridge, Alberta
1989	Paper Presentation, "On Native Art in Canada to Canada Council for the Arts" Ad Hoc Native Committee to Discuss Appropriation, Vancouver Friendship Centre, Vancouver, British Columbia

1989	Guest Speaker, National Curatorial Symposium, Art Gallery of Greater Victoria, Victoria, British Columbia
1989	Guest Speaker, Western Canadian Art Association Conference, Saskatoon, Saskatchewan
1989	Lecture, "New Alberta Art – Diversities," Glenbow Museum, Calgary, Alberta
1988	Lecture, Panellist Speaking Engagements, Peace River Adult Education Centre, Peace River, Alberta
1988	Lecture, Society of Education through Art Conference, Palliser Hotel, Calgary, Alberta

Selected Scholarships, Bursaries, Awards, Honours

2007	National Aboriginal Achievement Award in Arts, National Aboriginal Achievement Foundation
2006	Alumni Award of Excellence in Art and Design, Alberta College of Art and Design
2003	Honourary Doctor of Laws cum laude, University of Calgary
2002	Queen's Golden Jubilee Medal, for contributions to community and country.
2002	Alumni Award of Excellence, Alberta College of Art 75th Anniversary Celebrations, Calgary
1995	Nominee, Arts, Canadian Native Arts Foundation, Toronto
1994	Banff Centre Scholarship
1994	Alberta Arts Foundation Scholarship
1994	Canada Council Exploration Grant
1993	Awarded Commemorative Medal of Canada for contribution to the Arts in Canada
1993	Nominated for the Women of Distinction Award, Calgary, Alberta
1990	Canada Council Travel/Project Grant

1989	Alberta Culture Project Grant
1987	Commission for a Commemorative Painting, Province of Alberta, Presentation to the Duke and Duchess of York, at the Official Opening of the World's Heritage Centre: Head-Smashed-In Buffalo Jump, Alberta
1986	Elected to the Royal Canadian Academy, RCA (the fourth woman to be elected into the academy)
1985	Molson's Publication and Purchase Award
1984	Western Canadian Art Association Publication Award of Excellence
1983	Canadian Museums Short-Term Study Grant
1983	Banff Centre Scholarship, Arts Administrators Course
1982	Stockmans Friends Award, Stockmans Foundation

Selected Independent Freelance Curator, Writer

2002	Reflection Paper Written for Heritage Canada, "A Passionate Paper" by Joane Cardinal-Schubert
1999	PASSAGES: Ways of Seeing, Nickle Arts Museum, Alumni Exhibition, First Nations, University of Calgary
1997–99	MarkMakers, Touring Exhibition, Norman MacKenzie Art Gallery, Regina
1995	Triangle Gallery, New Gallery: Seven Lifetimes: Yesterday, Today, and Tomorrow; Beyond Barriers; Emerging Native Artists; Children's Art Contest; Native Film and Video Festival; Through Elder's Eyes Glenbow Museum.
1993	Time For Dialogue, Triangle Gallery, Calgary, Alberta
1992	Share the Heart Song of Our Families, Triangle Gallery, Calgary, Alberta
1991	Our Worlds Are One, Triangle Gallery, Calgary (Curator)
1988	Art is Our Game, Alberta Society of Artists, Gulf Canada

Video

1993–94	Art Director, Writer, Assistant Director, Sound, Animator PSA Project (Public Service Announcements) Self-Government: Project of the Aboriginal Film and Video Arts Alliance, Banff Centre, Banff, Alberta.
1993–94	Exhibited/Screened: Walk With the Ancients MOMA, NY
1993–94	*Guess Who's Back*, a video produced by the Enowkin Centre. Director, Art Director, Audio Design, Set Design, costume design, Banff Centre, Banff, Alberta

Theatre

2003	Reader, *Vagina Monologues*, An Aboriginal Presentation in Honour of International V Day, Boris Robakaine Theatre, University of Calgary
2001	Pumphouse Victor Mitchell Theatre, Producer; Set Design; F'N Haute Café Celebration of Aboriginal Artists, video, film readings, performance
2001	Pumphouse, Victor Mitchell Theatre, Producer; Set Design, Variety Theatre
2000	Pumphouse, Victor Mitchell Theatre; Assistant Director, Set Design: *Laughing 4 Those Who Can't*, a play by Michelle Thrush
1999	One Yellow Rabbit, High Performance Rodeo; Assistant Director: Assimilating Richard, a Music/Dance/Drama by Troy Emery Twigg
1998	Spider Tribe Theatre, Producer, Director, Set Design, Costume; *Juliet/Juliet*, a play by Alice Lee, Performing Arts Centre, Calgary, Alberta
1997	Spider Tribe Theatre, Producer, Director, Set Design, Costume; *Juliet/Juliet*, a play by Alice Lee, Engineered Air Theatre, Performing Arts Centre, Calgary, Alberta
1996	Calgary Aboriginal Awareness Society; production: Assistant Director: A Land Called Morning

Selected Bibliography

Ace, Barry, and July Papatsie. *Transitions: Contemporary Canadian Indian and Inuit Art*. Ottawa, Ontario: Department of Foreign Affairs and International Trade; Indian and Northern Affairs Canada, 1997.

"Art autochtone ‡ la Plaza Alexis-Nihon." *Journal de Montréal*, 12 décembre, 1992, WE-2.

"Artist Fights Stereotypes." *Windspeaker* 7, no. 8 (April 28, 1989): 13.

"Artist Shares Her Vision." *Windspeaker* 7, no. 18 (July 7, 1989): 13.

"Artist's Work Hits Us Like a Smack across the Face: Joane Cardinal-Schubert Writes the Sad History of Native Peoples in Simple, Printed Letters." *Montreal Gazette*, May 12, 1990, K5.

Baele, Nancy. "Five Artists Join Past to Present." *Ottawa Citizen*, April 19, 1990, p. El.

———. "Native Artist Puts Writing up on the Wall." *Ottawa Citizen*, April 26, 1990, E1.

Beauchamp, Elizabeth. "Native Art in Spotlight: Festival Perks Up Slow Summer Visual Scene." *Edmonton Journal*, August 3, 1990, C12.

Canadian Museum of Civilization, ed. *In the Shadow of the Sun: Perspectives on Contemporary Native Art*. Hull, Quebec: The Museum, 1993.

Cardinal-Schubert, Joane. "In the Red." In *Borrowed Power: Essays on Cultural Appropriation*, eds. Bruce Ziff and Pratima V. Rao, 122–33. New Brunswick, New Jersey: Rutgers University Press, 1997.

———. *Joane Cardinal-Schubert: This Is My History: An Exhibition of Works on Paper and Canvas*, June 7–July 7, 1985. Thunder Bay, Ontario: Thunder Bay National Exhibition Centre and Centre for Indian Art, 1985.

———. *Time for Dialogue: Contemporary Artists*. Calgary, Alberta: Aboriginal Awareness Society, 1992.

"Cardinal-Schubert Retrospective Spans 20 years." *Windspeaker* 11, no. 20 (1993): 13.

Cronin, Ray. "Captain Vancouver by Charles Comfort: Four Native perspectives." *ARTSatlantic* 15, no. 3 (Fall/Winter 1997):

"Curator (Joane Cardinal-Schubert) Hopes to Change Racism." *Calgary Herald*, May 5, 1989, C1.

Danzker, Jo-anne Birnie. "The Revolver: Cultural Convergence, or, Should Artists Appropriate Native Imagery?" *Canadian Art* 7, no. 3 (Fall 1990): 23–4.

Dibbelt, Dan. "Calgary Vandals Attack Environmental Art and Strengthen its Statement (Abandoned Camp Keeper of the Culture)." *Windspeaker* 5 no. 47 (1988): 3.

"Dream Beds." *Vancouver Sun*, September 30, 1995, D5.

Enright, Robert. "The House That Joane Built: The Art of Joane Cardinal-Schubert." *Border Crossings* 11, no. 4 (1992): 47–9.

———. "The Sky is the Limit: Conversations with First Nations Artists." *Border Crossings* 11, no. 4 (1992): 46–57.

Garneau, David. "Eye Streaming." *Border Crossings* 17, no. 1 (1998): 49–50. [Review: Muttart Public Art Gallery]

Gaudet, Elaine. "Des artistes autochtones contemporains." *Le Droit*, 12 novembre, 1991, 34.

Gilmor, Alison. "The Practice of Conflicting Art." *Border Crossings* 11, no. 4 (1992): 73f.

Burns, Kathryn, and Gerald McMaster. *Joane Cardinal-Schubert: Two Decades*. Calgary, Alberta: Muttart Public Art Gallery, 1997.

Kanbara, Bryce, and Alfred Young Man. *Visions of Power: Contemporary Art by First Nations, Inuit and Japanese Canadians*. Toronto, Ontario: Earth Spirit Festival, 1991.

Lunn, Dr. John, et al. *Canada's First People: A Celebration of Contemporary Native Visual Arts*. Fort McMurray, Alberta: Syncrude Canada; Alberta Part Art Publications Society, 1992.

MacKay, Marilyn. "Changers: A Spiritual Renaissance." *ARTSatlantic* 11, no. 2 (Winter 1992): 34–6.

Mainprize, Garry. *Stardusters: New Works by Jane Ash Poitras, Pierre Sioui, Joane Cardinal-Schubert, Edward Poitras*. Organized by the Thunder Bay Art Gallery; Translation, Sylvain Topping. *Stardusters : oeuvres récentes de Jane Ash Poitras, Pierre Sioui, Joane Cardinal-Schubert, Edward Poitras*. Organisée par la Thunder Bay Art Gallery. Thunder Bay, Ontario: The Gallery, 1986. [Catalogue of a travelling exhibition: November 8, 1986–December 22, 1987]

Marcus, Angela. "Cross Cultural Views." *Art Post* 4, no. 3 (February–March 1987): 32–4.

Mays, John Bentley. "Native Artists Seize the Moment to Display Anger against History." *Globe and Mail*, May 16, 1992, C4.

McMaster, Gerald, and Lee-Ann Martin, eds. *INDIGENA: Contemporary Native Perspectives*. Vancouver, BC: Douglas & McIntyre, 1992 / *INDIGENA: Perspectives autochtones contemporaines*. Hull, Québec: Musée Canadien des Civilisations, 1992.

"Native Art is in Demand." *Calgary Herald*, April 19, 1992, C1, C3.

Pakasaar, Helga, Deborah Doxtater, Jean Fisher, and Rick Hill. Revisions. Banff, Alberta: Walter Phillips Gallery, Banff Centre, 1992.

"Print Fosters Stereotype of Natives, Artist Says." *Globe and Mail: Metro Edition*, July 7, 1989, C10.

Redcrow, Jackie. "Artist Inspired by Traditional Sites." *Windspeaker* 5, no. 31 (1987): 12.

Ryan, Allan J. "Postmodern Parody: A Political Strategy in Contemporary Canadian Native Art." *Art Journal* 51, no. 3 (Fall 1992): 59–65.

Smith, Steven. "Western Canadian Icons." *Border Crossings* 7, no. 3 (Summer 1988): 28–30.

Teel, Gina. "Cardinal-Schubert Retrospective Spans 20 years." *Windspeaker* (December 20, 1993–January 2, 1994): 13.

Tétrault, Pierre-Léon, Dana Alan Williams, Guy Sioui Durand, Alfred Young Man, et al. *New Territories: 350/500 Years After: An Exhibition of Contemporary Aboriginal Art of Canada*. Prefaces by Robert Houle, Tom Hill. Montreal, Quebec: Ateliers Vision planétaire, 1992.

Townsend, Nancy. "Joane Cardinal-Schubert: Preservation of a Species, 1987–88." *Art Post* 5 no. 4 (Summer 1988): 23–5. [Review: Gulf Canada Gallery, Calgary]

Residencies

2002	Gushul Studio, arts residency, August, University of Lethbridge, Blairmore, Alberta
2001	Ten Little Indians, arts residency, month of August, St. Norbert Art Centre, Manitoba
1996	Art Associate, Banff Centre, Banff, Alberta
1994	"Nomad," Art Associate, Banff Centre, Banff, Alberta
1994	Residency, Commissioned Mural, Steele, Germany
1990	Womens Bookworks, London, Ontario. Street Project Installation
1989	Gushul Studio, Blairmore, University of Lethbridge
1988	Leighton Colony, Banff, Alberta

Other Activities

2000	Appointment to the Canada Council Aboriginal Secretariat, National Visual Arts Representative
2000	The Trickster Shift, Publication, Allan Ryan, UBC Press
2000–02	President, Calgary Aboriginal Arts Awareness Society – Initiated the opening of The First Nations Public Art Gallery
2001	Profile on APTN

Collections

National Gallery of Canada, Art Bank, Smithsonian, Indian Arts Centre Collection, Ottawa, Canadian Museum of Civilization, Thunder Bay Art Gallery, Art Gallery of Greater Victoria, Alberta Foundation for the Arts, Alberta Government House Collection, Robert McLaughlin Gallery, Glenbow, City of Calgary, University of Lethbridge, Kamloops Art Gallery, Red Deer Museum and Art Gallery, Fort Calgary, Department of Indigenous and Northern Affairs, Canadian Embassies in Japan, New York, Stockholm and Tokyo, Presidential Collection of Mexico, Collection of Her Majesty Queen Elizabeth II (Duke and Duchess of York), London, England, Shell Canada Limited, Bank of America, Molson's, Esso Resources, and Northern Telecom and many national and international private collections.

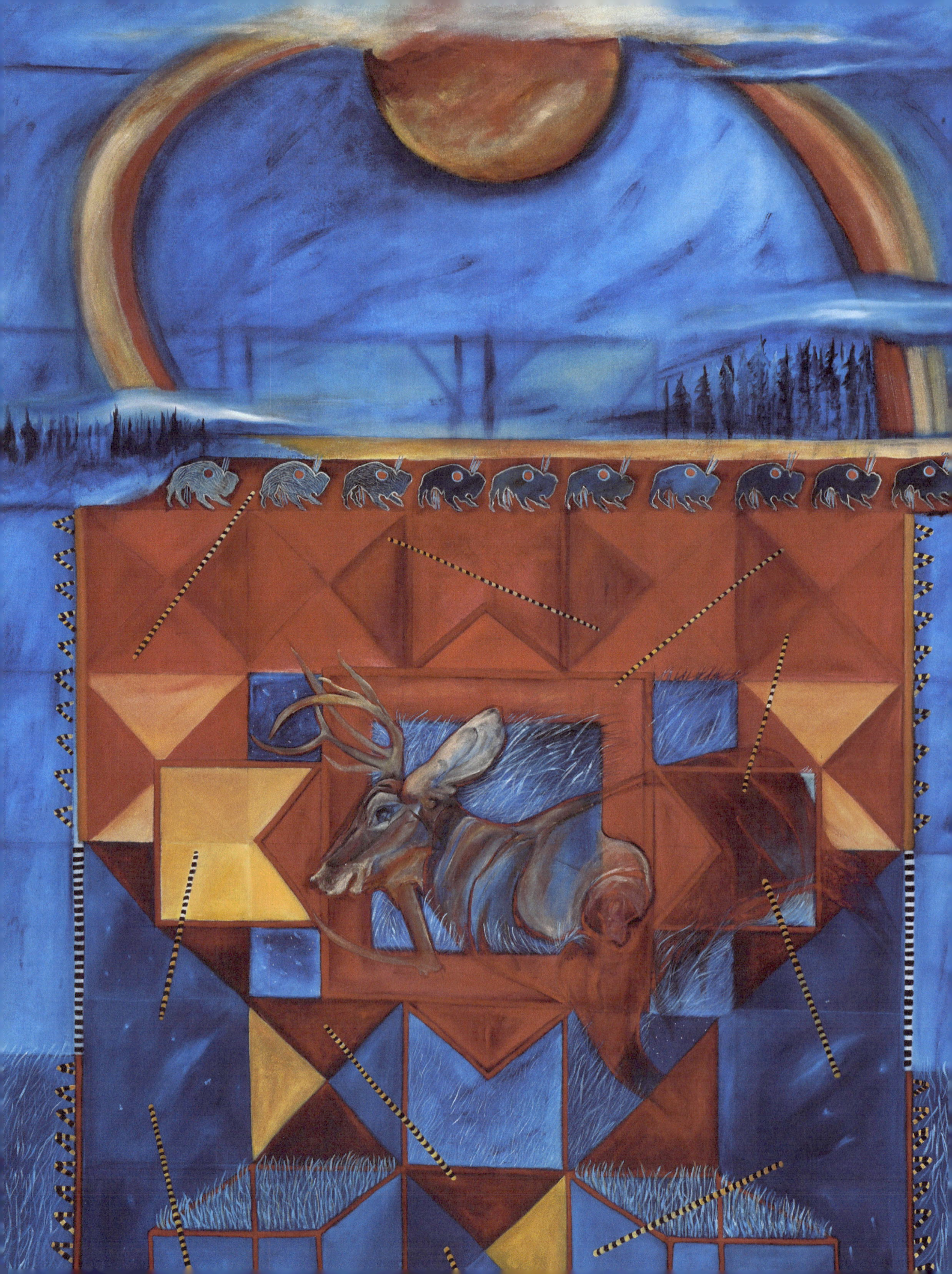

CONTRIBUTORS

LINDSEY V. SHARMAN

Lindsey V. Sharman is a curator for the University of Calgary and adjunct professor for the university's Department of Art. Born in Saskatoon, Saskatchewan, Sharman has studied art history and curating in Canada, England, Switzerland, and Austria. Lindsey V. Sharman has an honours degree in Art History from the University of Saskatchewan in conjunction with the University of Essex. She completed research for a master's degree in curating from the Zurich University of the Arts in 2012. Her primary research interest is in politically and socially engaged art practice.

MIKE (ECKEHART) SCHUBERT

Mike Schubert was born in Germany in 1943. He and his family immigrated to Canada from West Germany in 1952 and settled in Ponoka, central Alberta. They moved to Red Deer in 1962 where he met Joane at the Lindsay Thurber Comprehensive High School. Joane and Mike were married at Gaetz United Church in Red Deer in 1967 – the same year he started studying chemical technology at the Southern Alberta Institute of Technology and Joane entered the Alberta College of Art. The couple moved to Edmonton in 1969 when Mike got a job in the Chemistry Department at the University of Alberta and then, shortly after, a lab tech position with Alberta Environment in Edmonton. Joane had started a BFA at University of Alberta then transferred to University of Calgary when Mike got a senior position with the Federal Department of Environment in Calgary, where he worked for eleven years. Not wanting to leave Calgary, because by that time Joane was working as a curator at the Nickle Museum, Mike found a job with the City of Calgary's Waterworks Department doing environmental analysis. After twenty-three years with the City, Mike retired in 2008. Mike lives in Calgary with his son, Justin Cardinal-Schubert.

MONIQUE WESTRA

For the past thirty years, Monique Westra has been professionally and personally affiliated with art and art-making as a curator, writer, and teacher. She worked as an educator at the Montreal Museum of Fine Arts and the Art Gallery of Ontario. Most recently she was art curator at the Glenbow Museum from 2002 to 2010, following more than a decade of teaching art history at ACAD and at the University of Calgary. Related to her essay about Joane Cardinal-Schubert is her writing about her own personal experience with breast cancer entitled "Radiation Diptych," in the *Canadian Medical Association Journal* (July 9, 2002).

DAVID GARNEAU

David Garneau is a nationally and internationally celebrated artist who works in paint, drawing, video, and performance. He is a critical arts writer, editor, and curator. He teaches painting, drawing, and criticism in the Visual Arts Department at the University of Regina. His work covers visuality and representation, focusing on ideas about nature and culture, masculinity, and ethnicity – especially Métis heritage. Garneau is interested in creative expressions of contemporary Indigenous identities, and moments of productive friction between nature and culture, materialism and metaphysics.

ALISDAIR MACRAE

Alisdair MacRae is an artist working in sculpture and installation, was born in 1974 in Dawson Creek, BC and raised in Victoria. In 2002, he received an MFA from the Milton Avery Graduate School at Bard College, which complemented the BFA he earned from the University of Victoria four years earlier. In 2012, he completed a thesis on Joane Cardinal-Schubert for his Master's degree in Art History at Carleton University. MacRae develops projects using plans to examine community and exchange, experienced through a do-it-yourself approach that enables social interactions.

TANYA HARNETT

Tanya Harnett is a member of the Carry the Kettle First Nations in Saskatchewan. She is an artist and a professor at the University of Alberta in a joint appointment in the Department of Art and Design and the Faculty of Native Studies. She has previously taught at both University of Lethbridge and Grant MacEwan University. Working in various media including, photography, drawing, printmaking, and fibre, Harnett's studio practice engages in the notions and politics of identity, history, spirituality, and place. She has exhibited regionally, nationally, and internationally.

GERALD MCMASTER

Dr. McMaster has over thirty years international work and expertise in contemporary art, critical theory, museology, and Indigenous aesthetics. His experience as an artist and curator in art and ethnology museums researching and collecting art, as well as producing exhibitions, has given him a thorough understanding of transnational Indigenous visual culture and curatorial practice. His early interests concerned the ways in which culturally sensitive objects were displayed in ethnology museums, as well as the lack of representation of Indigenous artists in art museums. As a curator, he focused on advancing the intellectual landscape for Indigenous curatorship through the foundational concept of voice. He curated *Indigena* (1992), which brought together unfiltered Indigenous voices for the first time. Until then, non-Indigenous scholars had dominated discussions of Indigenous art, history, and culture. McMaster made the point that Indigenous artists and writers were more than capable of representing themselves in articulate, eloquent ways.

www.ingramcontent.com/pod-product-compliance
Lightning Source LLC
Chambersburg PA
CBHW041312180526
45172CB00004B/1073